A Mythic Obsession

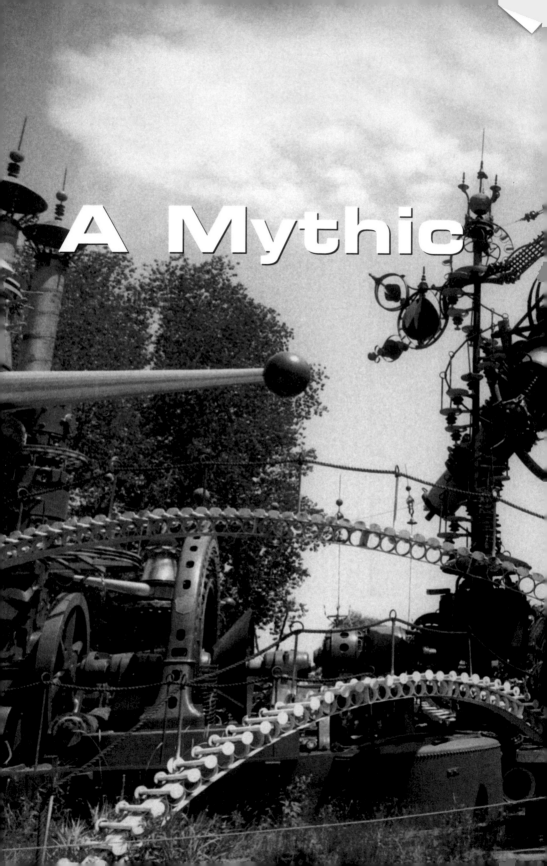

Obsession

The World of Dr. Evermor

Tom Kupsh

CHICAGO
REVIEW
PRESS

First hardcover edition published 2008
First paperback edition published 2021
Published by Chicago Review Press Incorporated
814 North Franklin Street
Chicago, Illinois 60610
ISBN 978-1-64160-800-8

The Library of Congress has cataloged the hardcover edition as follows:
Kupsh, Tom.
 A mythic obsession : the world of Dr. Evermor / Tom Kupsh.
 p. cm.
 Includes bibliographical references and index.
 ISBN 978-1-55652-760-9
 1. Dr. Evermor, 1938—Criticism and interpretation. 2. Junk sculpture—United States
 3. Metal sculpture—United States. I. Dr. Evermor, 1938- II. Title.

NB237.D69K87 2008
730.92—dc22
 2007048062

Cover and interior design: Scott Rattray
Cover photo: Ron Gordon

Printed in the United States of America

Contents

Start a huge, foolish project,
like Noah.

It makes absolutely no difference
what people think of you.

—Rumi

Preface

Visionary artist Tom Every—Dr. Evermor—is known throughout the world for his rare vision. His sculpture, especially his Forevertron environment, has been featured in countless magazine and newspaper articles in the United States and abroad. Local, regional, national, and international film and television crews have visited his sculpture site over the years, and thousands of people from all walks of life come to see him and his work each year. He is somewhat of a celebrity in the world of self-taught artists and has earned the respect of scholars and collectors who eagerly seek him out.

All of the writing and reporting about Tom and his work falls into three categories: First, what I call weekend-getaway pieces, which appear in local and regional newspapers, on television, or in guidebooks. These are of uneven quality, and sometimes the research is scant or incomplete and often filled with misconceptions. Second, more serious reporting about Tom and his work does occasionally appear in the form of feature articles found in nonart magazines and art sections of newspapers. Some of this material is well researched and well written. Third, there are a growing number of serious and scholarly pieces in publications that focus on outsider art; these works are well researched and carefully written and some are cited in the bibliography of this book.

Missing from all of these is the broader narrative of who Tom Every—Dr. Evermor—is and how his work came into being. I knew Tom in the 1970s when he was still formulating his artistic voice and working as a builder and salvager. After 1982, our paths went different ways, but I occasionally wondered what had become of him. I heard that he was making weird metal sculptures near Baraboo, Wisconsin, and in the fall of 2004, on an impulse, I drove up to where I thought his sculpture site might be. I finally found him, not the robust hellion I had known but a semi-ambulatory stroke victim full of pain and barely able to use his left side. I also found him surrounded by a body of extraordinary work.

Soon it became clear that despite his physical limitations he was full of passion for his art, and his memory and imagination were sharp and bright. I knew in those first few visits that I had found the writing project I had been looking for.

Tom was enthusiastic about this project, and in fall 2004 I began to visit with Tom and his longtime wife, Eleanor, and record our conversations. The hundreds of pages of transcripts that resulted from our conversations, and from visits with his family, friends, and helpers, are the primary source for the information in this book. Tom and Eleanor also shared with me some family records, photographs, documents, and print articles from their archives and gave me access to Tom's sculpture and drawings as well as lists of contacts they felt would be useful.

The goal of this book is to allow Tom's voice, and the voices of those who have been close to him, to tell the story of his life and art. This is not a definitive biography but rather a narrative history of his process; those searching for further details will find the endnotes and bibliography useful. This book is a celebration, not an exposé, and those looking for stories of misbehavior will be disappointed—mostly. They will find that the notes may lead them where they want to go.

Ultimately, Tom Every's art will be the most articulate voice heard here. To ensure that the voice of the work is clear and powerful, I partnered with art photographer Jim Wildeman, whose photographs document Tom's work. Jim also has included snapshots and collected photographs from the Every family collection.

Acknowledgments

Thanks to the many folks without whom this book would never have been possible, particularly Tom and Eleanor Every, who talked freely about their life and art and also shared with me many family photos and records. Special thanks to Bobbi Lane, Silke Tudor, Doris Litscher Gasser, Aaron Howard, Ron Gordon, and Ann Parker for the use of their photographs.

I want also to thank everyone who talked with me about Dr. Evermor and his work, especially Karin Shoemaker, Erika Koivunen, Aaron Howard, Jake Furnald, Homer Deahn, Richard Springer, Ann Parker, Pete Burno, Jim Wildeman, Don Warren, Curt Meine, Roman Slotty, Barbara Banks for her e-mails, Dr. Gary Maier, Kim Knuth, Ray Blackburn, Doug Britton, Larry Waller, Dan Woolpert, Dee Hanson, John Greene, Petra Backonja for her interview and poetry, Dr. Misha Backonja, Nobuyoshi Kitamura, and all of Tom and Eleanor's many friends who encouraged this project.

Thanks to Thayer Every for many things and especially for operating the crane that lifted Jim Wildeman high above the sculpture park for his great photographs (and set him down again). Thanks to Jerome Pohlen at Chicago Review Press for all his suggestions and help.

Thanks to the most patient woman in the world, my wife, Lisa Anne Lair-Kupsh.

1

"The Child Is Father of the Man"[1]
Background and Early Life

By the close of the nineteenth century, Captain Oswald Every had retired from a distinguished military career as a decorated officer and veteran of the Crimean War and the Indian Mutiny and had been, for a time, the governor of the British prison in Gibraltar. He expected to settle into a pleasant retirement in the English countryside, but the captain was distracted; his son Edward had long since come of age but remained a constant worry. He had done his best to send Edward to the finest schools in England and Spain. He surely was bright enough and fluent in several languages.[2] But all the education seemed of little use. Edward's lack of progress in business, and his other behaviors, troubled the captain. Drawing on his meager knowledge of him (Edward died in 1928), Tom Every ventures, "I think he was drinking whiskey and chasing women, and that's what I think he was doing. He was a rowdy, that's what he was."[3] Family history might have given the captain further cause for worry. Two hundred years before, a distant relative, Henry Every (Avery), had given up legitimate trade and had become a well-known pirate holed up on the island of Madagascar. The "arch-pirate," as he was known, would later be lionized in the stage production of Charles Johnson's play The Successful Pirate.[4] Henry Every also inspired a fictional tale of piracy in Daniel Defoe's novel King of the Pyrates in 1719.[5] Tom holds the pirate Henry Every in fond regard, thinking himself cut from the same cloth; he even went so far as to name his truck the "Fancy" after the arch-pirate's ship.

Captain Oswald Every came up with a then-common solution to his problem—soon Edward was on a ship with one thousand dollars in his pocket and two hunting guns in his baggage. The plan was for him to become a gentleman farmer in America, but that's the last his family ever saw of him. This kind of situation was not uncommon in the 1800s. Mark Twain, writing at this same time, explains:

> Dissipated ne'er-do-wells belonging to important families in England and Canada were not cast off by their people while there was any hope of reforming them, but when that last hope perished at last, the ne'er-do-well was sent abroad to get him out of the way.[6]

Whether Edward (Ted) was a "dissipated ne'er-do-well" or not is hard to say; he seems to have been on good behavior in his new home, where he soon traded one of the hand-tooled shotguns for a buggy worth only ten dollars. Tom says, "He was never very good with money or business." He soon found he could not keep himself in the lifestyle that he was used to in England, and his dreams of a life of estate management and leisure faded away. We next hear of him in Wisconsin, where he met and fell in love with Adeline Smith, a schoolteacher and a dedicated Christian Scientist whose Yankee English family had moved to Wisconsin in the 1870s from Springfield, Massachusetts. Ted and Adeline were married in August 1902 and settled in Brooklyn, Wisconsin. "I never heard of him doing any drinking over here," recalls Tom. In Brooklyn, he was industrious, working as a butter maker in the Brooklyn Creamery—where after hours he could be found taking baths in the cheese vats—and later as a clerk in the local mercantile, where he could be heard crowing loudly whenever an embarrassed young lady asked for Rooster brand toilet paper. He was a well-liked character around town; he was the only person in the area with an English accent and was, according to Tom, "laid back and would sit on the porch and smoke cigars."[7]

The Everys come from an old English family who took their name from their place of origin in France. The older form of the family name is Yvery, or Ivry. They are proud of their Norman origins and claim that their forebearers arrived in England at the time of William the Conqueror in 1066 and settled in the Midlands, where they lived and prospered over the centuries, finding favor with the

royal court through the era of the Tudors. The family managed to survive the upheavals of the English civil war and the political intrigues that followed and kept possession of their titles and estates near Egginton, where Tom and his sister Barbara have visited their present-day relatives.

The Every coat of arms contains the Latin motto "Suum Cuique," which translates as "to each his own." These days it could be translated as "do your own thing," a motto that would be lived up to in its fullest in the person of Tom Every.[8]

Ted and Adeline Every had three sons: Edward Malcolm in 1903, Roderick Desmond in 1904, and Donovan Richmond in 1911. Tom's dad, Malcolm (Mac), grew up in Brooklyn and early on showed an interest in tinkering. As a boy he had a 1908 one-cylinder car in which he clanged up and down the streets delivering newspapers. He gravitated to Graves Machine Shop, where he spent his spare time fixing his motorcycle or working on his Model T race car in which he sped around town. Mac was a smart and self-conscious young man and did well in school, and when it was time to go off to college he chose the University of Wisconsin at Platteville. He told Tom that he chose Platteville because the dress code was not as tough as the code at the University of Wisconsin in Madison and he didn't have a lot of money. He made his way through the first two years there attending classes during the day and sleeping in the warm powerhouse, where he had a part-time job watching the boiler gauges, at night.

After two years in Platteville, he transferred to the university in Madison, where he pursued a degree in civil engineering. After graduation, he took a job with the state, where he spent his working life making his way up through the ranks and ending up as the chief of engineering services for the State of Wisconsin. During his career, he was responsible for the layout of state highways.

In 1934 Malcolm married Clarice Doane. The Doanes trace their ancestry right back to the Mayflower. The family advanced in the New World as industrialists and builders. Clarice worked as a secretary in the office of Farmers Mutual Insurance Company when there were only six people in the office; the company would later grow much larger under the name American Family Insurance. In later years, when the children were of school age, she worked as a bank secretary in Brooklyn.

Thomas Owen Every was born in Madison on September 20, 1938, and even as a small child he was a natural-born forager and loved to play near the local bus barn (although this was strictly forbidden) because it was, in his words, "where you could find the really good stuff." Whether on the Indian trails along the lake or at the dump, a boy could fuel his imagination of the east side, the industrial side, of wartime Madison.

Tom recalls the smell of stale beer from the Union House Tavern owned by his next-door neighbors, the Essers. The tavern served the air force fliers from nearby Truax Field. On week-

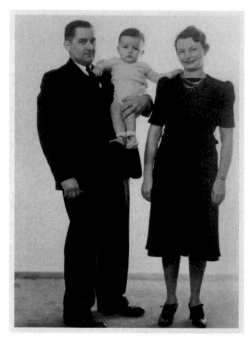

Tom with his parents EVERY COLLECTION

ends he was often invited to come along for a ride in the country in the back of the Essers' black DeSoto with their daughter Betty Jo.

More than fifty years later Tom would be made uncomfortable by a woman intently looking at him in the sculpture park, so he asked her if there was something that he could do for her. She introduced herself as Betty Jo Esser and reminded him that she was the girl of his first kiss.

Tom was too restless for Lowell School, where he attended through the third grade. He says he didn't do too well.[9] His grandmother Every (a schoolteacher) had a big influence on him. She stayed with the family in her later years and read to Tom all of the classics of children's literature including *Huckleberry Finn* and *Tom Sawyer*. She was set in her ways—Tom recalls her resisting the family when they tried to take her to the hospital when she broke her arm. They did manage, after much wrangling and arguing, to convince her to see a doctor. Tom would, years later, have a similar suspicion of doctors and hospitals.

What Tom really liked was collecting loads of newspapers and hauling them to collection centers in his red Radio Flyer wagon. It was wartime, and the whole

country was collecting and recycling strategic materials; it was a patriotic duty to collect materials needed for the war effort. Young and old alike did what they could. As the war came to an end, interest in collecting and recycling waned for most people, but not for Tom. He kept gathering up almost anything that people didn't want: paper, used toothpaste tubes, scrap metal.

In 1942 Tom's sister, Barbara, was born. The family continued to live on the east side of Madison until 1946, when they moved to Brooklyn, Wisconsin. They took up residence at 102 Lincoln Street, the former home of grandfather Edward and grandmother Adeline.

Tom in grade school EVERY COLLECTION

The gently rolling hills and flat prairie around Brooklyn stretch out to the horizon in every direction. You can see summer storms gathering in the distance and raining on the fields. Songbirds today make melodies in the green woodlots and fencerows, and Holstein cows graze the green fields as they did years ago. Some of the smaller farms scattered here and there have been joined together to form larger operations, but many old barns and farm homes still stand as they have for a hundred years or more. Brooklyn is typical of the many small Wisconsin villages that grew up to serve the neighboring farms. Although some of the old buildings are gone, and the creamery has long since been torn down, it's easy to imagine the main street full of life and business. The chug and whistle of the steam trains that Tom loved so much have been replaced by diesel engines; the Chicago and Northwestern tracks are still there, but the trains no longer stop in Brooklyn and the station is gone. If you close your eyes, you can imagine the slap of the screen door on the white frame house at 102 Lincoln and Tom running off on one of his foraging missions.

Tom followed his dad around the family farm (the Doane farm) near Stoughton, where they raised beef cattle and hogs. Tom spent many days there

watching his dad, picking up carpentry skills and learning how to use the materials at hand. He has fond memories of those days:

> The one thing that I really loved more than anything else is that he always cut up old Pennzoil cans and used them for patching the buildings. There was a shortage of wood in that era and Dad would take me twice a year to collect old signs from sign makers. He had a box built into the back of his 1940 Ford and he loaded that thing up with those old signs and we used them to patch the buildings—always trying to figure out how to do something with what you've got.

Tom on horseback EVERY COLLECTION

One day in 1950 his dad got tickets to the fights at the University of Wisconsin Field House. There, from a ringside seat, Tom first saw Alex Jordan. By this time, Jordan was really too old for the sport, but he boxed that day as a heavyweight. Alex Jordan would later play a role in Tom's life, and he would contend with Alex, although not in the boxing ring; for now, Tom was just a boy out for the day with his dad. Tom remembers his time with his father with nostalgia, saying, "I think it was a wonderful bond."

Tom began to bring home everything. He says that his saving, this "disease of all," as he calls it, came from his first experiences on the east side of Madison.[10] Soon people in and around Brooklyn knew just whom to call when they wanted to get rid of their unwanted materials. Tom's mother would take the message over the phone and he would go pick up whatever they gave him. His parents really didn't know what to think.

The mess and debris around 102 Lincoln Street got to be too much, so to keep peace Tom found a place along the railroad tracks to stash his stuff. Vince Martin was the stationmaster at the Brooklyn railroad depot and soon befriended Tom. This was at the end of the age of steam trains; in those days, all of the little towns depended on the railroad to bring goods and to take their products to market. Tom recalls, "I was always there when the old steam trains came in. So I felt the spirit of the old steam trains and the old depot. It had two rooms and a big stove and a telegraph. Vince Martin was an old bachelor and he did everything an old railroad guy would have done." Tom hung out there, watching the trains come and go, and gave Vince a hand as much as he could, even helping unload boxcars. Tom says he thought that he was a frail child and he needed to work on his upper-body strength, so he wheeled the hundred-pound sacks of powdered milk into the boxcars, trying to put on some muscle.

He also found out that when Vince was looking the other way he could order illegal fireworks from out of state and have them shipped in by rail express. "I used to sell [them] and make the money—I was a kind of kid bootlegger," he recalls. It irritated Constable Waldo Hanson that everybody had fireworks and he couldn't figure out where they were coming from. Tom says he always had a lot more respect for the bootleggers than for the revenuers.

Tom was always building things. When he was ten he earned fifty dollars for designing and building a float for the local Texaco gas station's entry for the Labor Day parade. He later built a rickshaw for his sister, Barbara. Tom was, and still is, naturally gregarious. He roamed all over the village making friends with adults and children and collecting. Daryl King, the bachelor village barber, befriended Tom. Daryl loved to tinker with cars and anything mechanical. Tom remembers, "He [Daryl] read the whole Bible thirteen times. I don't think any of it sunk in. But he was not a Bible thumper. We talked about spiritual things that were in the Bible." Tom's family is from the Methodist tradition and he attended Methodist Sunday school, but in future years his beliefs became more nontraditional and eclectic.

It wasn't long before Tom and Daryl earned their reputation as troublemakers. Under cover of night (one of Tom's favorite times to work) Daryl and Tom would park in the cemetery next to the padlocked dump. Over the fence they

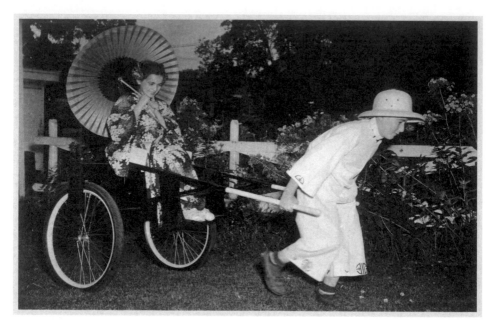

Tom with Barbara EVERY COLLECTION

climbed and collected all the scrap plastic they could carry, filling the massive trunk of Daryl's souped-up 1935 Ford coupe. Off they would go, the two Dumpster pirates, with their booty. They gave trimmed plastic strips to their blind friend, Clair Ellis, who wove them into rugs.

Constable Hanson eventually caught up with them. One summer evening, Tom and Daryl rode Tom's Schwinn bike (without a light) over to the local restaurant to get some ice cream; Daryl waited outside and Tom went in to get the cones. What happened next is the stuff of small-town farce. In Tom's words:

Waldo [Constable Hanson] came out from between the post office and the hardware store and started screaming at Daryl, "Where are you going?" And Daryl said, "Piss on you!" [Daryl took off into the darkness on Tom's bike.] I came out of the restaurant with the two ice cream cones and I said, "Where are you Daryl?" . . . I didn't see him anywhere but I saw Waldo running down the street like a murder had happened. The next thing I knew, Billy Barnes was on deck (he was the night watchman), cranking up his 1948 DeSoto. It had real soft

springs and pretty soon he was bouncing down the street after Daryl. And I'm standing there with the two ice creams.

He looked down the street to where the chase was disappearing into the darkness, then he looked at the two ice-cream cones. He sat down and ate the ice cream. After a while, he strolled past Daryl's house and saw his bike outside but no sign of Daryl. But that was not the end of it. The next day, the constable showed up with a fifteen-dollar ticket for each of them for operating a bike at night without a light. They were hauled before the justice of the peace, who treated the matter, in Tom's words, "very seriously." They were found guilty as charged but the fine was cut in half. Crime had been stopped, and the citizens of Brooklyn could rest easy in their beds.

As usual, Tom could not leave well enough alone. The Labor Day parade was coming up, and he was determined to create a response to his run-in with the local authorities. He got some batteries and decorated his bike with every light that he could find. He mounted a large sign above it that read "Legal Bike—

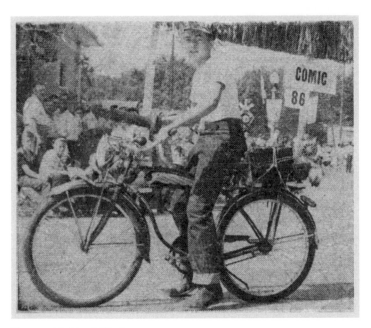

Tom on his "legal bike" EVERY COLLECTION

Approved by the Police Department." He got one of his friends to dress up like a policeman (complete with pillow potbelly to imitate Waldo) and chase him down the street. He took second prize in the comic division.

Cyril Graves, who owned the Brooklyn Garage and Machine Shop, let Tom store his growing inventory in the back of his shop. Tom recalls, "He kind of liked me and he didn't have any children and he used to smoke Pall Mall cigarettes. He used to come back there and look at my stuff but he never told me to get the hell out of there because my dad and him had worked together back in 1918, so it was an old connection."

Tom admits that this was his first experience at squatting. Throughout his life, Tom would find ways to store his scrap on the properties of friends and associates. Soon he convinced one of his friends to move a garage he found onto Graves's lot next to the shop to serve as his office and base of operations. It wasn't long before he had sold a whole railcar full of scrap iron he had collected from the local farmers—before he was even old enough to drive.

Tom says, "I have good memories of Brooklyn. It was a little town of 450 people; everybody knew each other." He attended Brooklyn High School and enjoyed English and history, but Wayne Nelson's shop class was where he excelled. The class dealt mostly with woodworking, but he did manage to get some experience welding, he recalls. "We did get a welder in there [the school shop], and I brought an old 1938 Ford truck down there and we made a boom truck out of it by parking it next to the school and running the [welding] cables out the window."

He helped out in the cafeteria so that he could get his choice of extra food. Tom never took much interest in athletics, but he did serve the football team as water boy. He never really attended the prom, but he did try to crash it once when a local beautician curled his hair and made him up like a girl. He fooled no one.

As soon as he got his driver's license, he modified his 1950 Ford truck to carry his goods. He expanded the bed, built racks on the top, and was ready for the wider world. On the side the sign read "Buy-Sell or Trade, See Trader Tom, Anything-Anytime-Anywhere, Write, Phone, or Send by Pony Express." At the end of school that year he and a friend headed for an auction he had heard about in

Oklahoma. This trip was a revelation to him. He says, "I went down there and I was shocked. I had never seen things bring so much money." He made many more trips to Oklahoma, buying, selling, or trading everything from Model T steering wheels to fifty thousand sets of salt and pepper shakers. His world expanded and so did his collection of odds and ends at Graves's garage, until the neighbors across the street began to complain about the mess. An article in the *Wisconsin State Journal* from May 1956 is headlined "Brooklyn Junk Man Retires at 17." It seems that Tom's early retirement was prompted by a reminder from the village clerk that his business had been "operated in violation of a 1947 village ordinance prohibit ing junk yards." During his going-out-of-business sale, he offered every customer a free gas mask from his inventory of twenty-six thousand. There were 350 jet gas tanks, old radio parts, thirty-five hundred army fatigue hats ("used but use-able"), and "some cans of paint, all colors but the one you need."[11]

He earned money painting tobacco sheds and performing other odd jobs and eventually began doing business under the name of the Brooklyn Salvage Company, and later the Wisconsin By-Products Company, which recycled leftovers from

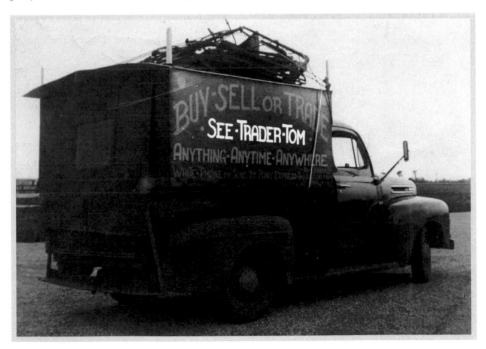

Trader Tom's truck EVERY COLLECTION

the U.S. Rubber Company. These early experiences taught Tom important lessons. He developed into a shrewd dealer. He also learned furniture refinishing and restored the better pieces of furniture that came his way. Like his boyhood heroes, Thomas Edison, Nikola Tesla, Alexander Graham Bell, Henry Ford, and George Westinghouse, Tom was a tinkerer and was fascinated by the "spirit" of many of the scrap materials that passed through his hands. He had an eye for the design and history of the salvage that crossed his path.

Tom soon started working for the Evansville Salvage and Wrecking Company and now had many sources of supply. He only occasionally took notice of the Stoughton dump. He never would have noticed the little blonde girl trudging up the hill to the dump on another collecting trip, her red wagon in tow. Years later, he would take notice of her. Her name was Eleanor Gryttenholm. She was, even then, his kindred spirit and would, much later, become his longtime wife and the mother of their four children. He would call her the Lady Eleanor.

Tom's high school graduation picture
EVERY COLLECTION

In 1958 Tom founded Eveco International, and he spent the next twenty-five years working in large-scale industrial wrecking and salvage. Eveco was responsible for dismantling and salvaging more than 350 commercial, industrial, and utility sites including eleven breweries, fifty-six powerhouses, tobacco warehouses, roundhouses, eight creameries, two thousand railcars, and many smaller buildings. At this time he met Jim Delaney, owner of Delaney's Surplus north of Sauk City, Wisconsin. The two formed a friendship, wheeling and dealing back and forth for years to come. Jim would later play an important role in Tom's life and art.

In that year also, Dr. (Col.) Chester Cjertsen, a World War II veteran and Tom's dentist, suggested that Tom join the military. After basic training at Fort Leonard Wood, Missouri, he was sent to carpentry school, where he excelled and was assigned to build scale models for classroom instruction. For example: Tom built a scaled-up (larger than actual size) machine gun, accurate in all details, even to the degree that it could be broken down and reassembled. In a large class situation, all the soldiers were able to see the demonstration.

Private Every did not confine his activities to the carpentry shop but also maintained his trading contacts in Oklahoma. Tom says, "I had bought all this goofy jewelry out of Oklahoma for two dollars and fifty cents a box." He sold these boxes of fake treasures to the GIs for forty-five dollars each. It wasn't long before the company commander put a stop to his retail operation, ordering him to "cease and desist." After two years of active duty, Tom completed his reserve obligation in the only unit locally available to him, the 44th Medics, as a carpenter.

Tom EVERY COLLECTION

Back home he bought the abandoned Armour Condensed Milk plant as a new operations base, and in 1962 he married Connie Utter of Stoughton. The marriage lasted only two years, ending in divorce in 1964.

In 1963 he joined with his then brother-in-law James Shertz, professor in the engineering department of the University of Wisconsin, to build a mobile car crusher. According to Tom, it was the first of its kind. Until then, if you wanted to flatten a car body in a scrap yard, you pounded it down with a crane and a wrecking ball. Their machine was designed so that the operator could drive into a scrap yard, buy the cars, crush them, then load them onto flatbeds. Engineer,

inventor, and collector Pete Burno describes the machine with its pedestal-mounted backhoe as a "gorilla machine."[12] Nevertheless, the crusher was a great success, and they quickly applied for a patent. But Tom felt increasingly uneasy about spending all his time in junkyards; he was searching for something else. He continued to work in the salvage and wrecking business and reused some of the materials to build a variety of buildings, including A-frame homes and a large apartment building.

In 1964 Tom met his lifetime companion. All of Eleanor Gryttenholm's grandparents had come from Norway to Stoughton, a frequent destination for Norwegian immigrants in the late nineteenth and early twentieth centuries. She and her twin brother were the youngest of the Gryttenholm's six children. Their home was next door to the Armour plant that Tom owned. From a young age Eleanor had been a forager, bringing home everything she thought was of value.

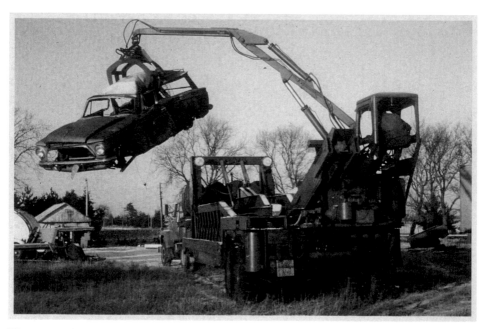

The car crusher EVERY COLLECTION

Her favorite collection spots were the high school dump and the Stoughton dump. She explains, "Nobody else in my family did this. It was a social place in Stoughton. Those were different kinds of dumps then. Adults were there with their kids talking—it was a very special place." Her dad let her use part of the garage to store her collection, "so I found an antique desk in the dump at the school and I brought it home and I set it up in the garage. I went back to the dump and I got all these wonderful papers that they had thrown out and I set up my school." When she was twelve, her enterprise came to an end: "I had my little red wagon and I came down from the dump with a big stuffed chair on it and that was that. My mother said that if I brought one more thing home she wasn't going to allow me to go again."[13]

Eleanor and Tom met in her senior year at Stoughton High School. The first time she remembers seeing him, "he just happened to be driving by. I felt so bad for that man driving by in the rain with his convertible top down and he was getting all soaked." And then later, "I was playing tennis in the road and he drove by and I looked up and we just went eye to eye and that was that."

Tom had been spying on her with binoculars from the roof of his building but just couldn't work up the courage to go over and talk to her. He had somebody take a note over to her asking if she would go out with him. She made no response—so he sent another, and another, and another. When the fifth note came it said, "If you don't say yes today, there will be no more notes." She did say yes and recalls, "He said, 'We're going to go to the House on the Rock,' and I said I can't go there because I'm only seventeen and I can't go to a bar—I thought that it was a tavern. So he took me there and then he took me to a Chinese restaurant in Madison . . . and everything moved on from there."[14]

Eleanor began working for Tom gluing vinyl scraps together to be resold in rolls, sorting salvage, and helping him with odd jobs whenever she could. This was the beginning of their life together, and when Tom's divorce became final in June 1964 they slipped off to Illinois and got married. At first they lived in an apartment in a building that Tom had a hand in constructing; later they moved into one of his A-frames. They went from richer to poorer and back again—it would always be a rocky road but never a dull one. Pete Burno remembers him

Eleanor's high school graduation picture
EVERY COLLECTION

from those years: "Tom was either way up or way down. And when he went down, he went all the way down."

In the early 1970s they lived on the Doane family farm owned by Tom's mother. Eleanor has good memories of this time: "I had more fun on the farm than I did later in Madison. There was a freedom there and Grandpa [Tom's dad] was there and that was just wonderful; he ran the whole farm."

Together Tom and Eleanor had four children: Thayer (1964), Treasure (1967), Tya (1968), and Troy (1980). Eleanor always found ways to enable Tom to continue his work, and later she became his collaborator and business partner.

By 1972 Tom enjoyed a great deal of success, but he became increasingly restless. "We had torn a lot of stuff down. After you tear something down, what do you have to look at? Nothing. You get a letter of appreciation from some president of some power company [saying] 'Nice job.' I've got piles of that stuff— what the hell does that mean?"

2

The Search for Artistic Voice
Opportunity and Trouble

Tom found two channels for his creative energy. The first of these was the home that Tom and Eleanor moved into in 1972. Tom came home one day and said to Eleanor, "I want to take you someplace and show you a house."[1] They drove from the Doane farm where they were living to the Highlands district of Madison, one of the most exclusive areas of the city. He showed her around the thirty-two-room mansion and asked her if she would like to live there—by the time they got back to the farm, she was already packing.

The estate, known as Edenfred—"Peace of Eden" in Norwegian—had been built by the Davis family in 1916. The Georgian three-story brick home is reminiscent of plantations of the American South, with over seven thousand square feet of living space, including a covered veranda, three-season conservatory, library, and swimming pool, all set high above the city on six acres overlooking Lake Mendota. Tom had been called in to give an estimate for the demolition of the house, but rather than tear it down he made an offer of $125,000. Before long the Every family moved in. Throughout the coming years he would spend his free time repairing and renovating the home they called the Highlands. On the inside, Tom went room to room repairing and renovating, and outside he installed a variety of features including a grand gazebo. He also used the grounds to display his new creations. The Everys idealize this time in their lives as the best of all.[2]

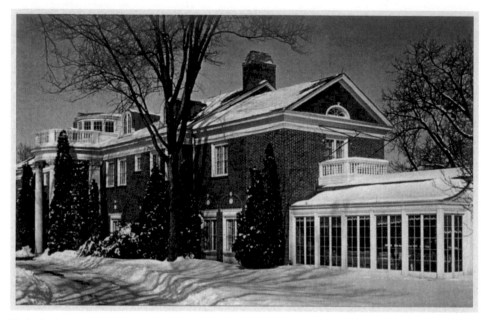

The Highlands EVERY COLLECTION

The second channel into which Tom poured his energy was about an hour west of the Highlands. The southwestern corner of Wisconsin is known as the "driftless" area, where glaciers of the distant past never flattened the land. The deep valleys and rolling hills provided a meager living for subsistence farms in the first half of the twentieth century. The hillside pasture and ridgetop fields are still farmed today, but many of the steep-sloped places have gone back to woods. Many of the old buildings have fallen into disuse, but a few have been restored. New homes are scattered here and there among the hills.

Alex Jordan came here from Madison in the 1940s, looking for a place to build a country retreat. During the next four decades, Jordan, with the help of many talented and hardworking people, built a very popular tourist attraction. The House on the Rock itself is built atop and around Deer Shelter Rock, a large chimney-rock formation rising from the floor of Wyoming Valley in Iowa County.

By the 1970s the House on the Rock had become much more than an intriguing house in the country.[3] It had expanded to include a large collection of antiques and would-be antiques, music machines, and other collectables and oddities. Jordan housed the collections in the house itself and in adjoining buildings includ-

ing a building known as the "Streets of Yesterday," a re-creation of a nineteenth-century American street. He had started charging admission years before, and attendance had grown steadily. Soon he could claim that the House on the Rock was the most popular privately owned attraction in the Midwest. Even as his profits grew, Jordan continued to live simply, turning all the money back into his collections and displays.

Tom had seen Alex Jordan only once since watching him in the boxing ring when Every was a boy. He had gone out to the House on the Rock in 1963 hoping to trade with Alex for a custom car, but he made no headway. Later on, Tom purchased twenty thousand whiskey barrels from a Kentucky distillery and was looking for a way to sell them. Eleanor ran an ad in a Madison newspaper offering them for sale, and Alex Jordan's friend Sid Boyum saw the ad and showed it to Alex. At the time, Jordan was in the hospital recovering from a near-fatal accident in which he had broadsided a horse while driving his station wagon. Sid

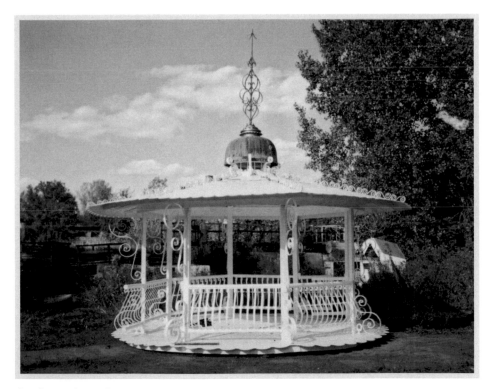

Gazebo at the sculpture site EVERY COLLECTION

was a photographer, writer, sculptor, avid fisherman, and local character; it was Sid who introduced Tom to his lifelong habit of eating cigars. They went to see Alex and sealed the deal for semi loads of whiskey barrels right there in his hospital room.

This was the beginning of a relationship that would last for more than a decade, during which Tom would be Alex's engineer, builder, collector, and travel companion. Both men were night people; Tom would drop in late at night, and he and Alex would sit and look through art and architecture books and talk about future projects. Alex was recovering from his accident and was depressed and housebound at the time. According to Tom, he would just sit around and watch television or listen to records. Tom recalls, "I'd come in late at night . . . so I'd get there and if it was early enough Jennie [Alex's longtime companion] would bring us some chocolate cookies or something . . . but it wasn't much of a social thing, we would be looking at stuff and having a good time." According to Tom, Alex was slowly coming back from his injuries and could only walk a few feet before he had to stop and rest. Nonetheless, Tom encouraged Alex to go with him on buying trips to Chicago, where they visited contacts all over the city, picking up artifacts for the House on the Rock. Alex was always eager to find new things that he could use in his work, and Tom began to supply him with materials and collectibles from his salvage work. Jordan and Every continued to make trips to Chicago, and as Jordan grew stronger so, it seemed, did their friendship. Eventually they would travel together around the United States touring attractions and acquiring collectibles.

Tom began to work on his own pieces and built two works of special interest to Jordan. The *Egginton* (1980) was named after his ancestral home in England. All of the bronze for the barrels in this cannon came from England; other parts came from a factory in Racine, Wisconsin. Jordan really liked the cannon and wanted it for the House on the Rock, but he never could talk Tom out of it. Today it sits in Tom's sculpture park as a silent reminder of that time.

The second piece that interested Jordan was the *Epicurean* (1977), which Tom made for Eleanor. This backyard grill is Tom's favorite work of all; he likes the fact that it's designed to make people happy. "I had envisioned a great big copper pot where a giant bellows came down to blow on the coals . . . and I incor-

The *Egginton* (71″ h × 7′6″ w × 13′ 3″ l) JIM WILDEMAN

porated other things." The center column is from the People's Brewery in Oshkosh. The tapered copper sleeve came from the Island Woolen Mill in Baraboo, where it was part of a dye vat. There were brew kettle valves and copper floats and a bridge truss that came from somewhere in Iowa. The brass trim was made from an industrial stamping mistake. "I got old antique railroad car hinges as the hinges for the lower cabinet," Tom said. The decking was made of cypress salvaged from the water towers of the Pet Milk plant in New Glarus, Wisconsin.

When the *Epicurean* (Sid Boyum thought up the name) was finished, Tom invited Alex over to the Highlands, where he presented him with the first hamburger from the grill. Tom recalls, "He [Jordan] sat down and had that hamburger and he kept looking at the *Epicurean*. And finally he said, 'I can't improve on it.'"

Alex was always looking for ways to make things his own—to improve on them. According to Tom, Jordan offered to build a large building at the House on the Rock and make the *Epicurean* its centerpiece; it was going to be an "eatery arrangement," according to Every. This project would change and transform in the coming years. The grand, if stormy, collaboration resulted in a work mar-

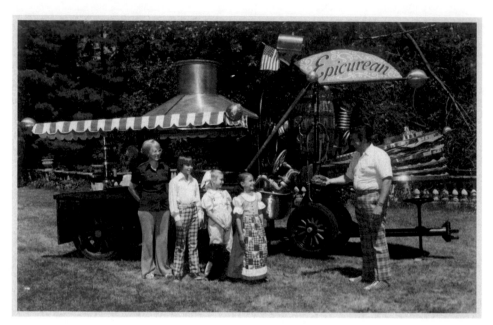

The *Epicurean* with the Every family EVERY COLLECTION

veled at and puzzled over ever since. Tom channeled all of his efforts toward this project because it sparked his creative urges. He also thought about the profits he expected he and Jordan would share from the food concession.

Tom began to call himself Mr. Buildmor of the House on the Rock, the first time he took on a persona through which he would work. He completely immersed himself in the project; in Tom's words, "I was motivated by passion and challenges." There would be plenty of both. The relationship was smooth and rocky by turns. Workers in the shop remember Jordan storming in and yelling angrily, "Where in the hell is that Every, have you seen Every?" Even if they had seen him, most knew better than to admit it. Yet the very next day they would come in practically arm in arm, laughing and talking, their tiff over for the moment.[4]

At first the building was called the Inferno Room after "The Inferno" of Dante's *Divine Comedy*. Later, with the assembly of a huge theater organ, it would be referred to as the Organ Building. All the stops were out and Jordan was spending money, in his words, "like a drunken sailor—bushel baskets of it—Jennie and I will have to crank up the old Model T for one last trip to the poor house." But Jordan had nothing to worry about.[5]

Some of the things they acquired initially cost nothing. The city of Madison was talked into giving their waterworks pumping station to the House on the Rock. Tom and his crew went down to Madison, pulled the gigantic works out, and installed it at the House on the Rock, where the huge machine dominates one end of the Organ Building. Tom directed the difficult installation, and when they were finished it was all inspected and approved by consulting engineers hired by Alex. Tom is very proud of his work there.

As was usual then, they did the work first and overengineered everything— then they got permits. The floor of the room is a terraced hillside—the idea was that visitors could get their food from the Epicurean grill, sit at tables that Tom designed, and enjoy the sounds of the theater organ while they ate.

There were daily deliveries of organ parts for the grand organ, brew kettles from defunct breweries, odds and ends of businesses that were updating or sell- ing out. Tom acquired a submarine engine and a ship's propeller to install on the floor, and copper tanks and vats came from his salvage work around the state. The tanks from a malted milk factory in Racine are three-eights-inch-thick cop- per imported from England, heavy enough to be used in a vacuum process. Tom says that there are thousands of pounds of copper in the building. Brew kettles from the Kingsbury Brewery, tanks from the People's Brewery in Oshkosh, motors from the Gisholt Company in Madison, all of it saved from the scrap heap and part of this fantasy work. Tom fabricated a huge engine using salvage from the Corn Products International Company in Illinois; he wound copper tubing around forms to imitate Tesla coils. He says about his work there, "There's nothing neg- ative about it, you've got to have somebody who wants something like this and is happy that you're doing it. I was just damn happy to see it go into a piece of art work and have the opportunity to work with it and get it into place." Tom designed and began building furniture for the eating area: "different kinds of tables and chairs. I started out with a bunch of hexagon-shaped tables—I had money in them [old coins laminated into the epoxy tops]."

There were memorable moments at the Highlands too. In 1979 the Everys hosted 150 guests at a Great Gatsby party. Revelers arrived in 1930s costume and partied through the night. The Epicurean was in full operation along with hors d'oeuvre carts built by Tom, with festive red-and-white-striped canopies sewn by

Eleanor. The band played on the veranda into the night as couples danced the jitterbug on a marble dance floor. In Eleanor's mind, "It was a party that went on forever because some of us still get together and have emotions about it."[6] Several children can trace their origins to this night, including Troy Every. Eleanor would have to keep these fond memories as treasures, because a not-too-gentle decline had already begun that would end this dream and land the Everys in a world of trouble.

At the House on the Rock, Tom was collecting artifacts from everywhere and had to move a lot of very big things into and around the state. There were all of those regulations and permits that he saw standing in the way of progress. He picked his routes across Wisconsin very carefully and did quite a bit of his work after nightfall, often with Eleanor following behind (with bail money) in case anything went wrong. They chanced it. He tried to avoid low-hanging power lines, but in a tight spot he used jumper boards. Jumper boards are made of one-by-six lumber; he bent the boards over the top of the load, and the power lines would hit the boards and slide harmlessly over. He was lucky.

It all came to a screeching halt one night when Tom snuck into the state with an oversized load. He had been stopped and warned before, and this time the Grant County sheriff's deputies were not amused. They took his license away and threw him in the Grant County jail. Since he had no license for the next twelve months, Eleanor often drove him out to the House on the Rock and waited in the car for hours while he worked inside. He eventually hired a helper who drove him to work.

The large space in the building at the House on the Rock began, over the years, to fill up with creations from Jordan's workshop, displays created in the building by Jordan's craftsmen, artifacts brought in by Every, and pieces from the House on the Rock collections. There was a chime tower from Florida that could be heard all the way across Tampa Bay, grand pianos everywhere, statues of tantalizing nudes and severe saints, all woven together in a wonderland of industrial machinery. Tom says, "When we were done with that big room, he [Jordan] leaned against a brick wall and he said, 'Man, this is really something.' I never really had a positive comment from him. And then he said, 'Oh, cost a lot of

money.' Then he turned and walked away. You know, he was very interesting that way." What Alex described as the World's Largest Carousel was under construction in an adjacent building. Every and his crew helped there too, moving the parts in and engineering and welding the structure.

Jordan had an eye for artifacts and a talent for recognizing artists and craftsmen who could be of use to him. He employed a large number of workers and artisans over the years on this and his other projects. For those who could figure out how to get along with the temperamental Jordan, and survive the Byzantine politics that swirled around him, the experience (sometimes painful) was the opportunity of a lifetime. Tom Every welcomed the challenge and created, alone and with Jordan, whimsical works of huge proportion. It had been a chance for Tom to explore his method of working and search for his artistic voice. The House on the Rock experience was preparation for his life's work, and though he thought at the time that the House on the Rock was where he was going to end up, it was only the beginning. He always remembered what Jordan had said to him very early on, before he had made anything for the House on the Rock: "There is a great artist inside you and he's trying to get out."

The Organ Room was finished, but the Epicurean was nowhere to be found.[7] The project had been transformed far beyond the original idea—not unusual for Jordan. But other forces were at work. In 1973 Tom was fined for failure to pay state taxes, and in 1977 he was indicted by a federal grand jury for failure to withhold the proper amount from his employees' pay. The long project at the House on the Rock was coming to an end, and so too was the friendship between Jordan and Every. It flew into pieces in a flurry of accusations, personal condemnations, and what Tom describes as "political entrapment." He felt that Jordan was getting involved with "miscellaneous people of dubious reputation." When the debris settled, Tom Every found himself on the outside and in deep trouble—financial questions, legal entanglements—and he was suffering from depression.

The net of legal trouble closed in and this time there would be no escape. Tom and Eleanor lost the Highlands to taxes in 1986, and that same year Tom served nine months of a one-year sentence in the Dane County jail for felony contractor fraud.[8] Eleanor waited for him and held the family together.

All of this would unfold in due time. But for now (1982) Tom made his escape into his own mythical world of creativity.

3

The Myth

Escape into Fantasy and Creativity

Tom now created a personal myth into which he immersed himself and hid from his demons. His collecting, his "disease of all," had been fed by what he had done and seen at the House on the Rock, where Alex Jordan had once described his own impulse to collect as a feeling that there never was enough of anything, and no matter how big anything was, it wasn't big enough.[1]

Tom journeyed down a similar path, acquiring and saving on an industrial scale. Collecting scrap and artifacts from the industrial age and creating his own sculptural world increasingly became his only focus. He came to expect everything and everyone to serve his obsession.

The transformation that had begun with his work at the House on the Rock continued as he found his artistic voice in new work. In future years, he again and again turned to his work to express what his words couldn't touch, for comfort in times of distress, or to escape the realities around him.

Like all stories passed on by word of mouth, his myth has expanded and changed in the retelling. The following is the version that Tom, with this author, has agreed on.[2] Reaching back into his family history, Tom conjured up a tale of an imagined ancestor; the story is set in the Midlands of England, near Egginton, the place of his family origins:

One night in 1846, a Presbyterian minister and his young son were caught in a fierce thunderstorm and they took refuge in a country barn. The lightning flashed all around them through the

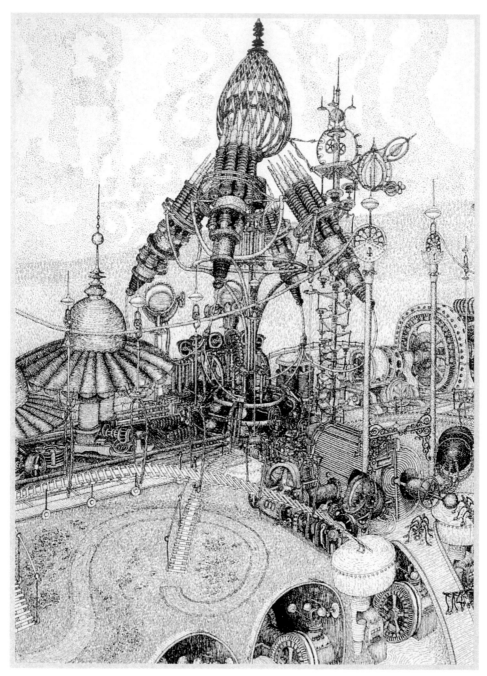

Fantasy drawing of the *Forevertron* by Jake Furnald

night and left the boy frightened and filled with wonder. He asked his father, "Where does the lightning come from?" The Reverend Every did not hesitate, he said, "The lightning comes from God Almighty."

The events of that night made a lasting impression on the boy and as a young man he never forgot what his father had said, thinking about it with childlike clarity and wondering: "If lightning comes from God, maybe I can get to God by creating lightning on earth and riding it up to the celestial spheres."

At that time the new technologies of the Industrial Revolution were just making their way into the English countryside. As the boy grew up, he became interested in the scientific discoveries and inventions of the nineteenth century. He did well in school and soon became a well-respected scientist and member of the Royal Academy known as Dr. Evermor; he continued to work on his passion. Remembering that night in the barn so many years before, he was designing and building a machine that he hoped would propel him to the celestial spheres. The electromagnetic lightning force beam of his machine promised to launch the good Doctor into the heavens and away from the evil of the world. He worked for years perfecting his machine and finally the day was at hand.

A large crowd of Victorian ladies and gentlemen, believers and skeptics alike, gathered on that day in 1899 to see Dr. Evermor and his Forevertron. Guests were treated to gastronomic delights from the Epicurean grill, popcorn from the Olfactory popcorn popper, and magical celestial peanuts (reportedly the elixir of life) from the Jugglenutter. Queen Victoria and the Prince of Wales presided in an elevated gazebo, sitting in their "Cocoon" throne.[3]

Dr. Evermor was getting ready. He stepped into the Gravitron, which scanned him for bodily defects and reduced his weight to acceptable levels. He then carefully weighed himself to check the results.[4] He climbed the winding stairway up to the Wind Spin and checked the weather and ran a copper ball up to the top of the signal post to announce that everything was ready. He crossed the bridge to the glass ball inside the copper egg as drums rolled and the military band struck up a chorus of "Nearer My God to Thee."

On a prearranged signal, Col. Chester Cjertsen, Dr. Cjertsen of the Norwegian Academy, took his position in the Overlord Master Control Tower. He switched on the Celestial Listening Ears, plotted the coordinates, and calibrated the Magnetic Steering Gyro, locking in the trajectory. When all was ready he signaled and shouted, "Power on, Doctor Evermor." The Doctor approached the travel chamber, turned to the crowd, waved, and declared, "I'm ready to highball it to heaven!" He entered the glass ball inside the copper egg. The band fell silent, the crowd hushed.

What happened next is a matter of speculation and difference of opinion. No two observers seemed to agree. The queen found it "rather amazing." The prince only blinked and was heard to utter, "What, what!"

The dynamos powered up and shook the ground, the thrusters glowed and rumbled with an unearthly sound, the groan grew louder and louder, many ladies fainted from fright, children covered their ears and cried. The piercing sound rose in a shrieking crescendo, and then—shhhhhhhhhhhhh-oooooooo—it was over. He was gone. Simply vanished.

One group said they had clearly heard a voice proclaiming, "Evermor forevermooooor!" Astronomers in attendance (called "doubting Thomases" by the Doctor) clambered up the ladder to Tyco's telescope to track the vanished Doctor. Some of them said they saw nothing, while others claimed they saw something "faint and far away," while a few said they "just couldn't make out what they had seen."

One thing was clear. The enigmatic Doctor was nowhere to be found.

With the invention of this myth, Tom took on the persona of Dr. Evermor and planned his escape into his own created world through the construction of Dr. Evermor's Forevertron. Tom says about the myth, "This is a whole new set, a whole new program . . . the story is nonthreatening and most everything else turns out to be love and passion and war and killing or murdering or something like that. . . . How we handle this stuff [these conflicts] is part of the myth and the fun and the luster and the ho, ho, hoing and the mysticism."

4

The *Forevertron*
The Myth in Iron

One thing Tom Every vowed was that he would never again be caught between creation and destruction. He turned over his company, Eveco International, to his oldest son, Thayer, and reinvented himself—in his own words, "I changed hats." Tom's escape from the turbulence swirling around him was to lose himself in the re-creation of the Forevertron of his mythical nineteenth-century ancestor, Dr. Evermor.

He began to move his salvage and scrap onto a vacant lot next to his friend Jim Delaney's Surplus outlet. He had been trading with Jim Delaney for twenty years by now, and Delaney's Surplus had been a reliable source of supply for Tom, who in turn made a profit reselling a great deal of what he found to Alex Jordan. Jim's sister had even steered Tom toward a large collection of dolls in Detroit, which Alex Jordan purchased as the foundation for the House on the Rock doll collection. Now that Tom had hit hard times, Jim let him store his salvage in the vacant lot south of his business. Jim recalls, "Tom had no place to go." He gradually moved more and more stuff onto the site.[1]

Delaney's Surplus is a family business that started out a little farther north, along Wisconsin Highway 12, in 1946 as a gas station and beer depot. They started to buy surplus lumber from the army after World War II, and one thing led to another. Soon they were bidding on all kinds of army surplus and whatever else came their way. Before long, the business outgrew its space, and Delaney's moved down the road to a building that had been used as a combination post office, general store, pharmacy, and maintenance shop as part of Badger Village—

the residential facility for the Army Ammunition Plant. Soon they started buying from dealers and expanding into hardware, insurance claims, railroad and truck salvage, closeouts, bankruptcies, fire claims, and so on. Delaney's did business from this building until December 2002, when the store burned to the ground. They moved into the current building on the site of the old place a year later.

For more than twenty years, Jim has generously allowed Tom free use of the acreage adjacent to his business to store his salvage and work on his vision. During that time they have continued to trade back and forth and send visitors each other's way.

Badger Army Ammunition Plant, which produced munitions for American wars from World War II through Vietnam, is directly across the road (Wisconsin Highway 12) from Delaney's. At one point it employed thousands of workers, some of whom lived in government housing across from the plant where Dr. Evermor's sculpture park is now located, on the site of Badger School, which served the children of the residents. Smokestacks from the heating plants still stand on the site as a last witness to those who lived there. Nothing else of the school remains except the traces of a few foundations and sidewalks. Tom debunks the romantic notion that he built the Forevertron there out of a desire to "beat swords into plowshares." He would adopt this theme later when he was making a proposal for the reuse of the closed Badger Ammunition Plant, but for now he made no statement about the military or about the war products made across the street; it was the only place he had left to go.

From 1983 to 1986 Dr. Evermor worked alone or with a small crew. By the time he finished with the Forevertron, he had found his artistic voice and created a place to contend with his demons. The Forevertron itself is 108 feet long, 65 feet high, and 72 feet wide; it weighs over 300 tons.[2] When Tom's friend Richard Springer talks about the impact of the Forevertron, he says: "Part of the thing about it is its scale. When people come here, they see the scale of the thing and they're in absolute awe. How could that possibly be? How could anyone create all of this? It's overwhelming."[3]

Visitors walking or driving into the park amid piles of Delaney's surplus scattered in orderly confusion find their eyes drawn to the Forevertron, which rises up among the salvage and cottonwoods, drawing the viewer in with its surprising order—it's more than one eyeful.

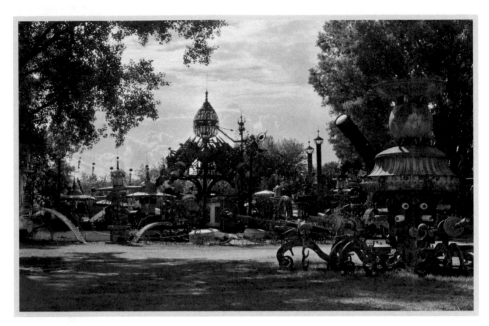

The *Forevertron* from the east JIM WILDEMAN

The Forevertron lies along a nearly north/south axis (north is to the right in the photo on page 35) with the egg-shaped travel chamber and thrusters standing over four stories high in the center and two somewhat shorter towers at the north and south ends of its 108-foot length. The south tower is the Royal Gazebo, while the north tower is the platform for the massive Tyco's Telescope. Extending to the east from the base of the central column is a forty-eight-foot platform trailer on which rests the Magnetic Holding Station. The ground plan of the Forevertron is in the shape of a T, with the longer arms stretching north and south. To the west, extending out from the central structure (more clearly visible in the photo on page 34), is the Magnetic Steering Gyro. The completed east-to-west axis of the Forevertron will be seventy-two feet. The assemblage of vintage machines, industrial detritus, and salvage from technologies of the last 120 years, and Dr. Evermor's Art Nouveau–like fabrications below and throughout, form the connective tissue of the mechanical fantasy.

The smooth and rough, painted and weathered surfaces of copper, stainless steel, iron, brass, glass, and ceramic give the Forevertron environment a sensuous texture that lives up to Tom's description of his work and process as "touch/feel." It is a dramatic sight in any light at any time of year.

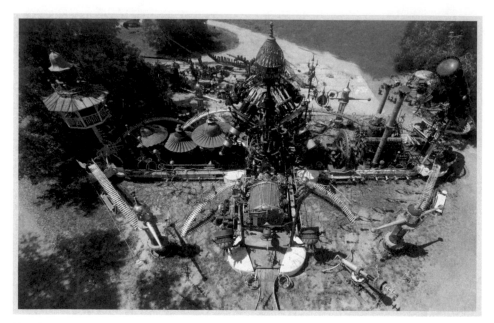

The *Forevertron* aerial view from the east JIM WILDEMAN

Most visitors search for answers to their questions: What is this? Who built it? How? Why? The story is filled with Dr. Evermor's dreams, humor, and special logic. The spirit of the whole project may be summed up in the answer Tom gave to a visitor who asked him what it was all about. He answered with a seamless rendition of the myth and embellished on the description of the parts and functions of the *Forevertron*. When he finished, she looked at him intently and asked, "Do you really believe all that?" There was a faint glimmer in his eye as he looked at her and said, "Everybody's got to have some whimsy in their life."[4]

The *Forevertron* is not only an aesthetically balanced piece, but each component plays a "logical" part in the mythical purpose of the machine. Where reason and science fail to explain, humor and fantasy fill in the gaps.

A few months after leaving the House on the Rock, Tom ended up putting together stoves from the salvage of a bankrupt stove factory in Tomah, Wisconsin. Harry Lutz and Ray Blackburn had worked at the stove company and now

helped Tom with the salvage. When they finished with the stoves, they packed up the scrap and moved it down to the vacant lot next to Delaney's Surplus. Ray Blackburn remembers Tom coming up and visiting him in his shop in Tomah. Sitting there, "he was drawing on a piece of paper and he seemed really torn up, and he said, 'I have to make a decision—whether to do this or not.' He started drawing these weird things. Well, I like weird and it looked fascinating and I really wasn't employed at the time. There was another fella who worked with me, Harry Lutz. And I said, 'If you want to come along with me you can have part of the action.' Anyway, Tom didn't know whether he wanted to build this or not. He was showing me some of his rough diagrams."[5]

The Forevertron is not the kind of work that starts with much of a drawing or a "plan." He had a general idea of how he would start and a rough sketch to guide him and his crew. Tom is fond of telling the story of the first time well-known artist Dean Meeker came to see the Forevertron. Dean looked at it and said, "Tom, do you have any drawings for this?"

Tom looked at him and said, "Now, Dean, you know I'm no drawer, you've seen my drawings."

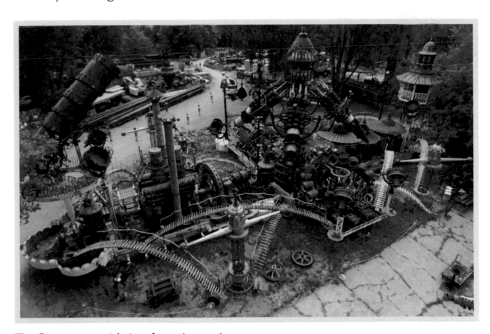

The *Forevertron* aerial view from the northwest JIM WILDEMAN

"Well, do you make maquettes?" Dean asked.

"What the hell's a maquette?"

"It's a model," replied Dean.

"Oh, I don't do that either," was Tom's laughing response.[6]

In the summer of 1983 Ray and Harry joined Tom in the empty field next to Delaney's. Tom and Thayer began to haul in pieces of salvage and the work started. Ray recalls, "The first thing was the tree—the column that holds the coils [thrusters]." Only Tom knew where they were going with this, and, looking back on it, Ray thinks that he had the whole thing in his head from the very beginning. They all followed his lead and did what he told them. Ray says, "For a while it was pretty much piece by piece. It was kind of like sandlot football—get down on one knee and everybody go out for a pass. At the time it was hard to get emotionally involved in it because there wasn't much of it there, and there was a lot of heavy welding." He thinks that you don't come to love welding but you do come to tolerate it; like most welders, he can show the burns of a lifetime on his hands and arms.

Harry Lutz 1983 EVERY COLLECTION

Ray Blackburn 1983 EVERY COLLECTION

The Forevertron rests on trailers reportedly used in the Apollo space program, acquired by Tom as they were being salvaged at the University of Wisconsin. The story is that the university had gotten what Tom refers to as the "Apollo decontamination chamber" and the two smaller autoclaves from NASA when they were finished with them. The chamber was reportedly used as an isolation unit for astronauts returning from the moon, while the autoclaves were used to store moon rocks. The university had no more use for them, and Tom heard from a local salvager that the trailers and the equipment were available. So he went down to Madison and made a deal for the three trailers and the equipment on them. Instead of being cut up for scrap, the trailers, the chamber, and all the other equipment became the foundation for the Forevertron; the chamber itself became the Magnetic Holding Station.[7] He added only the ball on the chamber door and a few copper tubes to the outside. The function of the Magnetic Holding Station in the myth is to store the magnetic force so that it can be used at the time of power up. The two autoclaves (in the foreground on page 39), with a few additions from Dr. Evermor, became Magnetic Projectors, which Tom imagines transfer the

Trailers in position, with "decontamination chamber" at left and autoclaves center EVERY COLLECTION

magnetic force during launch. The trailers themselves are intact, but Tom has added a few structures to them. He cut the ends off railroad tank cars, inverted them, and painted them white to form the platforms for the *Forevertron* components. He then welded discarded cast iron pots around the scalloped edges (see page 42, right end of the structure).

By the time the column and the gussets were in place, they had built the thrusters on the ground. Tom says, "We did the pieces on the ground and lifted them up in the air; they're all sleeved and pinned like a carnival ride so the pieces could be disassembled and moved."

Ray remembers the day they assembled the thrusters very well. "On the day we hung those—then you could start to get emotionally involved. You could see at that time what he was doing—both with the equipment and the materials he was using. And I proceeded to have really no question of his ability to engineer it so that it would hold and support itself." The first thruster would be the most critical because until the second (and opposite one) was installed, the "tree" would be out of balance—and each thruster weighs six thousand pounds. Tom says, "The thrusters came from the original transformers that were used in the

Prairie du Sac [Wisconsin] powerhouse dam. Instead of cutting them up and selling them for scrap copper, I built that compound thruster; of course, there's nothing that big or that long." The thruster assembly with its massive electrical components adds an element of plausibility to this whimsical machine. Here and throughout the Forevertron assemblage, we will see how Tom has combined a series of machines and devices that once worked (or could work); some of them he gives new functions, others he incorporates as if they could be switched on today and bring his mechanical fantasy to life.

The column and structural steel were salvaged from Palmyra Iron and Metal, and the rings around the upper part of the thrusters come from an agricultural irrigation system. All of the curved pipes that make up the four gimbals for the thrusters and the central ring are made from boiler tubes salvaged from Wisconsin Electric in Milwaukee (see photo on page 41). Tom engineered a cabling and counterbalance system to prevent the whole thing from tipping over while there was only one thruster in place. He operated the crane while Thayer and Ray balanced from ladders guiding it into place; that first one went smoothly, as did the others. Ray says, " It was quite a kick in the head. He had it very well thought

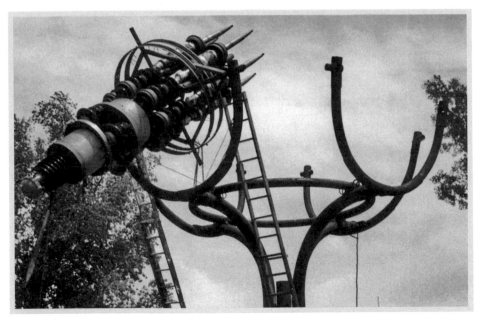

Thruster construction EVERY COLLECTION

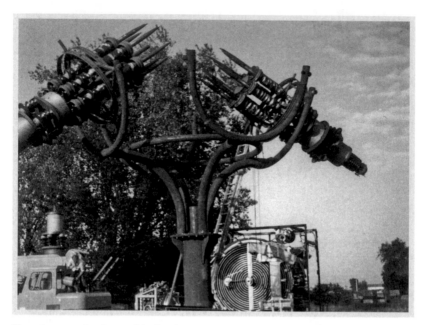

Two thrusters in place, with the decontamination chamber below EVERY COLLECTION

out. By that time, I had confidence in him and I had no fear up there on that ladder. He knew how to run his machines and I had no fear of it breaking, and at that point in time we were just having fun." Ray adds, "I liked the time frame that he was working with—I think that we were both born two hundred years too late."

Thayer was just eighteen when the project got under way, but even at this age, he earned Ray's respect for his equipment operation and his work ethic; with the Everys, ten- and twelve-hour days, or longer, are commonplace. As the years went on, he became the image of his father: always busy, running somewhere for salvage or scrap, but with time to show up at the sculpture site to help or to bail his folks out of some problem they had gotten into. He has a smile, in the words of Tom's friend Doug Britton, "bigger than his face."[8] He has none of the fascination with piracy or angst of his dad. He is a busy and happy man.

Tom felt enough confidence in his crew to give them instructions about what he wanted done and then leave for periods of time. Over the course of the summer the basic form of the *Forevertron* started to take shape. Ray says, "It turned from something that I was picking up a little money for into something that was the

start of a love affair with the thing that up until then was just nuts and bolts. It was then that I realized that I was hooked on it. Somewhere along in there I became vaguely aware that I would be there until the end of it. And as more pieces went on, as they said in that movie, 'Build it and they will come.' And they did." Among them was *The Guinness Book of World Records*, who in 1999 recorded it as the world's largest scrap metal sculpture.[9]

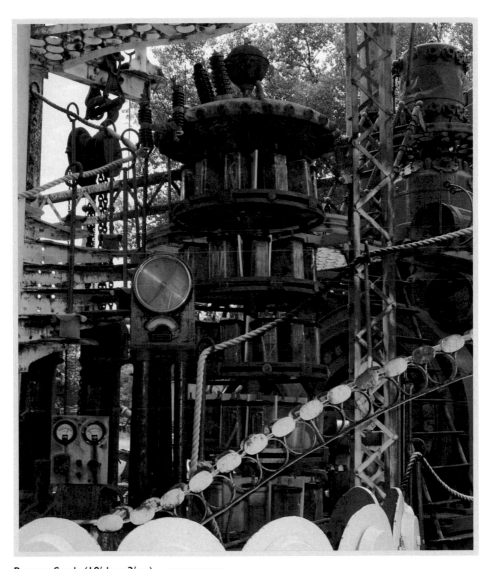

Battery Stack (10' h × 3' w) JIM WILDEMAN

The maze of industrial elements that make up the remainder of the Forevertron can probably be best explained by following step by step the long and complex "launch" sequence.[10] According to the myth, when Dr. Evermor and the ground crew are satisfied that all systems have been checked, he turns on the DC power by throwing a series of switches just to the west of the thruster column. This activates the battery stack. Doc says, "These are acid batteries that I got from Badger Army Ordnance across the road, and they're the kind that were used to back up switchboards in powerhouses." The use of actual batteries is another example of Tom lending a little more credibility to his machine, blurring the boundary between fantasy and reality. The column of batteries is protected by a copper roof fabricated by Doc, topped with a finial made from a salvaged horn. The current from the batteries, Tom explains, is used to start two "exciter motors," one of which slowly begins to turn the great generator until inertia is broken and the steam engine can begin to turn it on its own. The second exciter motor starts a smaller steam generator nearby. The Battery Stack is located just under the telescope tower (page 52). The exciter motors are painted bright orange and are located at either end of the giant steam engine just to the right (south) of the telescope on page 52.

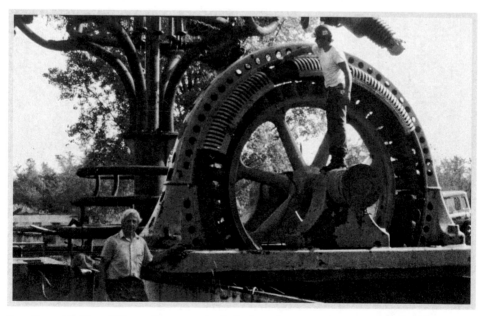

Pete Burno (left) and Thayer Every on the Bullock generator (14′ dia.) EVERY COLLECTION

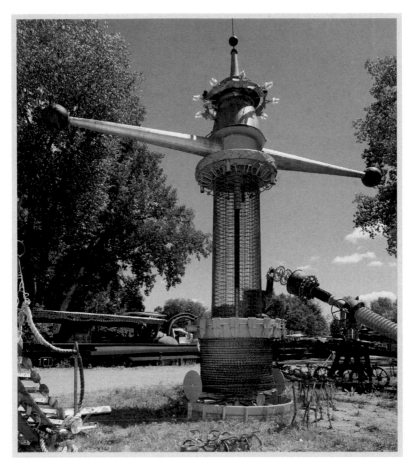

Faraday Stray Voltage Cage (18′ 4″ h × 17′ w at arms) JIM WILDEMAN

The "steam engine" was originally a huge compressor that Tom salvaged from the Edgewater Power Plant in Sheboygan. Originally it had just two heads; Tom found two more and "I just stuck [welded] them on there and I Rube Goldberged that governor on there so that it looks like a double compound steam engine." The four heads (domelike forms) can be seen on page 44 above the steam engine. On the side of the engine Tom has installed several relief valves known as "steam worts." Steam for the engines comes from two sources: Tom's concept is that steam would be generated from underground conventional coal-fired boilers; the chimneys are located on either side of the steam engine. He explains, "Oh my God, are those beautiful, they came from the Paine Lumber Company in Oshkosh and

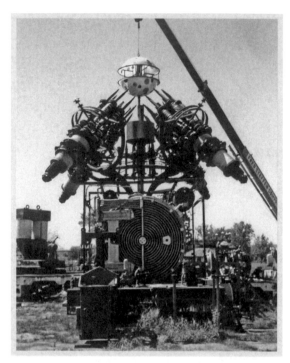

The "Mars egg" being lifted into place EVERY COLLECTION

they are very old, twisted pipe—and riveted—they were used for blowing sawdust. Here they are smokestacks." The second source for steam would be geothermal—from the heat of the earth itself. The steam engine with its smokestacks is clearly visible just to the right (south) of the telescope on page 35.

The steam engine takes over from the "exciter motor" and turns the smaller generator and the fourteen-foot-diameter Bullock generator (large, bright orange, wheel-like structure just to the right of the steam engine on page 35), which was salvaged from a hydroelectric plant by Tom's old friend Pete Burno. It is one of the first AC generators and dates from the late 1800s, a rare collectable resting here in the *Forevertron* where it produces only phantom power.[11]

Meanwhile, at the other end of the *Forevertron*, steam feeds from underground to a smaller engine that powers the Edison Bipolar Dynamos, producing more power. The dynamos can just be seen in the photo on page 47, under the round copper roofs to the south of the travel chamber. Tom acquired several dynamos and motors from the Ford Museum in Dearborn, Michigan. When he was a small boy, Tom's dad took the whole family on vacation to Dearborn to visit the Ford Museum. The trip had a profound effect on Tom, and years later when some of the motors and the Edison Dynamos came up for sale, Tom made sure he was there to bid. He is very proud of this collection, which documents the early history of motors and the generation of electricity; all of these silently play their part in the *Forevertron* myth. He points out, "That one with the white wrappings weighs thirty-four thousand pounds."[12] There are two backup sources of power,

the Juicer Bug and the Albert Mellentine, which are discussed later in this chapter in the section on satellite pieces of the Forevertron.

At power up, the electrical current runs through a cluster of five resistors on its way to the thrusters. Tom explains, "Those are beautiful. They're large copper-core-spun resistors and they came from the Prairie du Sac powerhouse, and the rivets around the tank end [top cover] are the ends of hand grenades." Above is an insulator and a horn finial. The brown tubes and equipment at the bottom are fuses, and all of this is part of the mechanical fantasy working as a safety device that prevents electrical overload during power up. The resistors can be seen on page 35 (page 4 of color insert), just to the right of the small orange exciter motor north of the central tower.

When in "operation," power passes from here into the thrusters through cables (not installed at this time) and is focused on the travel chamber by the thrusters. Dr. Evermor insists that as the Forevertron powers up, the sound would not be mechanical but more like a combination of an "electrical hum and a natural groan." He imagines: "Because of the fact that this is electrical power and magnetic power, you don't have all that change of pressure. It goes like, 'Shhh-hhhoooooo' versus 'Bam'—it's a whole different kind of power."

But there would be danger from all the electrical current generated at launch. The four Faraday Stray Voltage Cages positioned at the corners of the Forevertron serve an important purpose. When the Forevertron powered up, it would produce a tremendous amount of voltage and static electricity. Dr. Evermor had to come up with a device to solve the problem of electrical short circuits in the machine and possible danger to the assembled crowd from stray voltage. The rotating arms on the top on the cages would pick up any electricity and harmlessly dissipate it. When in operation, the arms make a buzzing noise, and each unit would have a neon glow not unlike a bug zapper. Tom intends to include this and other animation and lighting effects as part of the show when he has put the finishing touches on the Forevertron. The tanks on the top of the Faraday Stray Voltage Cages are salvaged stainless steel, and above is a copper kettle dome with horn finial. The bronze screening of the main columns came from a paper mill. Each of the four cages is made in modules for easy breakdown. The cylindrical shape is formed around tank cutoffs and agricultural wheels and wrapped on the outside with

marine rope. They are named after Michael Faraday, the nineteenth-century physicist who originally proposed the principles that underlie the modern theory of the electromagnetic field.[13]

The magnetic lightning force beam that would be produced by the thrusters and magnet (see below) is focused on the travel chamber, a glass (Plexiglass) ball inside a copper egg. Ten years before he began work on the Forevertron, Ray Blackburn had taken his family up to Green Bay for a real treat. They had Packers tickets and they made a day of it. On their way back from the game they stopped in DePere, Wisconsin, to get something to eat. Ray was looking for a cheap place, so he settled on the Mars Hamburger Stand, where they sat and ate their hamburgers under the Mars Hamburger globe. Now, a decade later, he was scraping the Mars sign off the globe and fastening the straps of the copper egg around it as it became the travel chamber of the Forevertron.

The glass ball of the travel chamber is five feet in diameter and is surrounded by a copper egg made of banding salvaged from the Parker Pen Company. In theory, this banding acts as a shield as the egg hurtles through space. The spearlike form on top of the egg is patterned after a medieval jousting lance and is made from rejected horns from the Elkhorn Horn Company. It is meant to deflect particles away from the egg during travel.

Just below the egg on the main column is an inverted tank, which Tom intends to wrap with inch-and-a-half copper tubing to make it appear to be a huge magnet. The story is that at the time of power up, magnetic force from the Magnetic Holding Chamber is shot through the Magnetic Projectors (see autoclaves on page 38) to a series of bushings on the main column. These lower bushings will be connected to the top series by cables that transfer the magnetic force to the huge magnet positioned just below the egg, which then releases its magnetism at the same time as the electric current (lightning force) is focused on the egg by the thrusters. The egg would then be launched by what Tom calls a magnetic-lightning force beam. In an animation to be added later, the column itself will hold the hydraulics that will raise and lower the egg during demonstrations for the public.

Just to the north of the travel chamber is the Wind Spin, which is the weather station of the Forevertron. At the time of launch, the Doctor climbs the cir-

cular "stairway to heaven" up to the Wind Spin, where he checks the weather. Tom explains, "That's not only for the wind speed but that's the tower that the Doctor goes up and he gets to the top and he feels things around and he cranks the [copper] ball up. There's a crank up there and the ball goes up, signaling to everybody on the ground that he's ready to 'highball it to heaven.' He then goes across the little bridge and gets inside the glass ball inside the copper egg."

To the west and below the travel chamber are two sets of lights (six lights) that were used to signal barges on the Mississippi River. Here they signal the progress of the launch or warn of problems

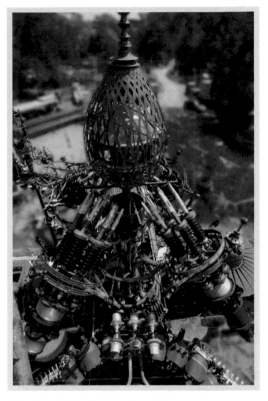

The Travel Chamber and thrusters JIM WILDEMAN

(see page 48). The ten scale dials lower down are here meant to appear to be large electrical gauges on top of the knife switches. These switches were once elevator controls in the state capitol in Madison and are now used to turn on the Forevertron. Tom bought the salvage from a scale company and used the components here and throughout his artwork. He says, "I was interested in the mechanical fantasy of it. . . . I'm going to put lightning rods on top of them to make it look busy." These switches and gauges are part of the Magnetic Steering Gyro that is just below them. This entire area will have its own platform and spiral staircase. The gyro itself (center in photo on page 50) will be covered by an egg "like the one above." On the ground below (raised two feet in the final plan) is a set of large rheostats from the Wisconsin Dells power plant. Other parts here were salvaged from the People's Brewery in Oshkosh and the Kingsbury Brewery in Sheboygan. The Magnetic Steering Gyro guides the trajectory of the egg.

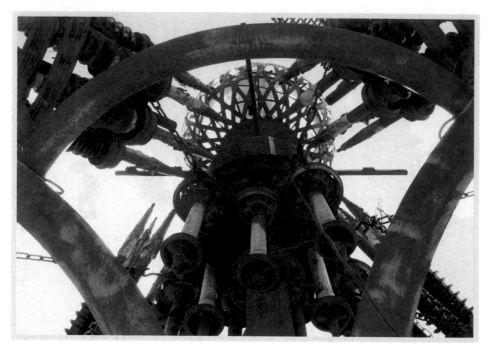

Magnet and bushings with Travel Chamber above JIM WILDEMAN

It relies on information from the *Overlord Master Control Tower* (which will be discussed later in this chapter) to plot the correct trajectory.

At the south end of the *Forevertron* is the Royal Gazebo (right on page 35). The royals would ascend a spiral "lily pad" staircase to the gazebo, which is equipped with a heart-shaped reclining cocoon chair and a wine font. Tom says, with the usual glimmer in his eye, that the Royal Gazebo is a reproduction of the one on-site in England at the time of his mythic ancestor's flight. It is from there that Queen Victoria and the Prince of Wales could witness the monumental event. Tom and his crew built the whole structure from salvaged structural steel and odds and ends on hand. It does not currently include the planned Royal Urinal for the prince's use. The copper cupola on the top came from an old barn in Kenosha County.

At the north end of the *Forevertron* is Tyco's Telescope (left on page 35). It is named after the sixteenth-century Danish astronomer/artist Tycho Brahe, who made his observations before the perfection of the telescope.[14] It is designed for

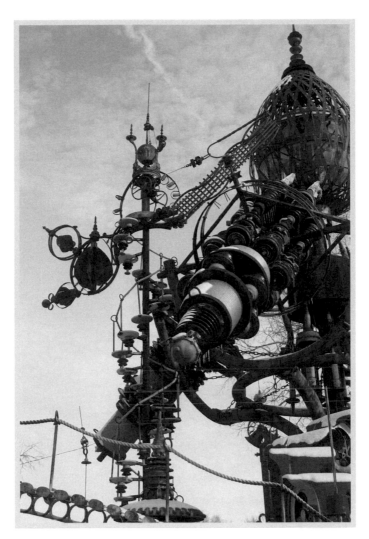

Wind Spin and bridge JIM WILDEMAN

the doubting Thomases to track the Doctor's progress. According to the Doctor, "It's made out of seven large agricultural wheels. The tubing is wrapped with copper. It's a total fabrication of the engineers working with Dr. Evermor." The telescope is mounted on a ladder mechanism from a fire engine that can be "cranked up and down" and moves on four "oddball wheels" from the Island Woolen Mill in Baraboo, rotating 360 degrees to view any portion of the sky. The stool for the telescope operator is from the same mill. Tom says, "It's a weird

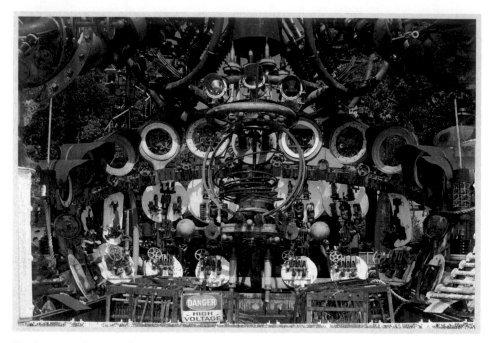

The Magnetic Steering Gyro JIM WILDEMAN

kind of thing; it sat next to a loom at the mill and it was important to me because somebody had sat their ass on it for a long time." The umbrella is made from a copper pot and scrap copper sheeting, and the circular viewing platform was welded from smoke rings from the stove company that Tom helped salvage in Tomah. The "lenses" of the instrument were once skylights at Mercury Marine. The short lightning rods on the upper end of the telescope were once part of the SS *Mercury*, a cargo ship that sailed the Great Lakes. Thinking about his mythic ancestor, Dr. Evermor says, "The telescope is very important because we have all these cotton pickin' nonbelievers around asking, 'Is the Doctor going to make it or is he going to end up in the River Thames or something like that?' So they had to have somebody to report back in to the rest of the nonbelievers. That's where the telescope comes in."

The *Forevertron* is equipped with searchlights to illuminate the launch in the event it occurs at night. The backs of some of the lights are cooking pots from a candy factory, while others are coffee urns, and the outer rims are agricultural wheels. Tom explains, "I took two of them about the same size and cut spokes

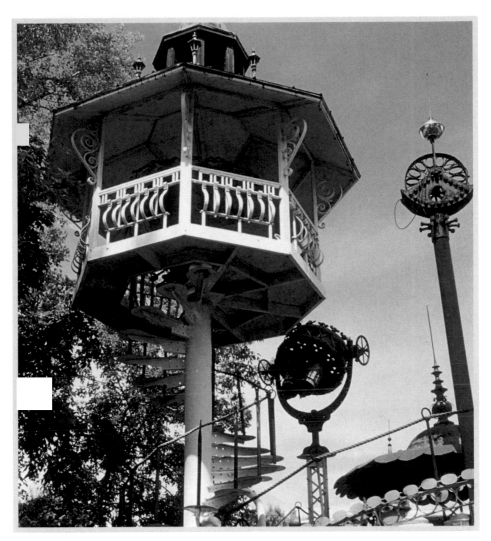

The Royal Gazebo BOBBI LANE

out to make that weaving pattern that you see there." Some of the lights have salvaged carbon arc fixtures in them, but Tom will install conventional spotlights.

The stanchion-like constructions that hang empty on the east side of the Forevertron (see page 54) are connected to cables held by suspension towers "made from agricultural wheels with those smoke rings in there to give it some busyness; those rivets are actual hand grenade ends." Each hanging unit is equipped with a lightning rod. Together they will hold a suspended walkway used by the

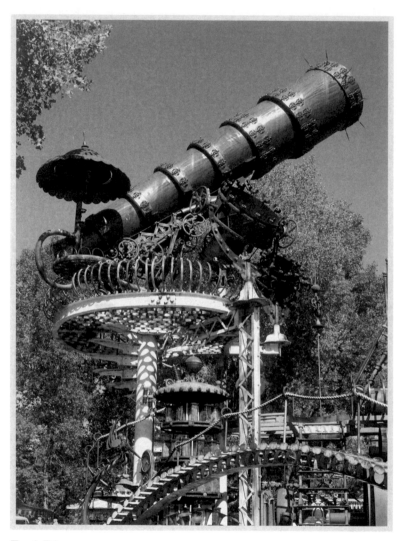

Tyco's Telescope JIM WILDEMAN

ground crew to service the machine and perform their duties at launch time. The bridges will also function as a "blender" to unify the whole environment and "busy it up," according to Tom. The walkways and rope railings have been removed for now out of concern for the safety of children visiting the park.

The stationary curved bridges around the structure serve the same purpose as the suspended walkways. The crosspieces are made from rejected material from a snowmobile manufacturer. The outside edge is welded from metal stampings,

and the band inside is made from roll stock that was used by a company making grenades and is reinforced with smoke rings salvaged from a stove company. These curved white bridges are visible in the photo on page 52.

In the beginning, the Forevertron had a different name. For the first few years it was called Force. The conversion of the name came from Walter Bleeker, an itinerant preacher who rolled into the park one day and set up camp. He took to painting Force, not bothering to ask permission. Soon the Doctor and the preacher started talking religion, and before long they were arguing. Tom's views had grown broad and eclectic over the years, and sometimes their arguments grew heated. Eleanor recalls, "They had a terrible fight one day toward the end of the day. We arrived back the next day and saw a long stick poking out of the window of his camper with a white flag on it." Doc and the preacher agreed to disagree, but Walter still thought that the name Force was militaristic, aggressive, and too reminiscent of the Star Wars films. Tom told him that if he could come up with a better name he'd

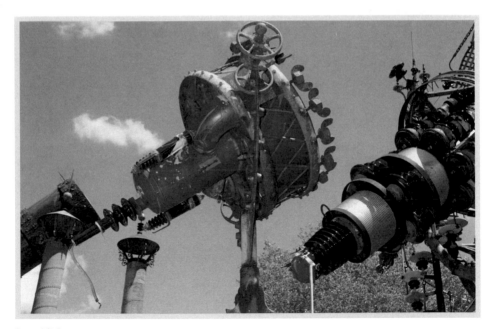

Searchlight JIM WILDEMAN

change it. When Walter suggested *Fore-vertron*, Tom agreed.

The satellite pieces that accompany the *Forevertron* play an important role in the myth. They include the *Overlord Master Control Tower*, *Gravitron*, the *Albert Mellentine*, *Juicer Bug*, *Celestial Listening Ears*, *Epicurean Grill*, *Olfactory*, *Chee-Shwer*, *Spritzen*, and the *Jugglenutter*.

The *Overlord Master Control Tower* is designed to be an eight-story structure adjacent to the *Forevertron*. In the grand fantasy of things, it is the control and guidance system. It is only partially completed at this writing and is illustrated here in Tom's drawing, done in 1987 and revised in 2004.

The fourteen-foot-high base will be made from a series of eight generators, compressors, rheostats, and motors combined with a navy buoy from Guantanamo Bay, Cuba, where it reportedly was used to support anti-submarine netting during the Cold

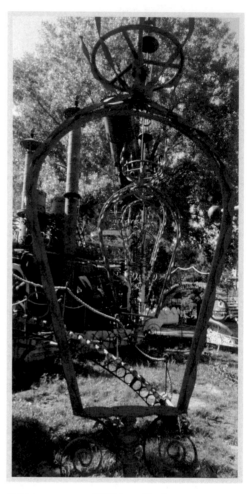

Bridge supports (7'1" h × 3' w) JIM WILDEMAN

War. Rising above, for twenty-two feet, are the Magnetic Laser Love Guns in position for firing. Dr. Evermor explains, "You see, there are cannoneers in there [mid-level of drawing page 55] and they have periscopes and they see somebody that's not smiling. They take that Magnetic Laser Love Gun and they're sitting there and they shoot and give them a laser shot in the ass." The periscopes are army surplus and were meant to be used in tanks. There is also a mobile Magnetic Laser Love Gun positioned next to the *Forevertron* and not connected to the *Overlord Master Control Tower*. This "field gun" is used for special operations when the target is out of range of the cannoneers on the *Overlord Master Control Tower*.

Tom's drawing of the *Overlord Master Control Tower*

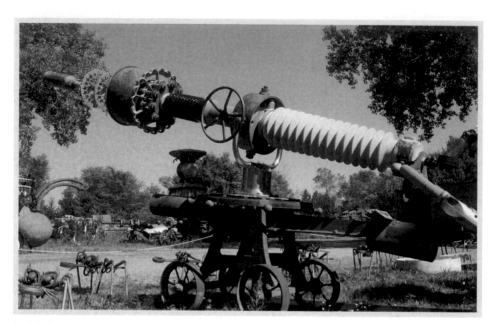

Mobile Magnetic Laser Love Gun (16′ 6″ l × 3′ w [gun carriage]) JIM WILDEMAN

Through the porthole on the cannon controller's level (see page 55) the Master Controller can climb the circular staircase to the master control chair (a dentist's chair). The person chosen for this position would be the most trusted the Doctor could find. Looking into his past, he decided that it would be his friend of sixty years, Dr. Chester Cjertsen, his dentist and former army colonel (on the theory that if you can't trust your dentist, who can you trust?). It is his responsibility to analyze the celestial messages sent to him from the observers in the *Celestial Listening Ears* (see below). When he is certain that all conditions are right, he sends a signal calibrating the Magnetic Steering Gyro on the *Forevertron* and announces "Power on!"

Rising above the master control bridge is the observation deck with a small telescope, the widow's walk, the sentry's crow's nest topped by the finial, and a lightning rod rising above the *Forevertron* to a height of eighty feet. Tom has designed the *Overlord* in modules so that it can be assembled in what he calls "the stacking principle" and eventually taken apart to be moved to a permanent location. At this writing only the center module is complete. The other components are lying throughout the park.

Larry Waller had been a salvager and a lover of fine objects before he met Dr. Evermor. His real passion would turn out to be handmade shoes.[15] He is an internationally known craftsman and has made over ten thousand pairs of shoes in his career; he specializes in period shoes for opera companies and historical reenactment sites. To put bread on the table he's also an industrial salvager. One day in the mid-1980s, while he was filling his car with gas in Delevan, Wisconsin, he looked across the intersection and saw a vehicle loaded down with all sorts of interesting metal salvage. He went over to the driver and asked him if the stuff was for sale. Tom said that it was not. When Larry asked him what he was going to do with it, Tom replied, "I make it into art." Larry looked at all the pieces and said, "You have to come over to my house." Intrigued, Tom followed him a few miles out of town to his farm. There on the lawn was an elevator cage and a large theater speaker. Larry had bought the speaker at a farm auction "because [he] just couldn't pass it up." It had originally come from the Beloit Theater. He had gotten the elevator cage from a salvage job in Elgin, Illinois. Larry thought that these two objects were art in and of themselves, which is why he had them on his lawn. They made a deal for the speaker and the elevator right then and there, and that was the beginning of their friendship.

Throughout the years Larry supplied Tom with a great deal of salvage, and he always kept his eyes open for things that he thought Tom could use. Tom didn't say what he was going to do with the speaker, but according to Larry, "You could just see the gears

Tom welding a section of the *Overlord Master Control Tower* EVERY COLLECTION

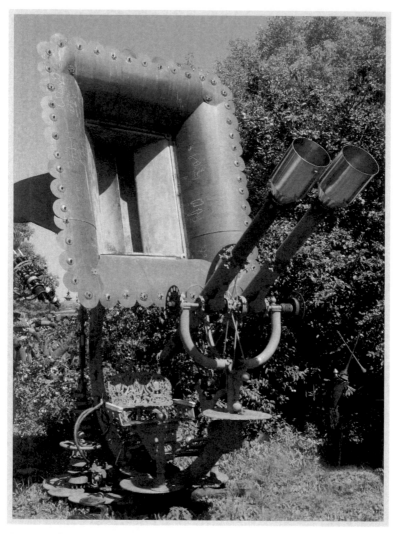

The *Celestial Listening Ears* (18' h × 9' w × 26' l) JIM WILDEMAN

spinning, almost like smoke rolling out," as he looked at him that day. Larry says further, "I've watched his creative process and whenever I get things for him, he sits down and draws me a picture of how it's going to be. It's like he has the plan in his mind and he's like a hunter/gatherer—when he sees something, that's it, this is where it's going. What you see here [at the sculpture park] is like the remnants and the leftovers—the stuff that's got the real 'woo, woo,' or the energy—here it is."[16]

Tom used the speakers as the basis for the Celestial Listening Ears.[17] On the day of Dr. Evermor's imagined flight into the celestial spheres, two of his friends will man the Celestial Listening Ears and scan the sky, listening for the voices that will give directions to the awaiting egg. Peering through the telescopes, they track the source of the voices and communicate the vital trajectory information to Col. Cjertsen in the Overlord Master Control Tower, who will accurately aim the egg on its heavenward journey.

The principle the Doctor used here is that if something can produce sound, all you have to do is reverse the process and you can receive sounds—in this case, celestial sounds. Dr. Evermor explains: "So I got a curved pipe in there, and that's on a swivel, so you stand off to the side (two people do) and they can rotate it so that it's a hand-rotated-type thing. That's an old barber chair, which I converted into a two-seated chair for two people listening to the voices from the heavens. . . . If they heard anything, they could look through their telescopes and get astrological bearings and plot the coordinates."

The Albert Mellentine is named for one of Tom's kindred spirits, Mr. Albert Mellentine, who put the machine together. Tom never met this tinkerer and local character, who died in 1960. Like Tom, Albert couldn't help collecting and reusing, even collecting drain oil from filling stations and designing a system to reuse it to heat his home. He also collected engines, parts of machines, and general salvage to reconfigure into his unlikely inventions.

Mellentine was a general handyman, but his pride and joy was what he called his Monster. It was a very powerful tow truck made from a nine-cylinder Guiberson radial engine that came from a World War II tank, a gasoline Franklyn engine of about 1929 vintage, two streetcar motors with rheostats, and so forth. The engine ran a generator (originally from a submarine), which ran the motors; a second engine supplied auxiliary power for winch motors. This mobile crane was the most powerful machine of its kind in the area, and he was often called on by the Wisconsin State Patrol to help with truck rollovers. Albert, like Tom, did not always bother to get the necessary permits. Once when Mellentine was moving a huge rock down the road he was stopped by the police and told he couldn't do that. He said OK and lowered the rock in the middle of the road and drove off. Pete Burno recalls that Albert would "throw switches at random in that cab—one

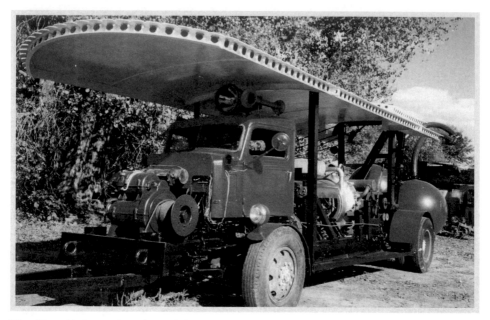

The *Albert Mellentine* (c. 44' l × 8'5" w × 10'3" h to top of canopy) EVERY COLLECTION

overhead, another right under his feet, and another under the passenger's seat. The speeds that he got on that truck were phenomenal."[18]

Tom acquired the *Monster* in 1965 by trading Jim Delaney eleven hundred sheets of plywood. He later sold it at auction but soon regretted it. It wasn't until twenty years later that he found it in a junkyard near Tomah, completely intact except for a tree growing up through it. Tom bought it back, put a roof on it, and placed it near the *Forevertron*, where it became part of the myth. It would be used to supply reserve power to the *Forevertron* at the time of the Doctor's transit to the celestial spheres. Albert always called it his little cherry picker, so Tom fitted it with two giant metal balls to represent "really big cherries."

The *Juicer Bug* (it has also been called the *Lightning Bug*) is an important part of the *Forevertron* set. In theory, this fifty-foot-long bug, according to Tom, collects lightning and saves it for transfer to the *Forevertron* in case it is needed on launch day. The Doctor is always concerned about having as many backup sources of power as he can. If there were a power failure during the *Forevertron*'s power up, the consequences for the Doctor would be unthinkable. Of the *Juicer Bug*, Doc says with a smile, "If you need extra juice it would furnish it to the *Forevertron*."

The thorax of the bug is made from a stainless steel spin tank used in a pharmaceutical industry plant in Verona, Wisconsin. The wings are cut from high-pressure gas tanks from a plant in Berlin, Wisconsin. The "busyness" under the wings comes from popsicle molds Tom acquired some time before (see photo page 62). When the bug's legs are completed, the Juicer will stand twenty-one feet high and will be connected to the Forevertron by a series of electric cables. The Juicer's completed weight is estimated at sixty thousand pounds. Tom built it in 1998, finishing up the main body on a cold and rainy Thanksgiving Day with the help of his friend Roman Slotty. The bug's leg assembly lies nearby, waiting for the day when Tom finds a permanent site for his work and the Juicer can rise to its full height.

The Juicer Bug had at first been named the Badger Clean-up Bug. Tom wanted to station it at the entrance to the decommissioned Badger Army Ammunition Plant when serious contamination problems at the plant became more widely known. It was to have been part of Tom's sculpture park proposal for the closed plant.[19] The park never materialized, so Tom converted the Clean-up Bug into the Juicer Bug, and it became part of the Forevertron set.

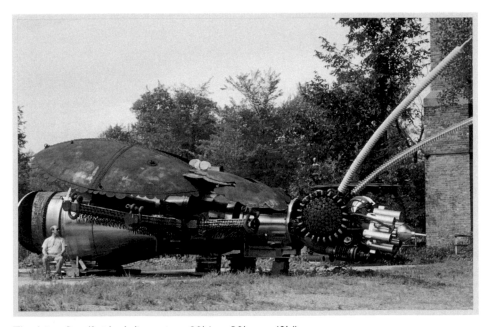

The *Juicer Bug* (finished dimensions 20' h × 30' w × 40' l) BOBBI LANE

Juicer Bug **underwing detail** TOM KUPSH

The *Gravitron* is a mechanical fantasy that is an important part of the myth of Dr. Evermor. Before the Doctor can be transported in the *Forevertron*, he needs to weigh the correct amount, and he has to be checked for any bodily defects that might cause the process to go terribly wrong—the *Gravitron* solves these problems. It's designed to be a nineteenth-century MRI, scanning the body for defects while adjusting body weight by "de-watering." After analysis and treatment in the *Gravitron*, Dr. Evermor would weigh himself to make sure he is the acceptable weight and then climb the "stairway to heaven" to the travel chamber of the *Forevertron*.

This machine was fabricated from an actual full-body fluoroscope that Tom acquired from a doctor in Madison. Those who grew up in the 1950s and before will remember the smaller fluoroscopes that were installed in shoe stores. Customers could try on a new pair of shoes, step onto the machine, and turn the fluoroscope on to look down at the live X-ray of their wiggling toes. The machine Tom acquired was much larger than the shoe store variety. "He [the doctor] had weasel-sacked it away and maybe it was his dad's or something," says Tom. It looks like a "Frankenstein thing." Tom had to assure the Madison doctor that it would

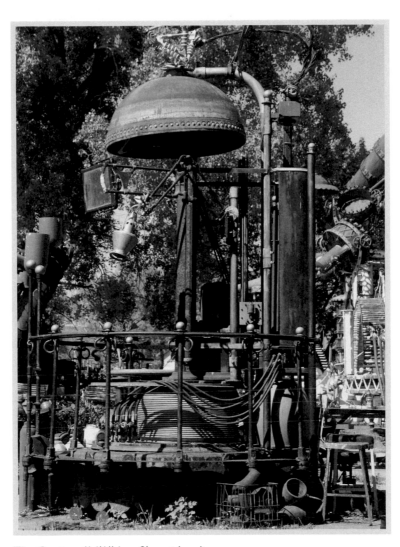

The *Gravitron* (14'1" h × 8' w at base) JIM WILDEMAN

never be turned on before he would part with it—imagine full-body X-rays from a 1930s machine. Dr. Evermor recalls, "I brought it back here and I set it up on that tank and I put those wheels around it and gingerbreaded it up and came up with this unit that the Doctor had to go into . . . and turn it on and all that stuff would go buzz. . . . Then he would step out and he would be reduced in weight that would be necessary for him to go up in the egg." The dome on the top is made from a copper vat salvaged from a chocolate factory.

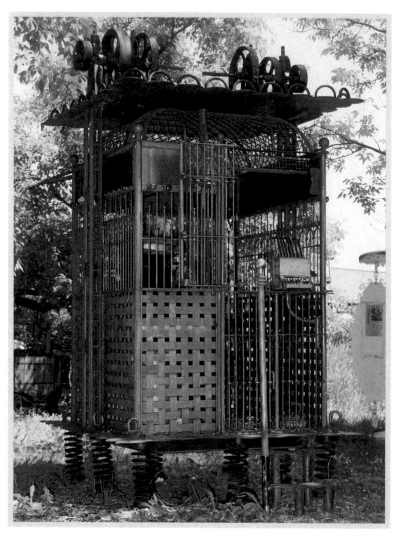

The *Olfactory* (c. 11′ h × 6′6″ w × 6′ l) JIM WILDEMAN

The *Epicurean Grill*, from Tom's days at the House on the Rock (1977), has become an important part of the *Forevertron* set. In reality, food service may one day become an important part of the park. In the myth, the gathered crowd will want to eat, so the *Epicurean* may finally find its place as a centerpiece of the site's food service (see page 22).

A companion piece to the *Epicurean* is the *Olfactory* popcorn popper (1992), which Tom calls a "smell sculpture." The elevator cage that Tom got from his

friend Larry Waller found its home in this piece. The Doctor added an antique popcorn popper and a couple of chairs to it so that two people could sit down and operate it. He attached some bric-a-brac and it was done. It produces popcorn "like it's going out of style," according to Tom. It sits on springs so that anybody walking around in it goes up and down—a spring-loaded popcorn popper. He built it for the grand event of the myth because "the old Doctor liked popcorn," and you can't have a good time without it.

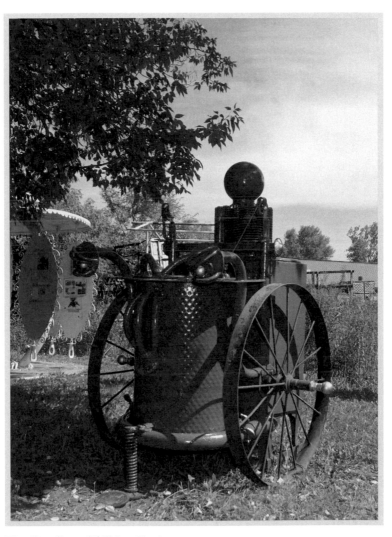

The *Chee-Shwer* (6'6" h × 5' w) JIM WILDEMAN

The *Chee-Shwer* (1992) is a refrigeration unit on wheels. Made from an antique refrigerator, a salvaged storage tank, and a cart, it provides cold storage for the *Epicurean* and the other food service equipment. Tom has also planned sets of tables made from copper kettles and a host of seating.

Still in the planning stages is his idea for bottled water: *Computerized Water*, also known as the *Spritzen*, will be made from outdated hard drives surrounding a stainless steel water cooler. The *Jugglenutter* is another food service machine he's thinking about. Tom intends to convert an old fire engine from the Wisconsin Dells fire department and a peanut roaster into a machine that produces "celestial peanuts." Tom says, "I'm going to remove the upper part on the back bed to expose all the pumps and add an air compressor underneath there and that would make those peanut shooters." These magical peanuts ensure happiness and youth to all who eat them. The *Jugglenutter* "brings the rays from the heavens to impregnate the peanuts for everlasting life," says Tom—the very elixir of life.

<p style="text-align:center">�</p>

In the *Forevertron*, Tom would come to more clearly define his methods and principles of creation. In his work he preserves intact many tools, machines, and artifacts that span the industrial age. Since his early days in Brooklyn, Tom has been fascinated by what he calls the "spirit" of the tools and machines that he salvages, and he wants us to see them as alive with the spirit of those who made or used them. He builds with respect for the "historic integrity" of the parts. He says it this way: "The reason you don't alter anything [is] you're making a statement, a very strong statement—I like you, it's just fine the way you are. Whether it's a little part, of a human being or anything else, instead of hacking away at it you take your wire feed [welder] and blend it together. That's why people who come to visit this stuff seem to really like it."

If he hadn't used these components, they would certainly have been cut up for scrap years ago; his work is not only a new work but also a preservation of the past. Tom often felt troubled when he saw the quality of the buildings and machinery he salvaged; now he finds new ways to use these pieces of history.

Dr. Evermor's intuitive approach to his work doesn't mean that the results are random or accidental. His advice to artists is that "you have to eliminate your ego [and believe that] you don't know, and just go entirely with the flow. It could be fantasy or it could be something else, but you go at great speeds." Aaron Howard, who welded with Doc years later, talks about the "zone" Doc seems to create when he's working: "There's a different time zone that happens when you put the helmet down with Doc. You just enter this time zone . . . he's just so much fun to work with. It doesn't seem like work. You're tired and you're sore and he's just got such a positive attitude—even when he's being a slave driver. And he's good about giving credit where credit's due." [20] Tom believes that you have to lose yourself in your work to find yourself in your life. "It comes from within and not from the outside," he says.

Dr. Evermor often juxtaposes parts from entirely different time periods. The Forevertron was created using a special logic in which time and place are malleable. In fact, Tom is fond of calling himself the Time-Binder—a person who binds together objects from different times and places. He says, "I take things from different time frames and put them together and come up with a piece of art and there isn't anybody like that. All kinds of people claim that they are artists but I'm the Time-Binder."

Tom moves smoothly between myth and reality, the past and the present, and bends ideas of time and space to suit his own creative vision. But he always manages to find his way back to present reality—or at least his own version of reality—when he needs to. Dr. Evermor often talks about the spirit of the designers and users of the timeworn tools that he incorporates as being "locked into the tool." The whole Forevertron, to him, is a chorus of the spirits of all of those people from the recent and distant past. And there is always his wry sense of humor running through it all. As an event he likes to relate points out: "I get a kick out of this stuff: I got those spotlights out there [on the Forevertron] and they came out here, this guy did, and he was supposed to be this great all-knowing artist and he had his yes-man with him. And he looks up at that and he says, 'My gosh that's an old one [spotlight].' And I just stand off by myself and laugh about it—it's a coffee urn and you could get it at the local coffee shop and those

brass things on there are xylophone parts—they're all component parts. You just add a little P. T. Barnum to it." (See page 53.)

Dr. Evermor works with curves, arcs, and circles. Numbers are very important to him. He believes in what he calls the One, Three, Five, Seven, Nine Principle. He explains: "I think your eye adapts to even things out so you go to an even number. It isn't worth a hootily hoot so you should have some jugglement around. Even the smokestacks here [from demolished buildings that were once on the site] are of different heights. So you've got those loops underneath the bridges [the white curved bridges on the ground next to the Forevertron on page 52] and in there are seven spots and it all goes on the One, Three, Five, Seven, Nine Principle."

He achieves visual tension by using an odd number of objects or spaces. Artist Jake Furnald says, "To me, all the stuff that Dr. Evermor makes has this energy that comes out of it through his designs. He practices a form of design that sweeps your eye around. It's real smooth and it seems like things keep moving. I like the feel of radiating energy you get from his stuff."[21] He combines his One, Three, Five, Seven, Nine Principle with a sense of balance, and the result is that our eye moves across the pieces, filling in spaces and feeling the textures in a playful feast.

The whole thing is unified by what Doc calls "blending." This is nothing more than joining the individual parts together with small pieces of scrap metal; for this purpose he has thousands of round metal stampings of various sizes lying around (he calls these "cookies"). These and other components that come as salvage Tom uses as "adjectives," which he defines with a laugh as "blenders to tie things in. You use them to schmaltz things up or gingerbread it. You know, meatball it up or something. That's my language—that's the way I look at it."

Over the years, Tom has amassed over one thousand tons of component parts ready to be used; much of it is held in fourteen hundred boxes around the site. Each of the four-foot-by-four-foot boxes, forty-two inches high, contains material that, according to Tom, is historical. The total amount of stuff on-site would fill thirty-three semis. "We have so much stuff around here because we can take a look and see whether it feels right for the occasion. Everything has a meaning and a purpose. And it's amazing the amount of stuff that would come in the day before and just fits in the next day." Blaine Britton, Tom's good friend, may have

Storage boxes at the sculpture site JIM WILDEMAN

said it best when he reflected on the stuff lying around everywhere in the park. He said, "Doc doesn't just collect the stuff and let it sit there, 'it's incubating.'"[22]

Not everybody can understand how to work with Doc. He tells it like this: "I hire young people and they have no idea what we're doing. They have to stand back from a weld for half an hour [as if they were saying], 'I did that, I'm a genius.' I can't hack it! I had two guys working over here and we were going lickety-cut and I said, 'Stop and put this ring in there and everything flows.' And they cannot believe the speed we're going. And instead of having the measuring stick out and everything—you know those measuring sticks are nothing—so put this line in here and put a soapstone mark over here and hold some pieces up and see we've got it straight—I think we got it—and we just use seven, nine, and eleven in there and go for it. Adjust it whichever way. And they get all tied up in their underwear measuring things! It's unbelievable!"

At this writing, the *Forevertron* set is not in its final location. When Tom finds a site that is suitable, he has a general plan for the positioning of the satellite pieces as well as the *Forevertron* itself. From time to time he makes a faint attempt to find a permanent location for the work.

The orientation of the *Forevertron* is of great importance to Tom. He believes that the earth contains energy points that can be discovered by those with special abilities. The study of ley lines (the lines that connect these energy points) and other esoteric systems, he feels, will guide him to the best site within any location.[23] Another factor in the final configuration of the *Forevertron* site is his study of ancient earthworks. This respect for ancient peoples and the notion that they possessed mysterious powers of perception guides his thinking about the final configuration. He continually mentions Stonehenge and other megalithic sites when talking about the final orientation of the *Forevertron*. He plans that the site for the *Forevertron* will have an astronomical and astrological basis and function as an indicator of the passage of time. He is especially interested in the views of the *Forevertron* at sunrise and sunset. He says, "You see, what bothers me is that all these buildings that are put on this planet by humans are usually not put down according to feng shui or anything. The ancient temples have a direction. Even the Egyptian dung beetle rolls cow dung only in an east or west direction. I don't understand that, but I would line up the *Forevertron* and all this stuff to have the winter solstice and the summer solstice, and all these angles would make some sense rather than being tossed down."

Part of his Peruvian Principle is a consideration of the meaning and message of the giant figures (usually made of earth or stones) that are found at various ancient sites throughout the world. He is especially interested in the Nazca Lines, a set of huge geoglyphs built by an ancient people on the desert plateaus of Peru.[24]

He is always vague when asked if he really believes in aliens or other beings from "out there" and uses the word *spiritual* for everything from traditional religious beliefs to New Age metaphysics. True to his nature, he is as eclectic and inclusive with his ideas and beliefs as he is in his work, trying to bind together many diverse notions to form a rationale for placing his work on a permanent site. However we evaluate these ideas and his belief in them, it is clear that Dr.

Evermor is trying to create a sense of mystery and a place of reflection. For many, the Forevertron set already has this effect, regardless of location.

He will add sound, lights, and animation to complete his vision of the Forevertron. Dr. Evermor plans to demonstrate his machine throughout the day once it is in place. In the background, visitors will hear the sounds of Indonesian music, which the Doctor feels has the "highest spiritual aura." The sounds of the First Brigade military band will introduce the event.

When the Forevertron is powered up it will produce its unique sound. Dr. Evermor says, "I don't want to use the word 'hum.' It's more like the sound of a living organism, like a groan. It's got to have its own personality—like a living organism." As the show continues, the thrusters begin to glow and the entire set lights up with a variety of fiber-optic and neon lighting. The arms on the Faraday Cages begin to spin, and the Cages themselves glow with a neon light and make their characteristic "bug zapper" noise. The effect is that "you get a visual pulsating look that builds to a climax."

At the moment of launch, the thrusters will glow and then focus their beams on the egg, which will begin to rise up as the thrusters swing back and out to guide the egg, which will start to "spin slowly so that it looks like it's going to take off." Dr. Evermor explains: "On the egg, I was going to put an air cylinder under it so that it would go up about ten feet. When the egg did that, the thrusters would be turning down so they look like they're actual thrusters coming out. I'd have to put lasers and fiber optics representing the magnetic force coming off the magnets. I've got that thing hollowed up there so I can put the equipment in it."

All of the satellite pieces, the *Overlord Master Control Tower*, the *Listening Ears*, the *Juicer Bug*, and the *Albert Mellentine*, will have their own lighting and will be connected to the Forevertron by means of large electric cables. The Forevertron itself will then be interlaced with suspended bridges for the ground crew and electrical cables to join the components.

Dr. Evermor envisions all of this taking place in an atmosphere of laughter and high spirits. Visitors will be able to enjoy themselves, eating popcorn from the *Olfactory*, grilled food from the *Epicurean*, and even celestial peanuts from the *Jugglenutter*. His vision for the future of the Forevertron is a vision of joy.

Sculptor Erika Koivunen (Tom's assistant in the late 1990s and early 2000s) says, "Every time he picks up a welder it's about healing. The Forevertron is all built on hopelessness. The Forevertron was built out of depression and not wanting to deal with the world. He built this piece to heal himself—to take [and use] all the treasures that he found that no one else was going to do anything with—so it was healing."[25]

Poet Petra Backonja gave a draft of a poem to Tom, which he carried around, folded and refolded in his pocket, until it fell to shreds.

> One day is serious, the next a fish in ruins, this
> egg's to win the inventor's love. Cold, and flown
> on steam engines upward I would, all my clouds
> at their best and the wrong tense like boom and
> stumble in heavy shoes, mere surface-farcical.
> Night. Good-night, then poised in air, zeppelins,
> the motorway spilled with icy dunnage, day an
> exploding boiler and me the janitor, o hysteria.
> The sky's a sponge and joistless, kissingly wet
> and slaughterous.[26]

5

The *Bird Band*
Whimsical Fantasy

Troy, Tom and Eleanor's youngest son, was six years old when the *Forevertron* was completed. He started to spend a lot of time at the sculpture site, watching everything. Eventually he began to glue plastic pieces together, making his own small sculptures. He then picked up pieces of scrap metal and positioned them into tabletop sculptures; he asked his dad to weld them. Tom says he acted as a "tool for Troy." Eventually Troy directed his father as they created a series of robots, gladiators, transformers, metal toys, and whatever else came to mind.

Troy's vision surprised both Tom and Eleanor when he had Tom weld up a series of ballplayers. Tom says, "The baseball players, to me, are the most spectacular because I never had any idea what he was doing. And so they had me come over there and I would just tack them. . . . And I said to Troy, 'Now, is that right?' He would say, 'No, bring the arm up a little bit.' So I would weld the whole thing up and put a base on it." Much to their surprise, Troy assembled the entire baseball scene in front of them. Eleanor recalls, "Tom was just welding pieces and Troy had the whole idea."

One day Troy put together a fuel pump and a few odds and ends and called it *The Happy*. They made a few of them and got the idea of putting them up for sale—and they turned out to be very popular. Until that time, Tom and Eleanor hadn't sold anything at the park, and Tom had not built anything there that was not somehow connected with the *Forevertron* set; now Troy would help them transform their future and the future of the park.

This was their first commercial venture at the sculpture park. Eleanor says, "It just took off. We never meant for that to be a business, but that's what happened." In the beginning, they didn't know how much to charge for the work. Tom suggested that they weigh it and charge by the pound, just like the scrap business. At that time, it figured out to about ten dollars per pound. That isn't exactly the way it works out now, but it worked then. Troy is actually named for a system for valuing precious metals known as "troy weight."

Troy and Tom collaborated on over two hundred pieces. By the time it ended, neither of them would ever be the same. This was the beginning of birds and the Bird Band, and the inspiration for hundreds of pieces. Tom felt that he had formed a strong bond with his son.

Baseball Player by Troy Every (18″ h)
JIM WILDEMAN

In Tom's words, "You can certainly see the difference between Dr. Evermor and Troy Every because he has a different set of eyeballs. . . . I believe Troy puts better energy in stuff than I do. . . . He's able to torque and twist [them] so it's got good energy and looks at you like a person would. . . . All of them are better than mine in my opinion." They worked together, off and on, through the mid-1990s. In 1997 Tom began work on a metal totem pole on which he incorporated

The Happy (8″ h) JIM WILDEMAN

Troy and Tom working ANN PARKER

some of his son's small figures, with a meditation spot at the base. He had wanted Troy to work with him to finish it, but it remains as it was left that fall; Troy moved away to finish high school and then studied graphic design at Madison Area Technical College, eventually graduating from the University of Wisconsin at Oshkosh in 2005.

Tom's response to Troy's gifts may not always have been as comfortable as either of them had wanted. Tom's life is fire and iron, push and pull, not always the stuff of nurturing. But his artistic response was dramatic; the dad in him was very moved by his son's work. When a skid of material came into the park from the Beloit Corporation, including a massive wrench, Tom set about saying in metal what words and actions had failed to express. In a few days he had transformed

the load of scrap into a sentinel for Troy's work. As usual, he did not change any of the parts, and this time he included movable eyes, something new for him. He fashioned footprints all around the base and named it the *Tracker* (1990) and installed the piece near the entrance to the section of the park where Troy's work is displayed. Tom muses, "I built it in honor to my son."

The birds in the *Bird Band* are members of the *Forevertron* set, representing the band that will play on the day that the Doctor travels to the celestial spheres. Tom turned his attention to building birds in the mid-1990s; his artistic col-

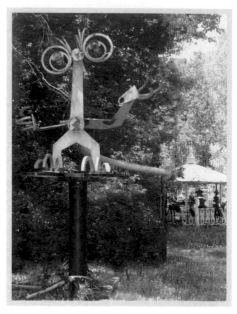

The *Tracker* (16′ h × 13′ w) JIM WILDEMAN

laboration with his young son Troy transformed Tom's work and inspired him to create in ways he had not imagined before. The works that followed were filled with whimsy and humor, color and motion, and they would also become a vehicle for Tom to fly above his troubles and deal with the darkness in his life.

These are Tom's words about birds: "Birds are a nonthreatening species. . . . These birds are a fantasy . . . they're all fantasies. Do you follow what I'm saying?

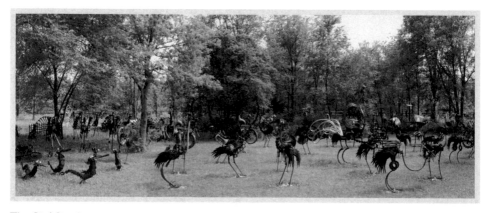

The *Bird Band* JIM WILDEMAN

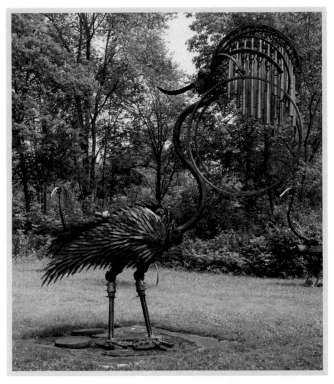

Volucris-Rubor (32″ w × 5′8″ [body] × 12′10″ h) JIM WILDEMAN

They're an illusion of birds . . . things with feathers on them that look like birds. . . . The bird idea is uplifting." Eleanor found many musical instruments at the local St. Vincent de Paul store as high schools in the region were getting rid of damaged and unusable instruments. Larry Waller eventually supplied Tom with horn bells—the blanks from which a variety of finished horns are made—that he had salvaged from a horn manufacturer. The band contains a large variety of instruments: French horns, sets of chimes, trombones, trumpets, steel drums, "Tibetan" bells, a gong, a marimba, baritones, tubas, and horns of every shape and size. Ever watchful, Dr. Evermor has also created the cannon birds (pirate birds) for security. They have pipes that look like gun barrels coming out of their rear ends, which can be fired as working potato guns to protect the band in case of attack. Tom built these pieces in the usual way, not altering the component parts, and many of the birds have large numbers of blade rejects salvaged from

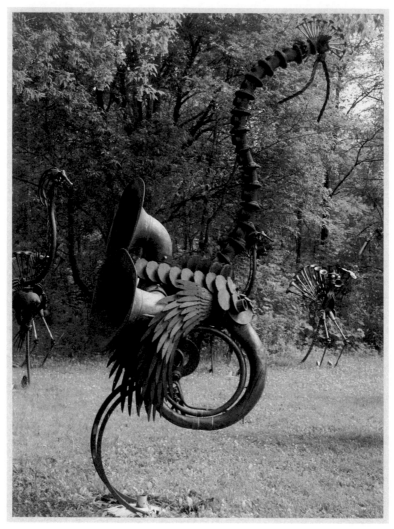

High Poker (4′2″ w × 3′5″ [body] x 10′8″ h) JIM WILDEMAN

the Fiskars Company that Tom has used here in the birds and throughout his other work. "I probably used up thirty ton," he says. The surfaces of the birds are graced with a soft brown iron oxide; the stainless steel remains shiny, while the copper has been reduced to an oxidized green. The patina continues to grow rich in the rain and weather. Here and there brass shines in the sun. The two speaker birds would be used in case an amplified sound system would be needed. The *Bird Band* currently spreads out in the field southwest of the *Forevertron*.

Speaker Bird (68″ h × 7′1″ l) JIM WILDEMAN

The largest birds in the band are titled *Fides Gravis* (9/3/97) on their bases. They are known by several other names: *Fiddle Birds, Banjo Birds,* and *Ukulele Birds.* At thirty-eight feet tall, they stand high above the other band members. These seven-string fiddles rise on gently curved necks to curious bird heads on stainless steel bodies that are counterbalanced at the base by steel balls. The scale and detail of these birds gives viewers a hint of what will come in Tom's monumental work, the *Dreamkeepers* (2001). "I thought I might have some ukuleles there," Tom explains. "Those great birds are special because they're made out of Hubbard tanks [that] were for burn patients. They would put the patients in and turn on the agitators."

Doug Britton came to the *Forevertron* to find peace in a hectic world—to smile.[1] Doug's father, Blaine, was a friend of Tom's for years and played an active part in the proposal to move Tom's work across the road to the decommissioned Badger Army Ammunition Plant.[2] Tom and Doug soon became friends, and one

day they were rummaging around in Jim Delaney's Surplus next door when they happened upon two hydrotherapy tanks. Doug thought that one of them would make a good hot tub for the back-yard of his Madison home. He bought it for $350 and asked Tom to store it for him until he was ready to install it.

Doug came back a while later and was greeted by Tom saying, "You're going to love this. I found a use for your tub. . . . This is really neat, you're going to love it." As Doug relates the story, Tom took him over to see the thirty-eight-foot bird, and there was his tub with the "guts torn out of it,"

Fiddle Birds (38′ h) JIM WILDEMAN

turned into a bird. In explanation, Tom said, "Don't worry, it's still your tub and your name is on it." That was the end of Doug's hot tub. Sometimes it takes patience to be Tom's friend. A sense of humor doesn't hurt either.

Tom's friend and trading partner Larry Waller showed up and saw the enor-mous *Fiddle Birds*. He told Tom that he knew where he could get another tank just like the ones used in the birds. Tom made a deal with him and has another tub in stock if he decides to make a third bird.[3]

The entire *Bird Band* is incorporated into the *Forevertron* myth. On the day that the Doctor is going to pass to the celestial spheres, the gathered masses will be entertained by a military band under the direction of Dan Woolpert. As the Doc-tor climbs the ladder up to the egg, the band will play "Nearer My God to Thee." Dan is the bandmaster of the First Brigade Band, which performs music from the Civil War era on authentic instruments in period costumes.[4] He is an active collector and preserver of vintage instruments, and he had heard that there was

somebody destroying musical instruments by incorporating them into junk sculpture up near Delaney's. He arrived at the sculpture site expecting the worst and ready for a heated exchange. When he examined the *Bird Band*, he found that Tom was destroying nothing, and he was delighted with what he saw. Soon after, Dan invited Tom to a First Brigade Band concert on the courthouse square in Baraboo. Tom sat transfixed. After the concert he approached Dan and told him that it had been a moving experience. Dan, recalling this incident, says that it seemed like it had been "almost like a religious experience for Tom."

Tom with Dan Woolpert in front of the *Director Bird* (10′6″ h) SILKE TUDOR

Tom at work ANN PARKER

When Tom tries to talk about it, he is lost for words. "I don't want to use normal adjectives because I'm looking at the people and the spirit of the integrity . . . and I can't tell you how I'm affected because not only Dan as the bandmaster and his spirit, but it goes all the way down to the people who were participating in the band and I just thought . . . when you see that total spirit it really is hard to express."

As usual, when words failed him, he turned to his craft and started working on the *Director Bird* with the help of a visiting relative, Ian Lister. "We built that bird and I put that flattop hat on there . . . and I put two batons on there, and, of course, he never uses two batons." Although Tom has dedicated pieces to his family and friends and put their names on the bases of the works, this is the only "portrait" he has done; the *Director Bird* (1998) and the *Bird Band* are now an important part of the *Forevertron* story.

But there is a darker side. Among the band birds, standing tall, are the *Mangascar Birds* [Tom's preferred spelling]. By the mid-1990s Eleanor had been with Tom through good times and bad times for over thirty years. But their marriage was at an end; Eleanor filed for divorce in 1997. Tom would tell it this way: "I actually built those [*Mangasgar Birds*] at a trauma-time of my life in which I lost my wife, Eleanor."

To work through this time in his life, Tom would call on his personal myth and his native ability. Tom reached into his past to get through his present difficulties and lose himself again in creative fantasy. The birds that he built now would join together parts of the near and distant past in a longing and heartfelt chorus. On the bases of these tall birds he inscribed the names of people in his past who had "some connection with the forces of goodness," and the word *Mangascar*, invoking his romantic notion of the pirate Henry Every, who had plied his trade around the island of Madagascar. He remembered people from his youth in Brooklyn—the barber who helped in the night raids at the dump, the high school principal he had not always gotten along with—and others, calling on their goodness to get him through.[5] Tom was pleased to find out from a visiting professor about elephant birds, the largest bird known to have existed. These birds, which stood fourteen feet tall, survived well into the Middle Ages on the island of Madagascar.

In the spring of 1996 Edgewood College in Madison held a major retrospective of Tom's work under the title "Dr. Evermor: Sculptures Made of History." The show was put together largely through the efforts of artist, educator, and curator Ann Parker. Ann had met Tom in the early 1990s while doing research on a book about self-taught artists in Wisconsin.[6] She began to visit the sculp-

ture park often and soon became Tom's trusted friend. She would later become head of the Evermor Foundation.

Tom moved three semi loads of his work and installed it in the DeRicci Gallery and on the grounds of the college. The exhibition featured not only Tom's work but also that of Troy, who helped Tom design several heads for birds made especially for the exhibit. Mural-size photographs of the *Forevertron* captioned with Dr. Evermor's own words filled the walls of the gallery, and visitors were invited to a special tour of the *Forevertron* with Tom and Ann present to answer questions. Tom narrated a slide lecture about his work and took part in a panel discussion. During the question period someone rose and asked, "Has anyone ever tried out the *Forevertron*?" There was a long pause while everyone wondered about the questioner and the answer that might come. Finally Tom said, "Well, nobody's ever had the guts to try it."[7]

The Edgewood College show stands as the only major exhibition of Tom's work to date outside of the sculpture park. There have been smaller events, including a 1996 exhibit in Kohler, Wisconsin, and at the Paine Art Center in Oshkosh where forty-seven of Doc's works (mostly birds) were on view in 2002. At this writing, no exhibition has matched the scope or quality of the Edgewood retrospective.

6

The Middle Works
From the Heart and Other Places

Tom's openness to people and to materials that become available to him can result in unexpected and unique works that flow from him spontaneously. In the summer of 1998 Timo Baerwalt pitched his tent at the park. The sketchy history of this sculpture student of Indonesian and Dutch background included experience as a merchant marine on the high seas. During his two-month stay he helped out around the site. Eventually Tom and Timo set to work on a piece that would symbolize his visit. They produced the *Gyromni* (8/17/98) by taking a ship's gyroscope, mounting it on a platform, and attaching legs and appendages to it. Tom says, "I did the welding on it. . . . It's got those little creatures that look like they're getting off of it."

It is related to the *Forevertron* set in the same way as the UFO (2004, in chapter 11) would later be. The story is that the news of Dr. Evermor's machine has reached outer space and the *Gyromni* is an alien spacecraft, complete with "little creatures" that have come to visit the Doctor.

In 1990 Tom produced the *Heart of Hearts* (9/4/90), a seventeen-foot-high piece made of one-and-one-quarter-inch-thick plate steel. In his words, it "symbolizes what happens when there are bruises on your heart." Tom further describes how he built it: "So I took and laid it down and I cut this regular normal-looking heart and I have the left ventricle with an opening. Then I stood it up and . . . I put those little stationary points on it so that you could put your hand on it and meditate. . . . I wrote 'Heart of Hearts' on it and I ran that big

85

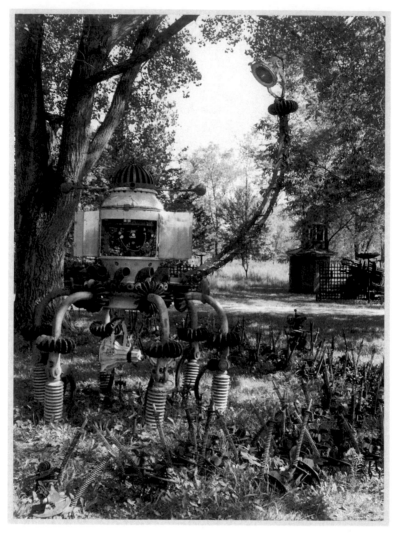

Gyromni (9′ h [14′ h to spotlight appendage] × 8′8″ w) EVERY COLLECTION

shaft which is through the right ventricle . . . which signifies that everybody's life takes a hell of a beating." The heart is fitted with a steam governor on top of the left ventricle.

The *Arachna Artie* (9/13/95) is nothing more than a fourteen-foot-high spider weighing seventeen thousand pounds, complete with male member. According to Tom, "I just had the component parts and felt like doing it. And so there wasn't any particular reason for doing it other than I had those unusual cast-iron pieces."

He used parts of large scales salvaged from grain companies around Wisconsin for the legs and a buoy that once floated in Guantanamo Bay for the back end.

One day a load of scrap stainless steel came in on a skid at the same time that his assistant Erika Koivunen had dropped off a piece of float copper (copper ore found on the surface of the earth). To hear him tell this story is to hear the melody of his work and to be brought into the act with sound effects and gestures: "I just saw this skid of stainless steel laying down there. . . . I just looked

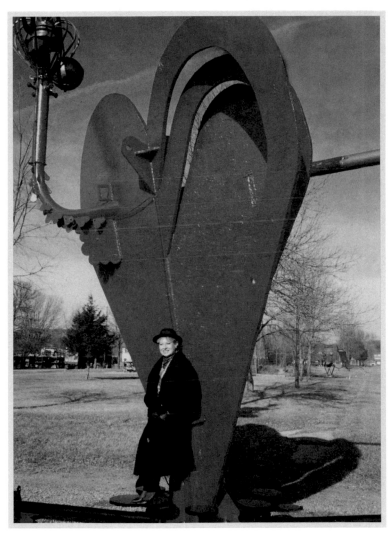

Heart of Hearts with Eleanor (17′ h) EVERY COLLECTION

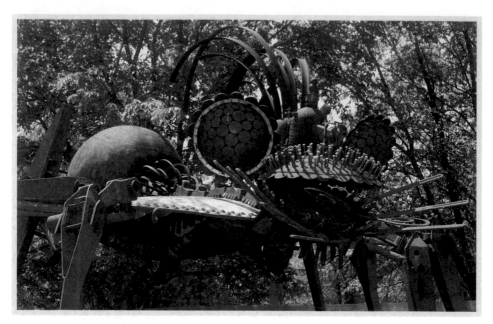

Arachna Artie (17' h × 23' w at base × c. 27'l) JIM WILDEMAN

at this stuff and I go [the sounds of Tom in his creative voice] ing, ing, oo, oo, pa, pa and I get an angel out of it in probably an hour and a half." Works like this just flow out of him; he doesn't think it's any big deal. He finished the piece by installing the float copper on top of the head. Tom calls this piece *Angel*; Erika refers to it as *Angel Brain* (9/20/99).[1] The arms end in round plates that Tom intends to hold brochures one day.

A 1912 compressor and the International truck (see page 90) that goes with it are pieces that Tom feels stand alone: "I feel that it's an art piece unto itself without doing anything to it whatsoever. It's got a Model A motor kind of Rube Goldberged on the side and I could just feel that somebody busted their arm trying to crank it over. And it's got a square-riveted gas tank on it and that dates it. It has an open four-cylinder arrangement on it. . . . You can see a lot of energy and activity in that piece and it's just about one hundred years old. . . . It was used for drilling rock in quarries. I did get it out of the Montecello [Wisconsin] quarry." These are pieces, like the smaller pieces, that Tom feels should never be touched. They will be displayed as they are. He says further: "I think that some pieces are art pieces without touching them. And if you think that you're going

to fix it all up and make it look beautiful, you take away from it rather than pre-serving." They are both parked under the cottonwoods near the *Forevertron*.

The "W," entitled *Forward* (5/5/89), is one of his few overtly political state-ments. About the time he made it, a number of farmers were losing their farms to foreclosure. They had been encouraged by the lending institutions, and sometimes by the government, to take out large loans to expand and modernize. The loans were granted based on what turned out to be an inflated estimate of future and

Angel Brain (59″ h x 42″ w) JIM WILDEMAN

Quarry truck JIM WILDEMAN

present land values as well as a generally overoptimistic prediction of future prof-its. Then it all fell apart and the newspapers filled with auction notices. The "W" is mounted on the business end of a manure spreader. Tom was still smarting from the state's insistence on collecting taxes and other offences. The "W" stands for Wisconsin, and the title *Forward* is the state motto. Tom says, "The 'W' was in the time frame when the farmers were getting crapped on, so what I did was I did that 'W' and I stuck a manure spreader on there when the government was pulling off that crap."[2]

In the early 1990s Tom created another political piece. He watched on tel-evision as "smart bombs" crashed through smokestacks and ventilation shafts and blew up buildings in Iraq. *Overkill* (undated) is made from a surplus bomb casing poised above a chimney where it is about to rid the world of "a couple of bugs" below.

There are more than a dozen whimsical *Weather Wizards* in the park. The one illustrated here is titled *Boson* and is dated 9/20/85. Tom says about them, "I just got those beautiful rings and stuff from a salvage job and just started building them and I couldn't believe that they started to sell."

Viewers can climb the stairs of the *Eagle's Head* (undated) and get, in Tom's words, "a bird's-eye view." He goes on to say, "It's a piece that really brings home the message that everything is in the way that you look at it." He attended a government surplus auction in 1994 and an "orange-peel digging device" came up for bid. Tom points out that it's all riveted rather than welded, which dates it to sometime before 1920; today similar units are used for digging up trees and moving them. This one was probably used to dig holes for marine pilings. Tom just looked at the piece and saw this *Eagle Head* in it. He says, "I just saw it as that head and added all those things to it." The eyes are made from misstamped surveyors' benchmarks.

In the early 1990s the Kohler Company expressed an interest in working with Tom and Eleanor to site and preserve the *Forevertron* and satellite pieces. The Kohlers have long been patrons of the arts, especially in Wisconsin. Tom and his circle referred to the negotiations that followed as the Kohler proposal. The plan was to relocate the sculpture park on a former landfill in Kohler, Wisconsin; the company offered to move Tom's work to the site, construct the park along the banks of the Sheboygan River, and manage and promote the park. They intended to operate the sculpture park for profit within the Kohler Company, with Tom acting as the creative director and independent contractor with his own employees. Kohler would hold worldwide rights to the artwork in the park, and Tom would be able to finish works in progress, construct his new large work, the *Air Fantasy*, and create other new works for the park with Kohler support.

Forward (6'4" h × 6'6" w) JIM WILDEMAN

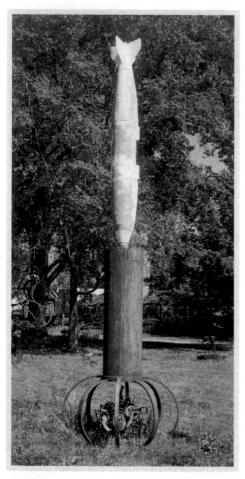

Overkill (18' h × 5' w at base) JIM WILDEMAN

The proposal included provisions for payment for sculpture already completed and salary and royalty agreements. The company wanted the right of first refusal for future work and limited Tom's ability to sell work within a strictly outlined portion of Wisconsin and surrounding states.[3]

The team at Kohler spent many hours planning for the park and negotiating with Tom. A site plan was developed, and drafts of the legal documents were sent to Tom for his consideration. So it went back and forth—Kohler visiting Tom and asking him to sign the papers—Tom talking about his grand schemes when they visited him or on the telephone and in many handwritten letters. He even lent the *Epicurean* to the Kohler Company for a period of time.

Meanwhile, Tom worked on a new design for a piece that would be bigger than the *Forevertron*. When he was working with Alex Jordan in the 1970s, he had presented Jordan with the *Air Fantasy* idea. But the details of the design he worked on now were totally different from the one he had presented to Jordan—only the idea remained the same. When Tom first mentioned the project to him, Jordan asked, "What the hell's an *Air Fantasy*?" Tom recalls answering him with a little rib-jabbing humor, "Well, Alex, it's for somebody who has everything; so he can take it with him when he dies." Jordan was not amused enough to want him to build it. Now, at Kohler, Tom had found an opportunity to bring his *Air Fantasy* (drawing dated 12/7/91) into being. It would measure five hundred feet long and more than two hundred feet high. Tom also intended to incorporate a five-

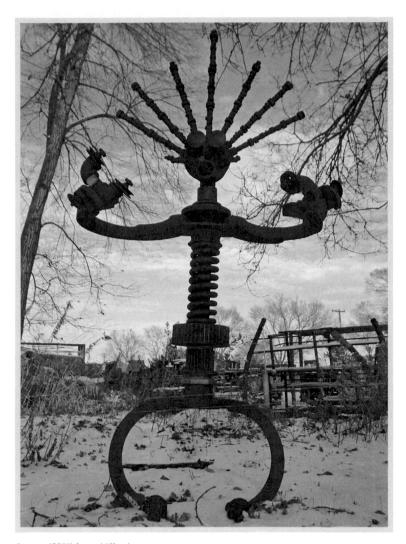

Boson (8'8" h × 46" w) JIM WILDEMAN

hundred-foot-long bridge that was being dismantled in New London, Wisconsin, into the main structure. The bridge would be reassembled on the site. He says, "I would raise it up [thirty to thirty-five feet] and put it on a concrete foundation and then I would put a little torque in it [see the aerial view on page 96] so it's got more energy in it." The *Air Fantasy* would be carried on four wheels that would be nine feet across and fifty feet high, which Tom intended to fabricate himself. At the stern he would incorporate generators, motors, compressors, and

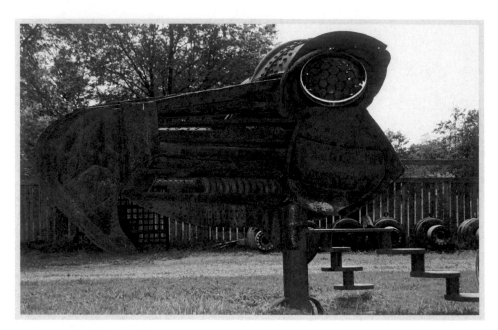

Eagle's Head (9'6" h × 14'3" l) JIM WILDEMAN

steam engines from his collection, and at the bow he intended to install a small submarine (he knew of one available in Alabama) so that "it covers all points—land, sea, and air." Tom was excited about these plans and showed the drawing to his friend, artist Dean Meeker. "And here," explained Tom as he pointed to a spot on the drawing, "I'm going to put a submarine, not a whole submarine, but just half."

Dean looked at the spot on the paper and said, "Oh, for Christ's sake, Tom, get a grip."[4]

There would be a giant steam-powered crane to load the passengers' baggage, and the illustration shows a boiler. Tom explains, "It's called a stiff-arm and it's from around the turn of the [twentieth] century. The boom is eighty-five feet long and it swings—you see them in shipyards." This fantasy creation would look like an unlikely nineteenth-century flying machine on wheels. Like the *Forevertron*, it was meant to carry him and his guests into the beyond and welcome all into his fantasy. It was intended that visitors could walk up onto the *Air Fantasy* and explore it by way of a series of ramps.

Tom also proposed that the park at Kohler would include the *Sultan of Salvage*, which is a maze designed for everyone but especially artists. The artists could wander the maze and pick out materials they could use from the surplus that Dr. Evermor has. Tom claims that he has enough of the four-foot-by-four-foot boxes of material to be stacked one mile high (see page 69). He explains: "Just figure a maze, I don't know the shape. Say it's a beehive—I've got one designed as a beehive. You get in there and you're hypnotized. . . . The beauty is in what's in all these boxes and people can come and look and see what's in all these boxes and also within the maze. At the end if they wanted they could buy component parts. And the only way that a part leaves Evermor is that you weigh it . . . you weigh everything. You see, the value system at Evermor is not dollars and cents or anything like that. But everything is based on the pound."

None of these plans at Kohler ever came to pass; the reasons for the failure of the proposal are not completely clear. On Tom's side, some of his associates

Tom's *Air Fantasy* drawing

Tom's *Air Fantasy* aerial view drawing

objected, saying that the agreement meant he was giving up the rights to his intellectual property and his freedom, and there were also rumblings about the money. Tom never felt the need to consult an attorney or make written counteroffers, and the people at Kohler were sometimes befuddled by Tom's arcane letters and personal style at meetings. It all drifted on and on. Gradually the contacts became fewer and the proposal faded away.

The problem may have been more about style than substance. Tom is fond of saying "Oh, I'm just an old scrap man from Brooklyn." Those who know him and his work often sniff at this, knowing that he's far shrewder and more complex than he sometimes lets on. But by saying this he is telling us something about how he makes deals and connects with people. The old scrap men carried a lot of cash in their pockets, and they (he) could look at a pile of metal or other salvage fifty feet away and know its weight and what it was worth to the penny at the mornings' price in Chicago.[5] Deals and trades were made by a handshake,

and some "cabbage" was exchanged. There was no paper trail; you did your deal and loaded up. Most of these fellows are long gone now. Things are more formal these days, even for Tom. And many of these scrap men were tidied up after by their accountants—usually their wives. Tom would prefer to live his whole life without signatures or documents—just a handshake and a deal. Even if it seems to be in his self-interest, he finds it nearly impossible to deal with lawyers or that host of people he calls "bureaucrats."

The Kohler Company naturally needed more than a wink and a nod. The problem seems not to have been the Kohler proposal or Tom's response (or lack of response). They were coming from viewpoints that are worlds apart, a gap they were unable to bridge. Tom also felt no urgency about moving his work; he was comfortable and in control and in the strength of his years. He never gave a thought to getting old or disabled, or to how long he could depend on the hospitality of Delaney's Surplus.[6]

In the year 2000 the John Michael Kohler Arts Center and the Kohler Foundation put together a major conference dealing with self-taught artists entitled "Negotiating Boundaries." Kohler asked Tom to make the *Forevertron* available for tours by guests attending the conference and he agreed. But it was Tom, so there would be a twist.

One day he showed up unannounced at the John Michael Kohler Arts Center in the Fancy and unloaded two of his birds. Tom's view of the way it went is: "I walked in there and I said, 'I got these birds for you.' And it shocked the hell out of them and they started scurrying around. They're all in a panic because that's management and everything's got to go just so.

Tom at work EVERY COLLECTION

I just set them up along the wall there. They said we need to sign some insurance papers and all this shit and I said, 'No you don't. We don't worry about any of that kind of crap.' That's all I said to them." Later Tom would say that his gesture was in support of all that Ruth Kohler was doing for the arts. The museum eventually ended up purchasing the works.

There have been several serious proposals offered for moving the Forevertron since the Kohler proposal, but all of them have come to nothing.

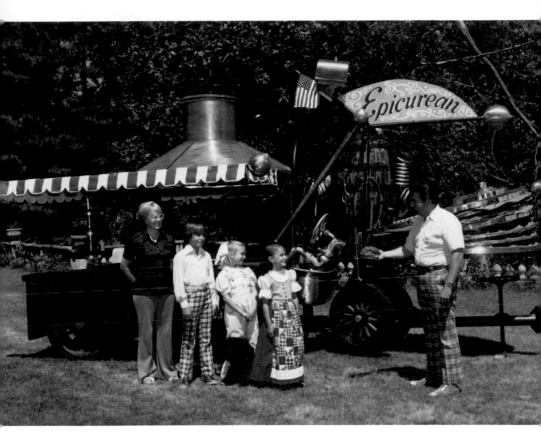

The *Epicurean* with the Every family EVERY COLLECTION

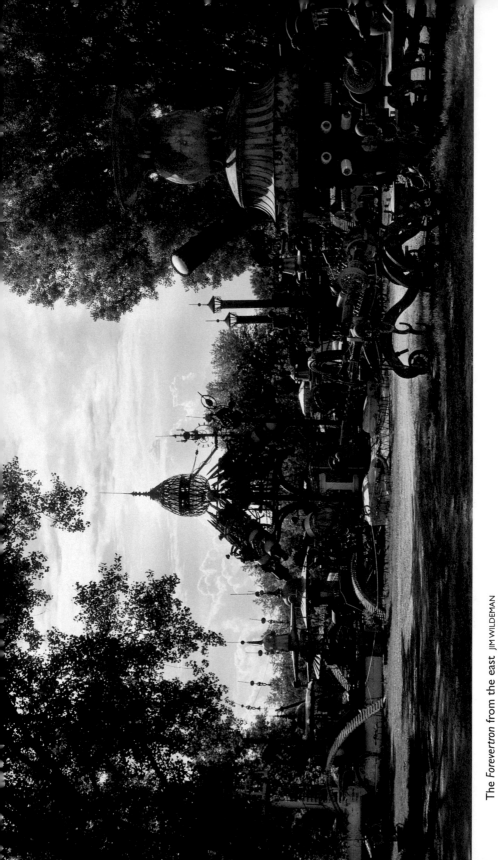

The *Forevertron* from the east JIM WILDEMAN

The *Forevertron* aerial view from the east JIM WILDEMAN

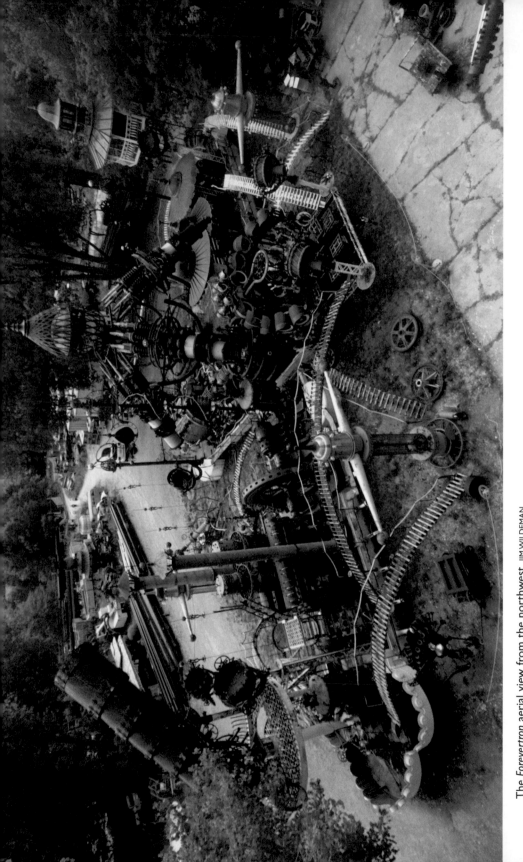

The *Forevertron* aerial view from the northwest JIM WILDEMAN

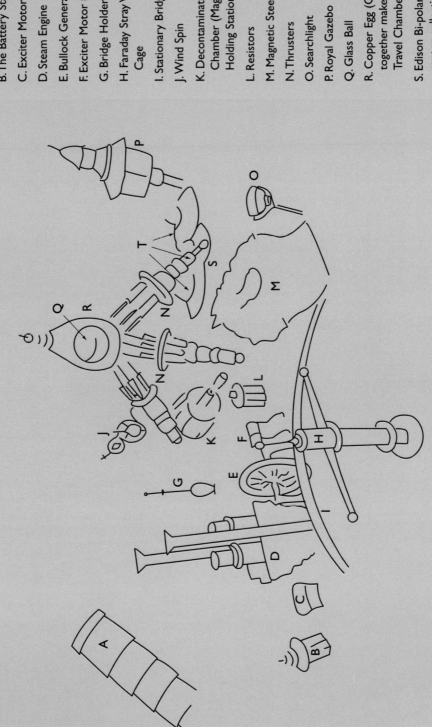

A. Tyco's Telescope

B. The Battery Stack

C. Exciter Motor #1

D. Steam Engine

E. Bullock Generator

F. Exciter Motor #2

G. Bridge Holders

H. Faraday Stray Voltage Cage

I. Stationary Bridge

J. Wind Spin

K. Decontamination Chamber (Magnetic Holding Station)

L. Resistors

M. Magnetic Steering Gyro

N. Thrusters

O. Searchlight

P. Royal Gazebo

Q. Glass Ball

R. Copper Egg (Q and R together make up the Travel Chamber)

S. Edison Bi-polars and motor collection

T. Copper roofs protecting "S"

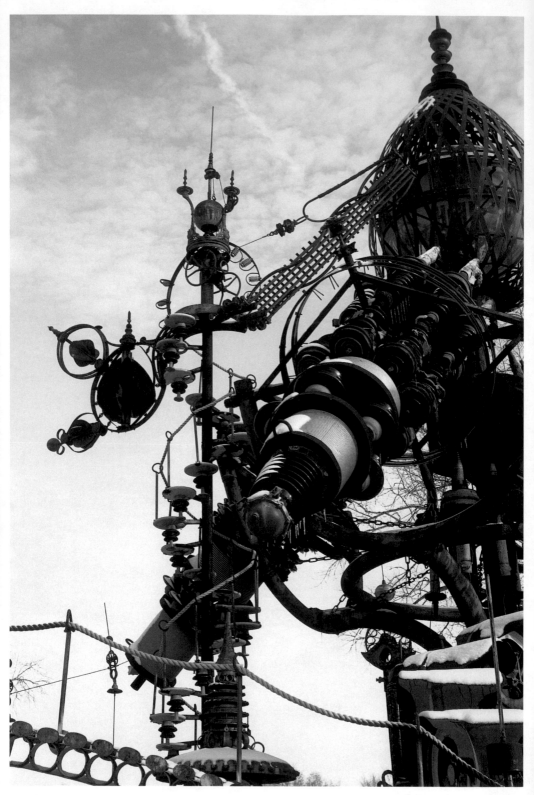

Wind Spin and bridge JIM WILDEMAN

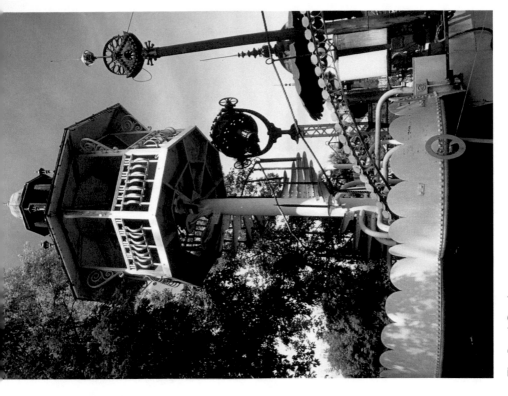

The Royal Gazebo BOBBI LANE

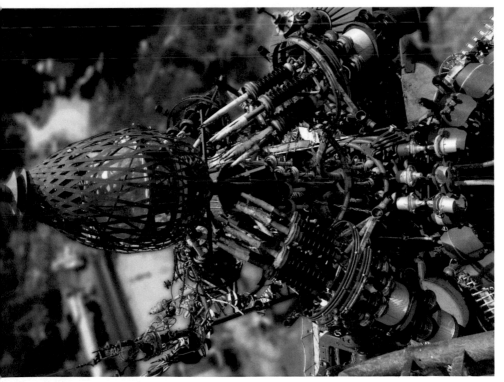

The Travel Chamber and thrusters JIM WILDEMAN

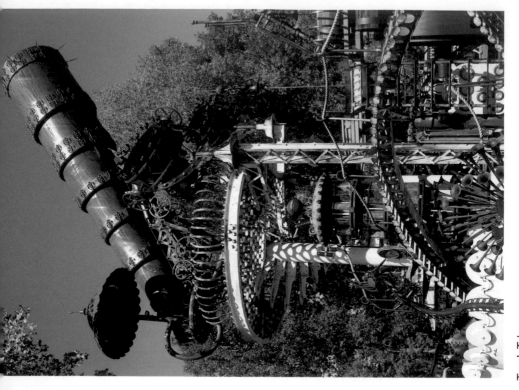

Tyco's Telescope JIM WILDEMAN

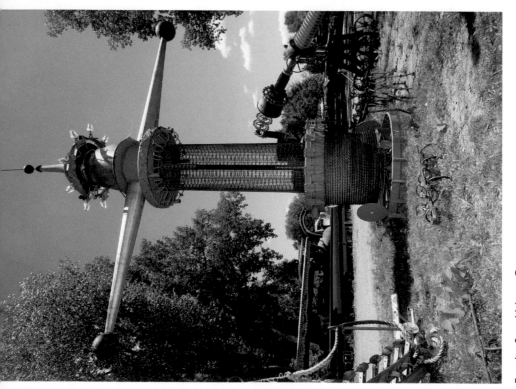

Faraday Stray Voltage Cage JIM WILDEMAN

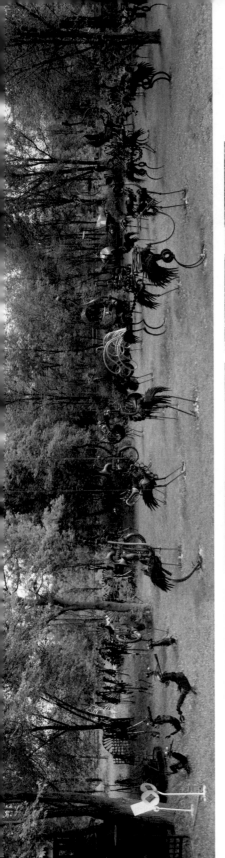

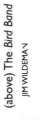

(above) The *Bird Band*
JIM WILDEMAN

(from left to right)
High Poker JIM WILDEMAN

Fiddle Birds JIM WILDEMAN

Volucris-Rubar
JIM WILDEMAN

The *Tracker* JIM WILDEMAN

Nenime Namod birds at the entrance to Goose Pond JIM WILDEMAN

Arachna Artie Jim Wildeman

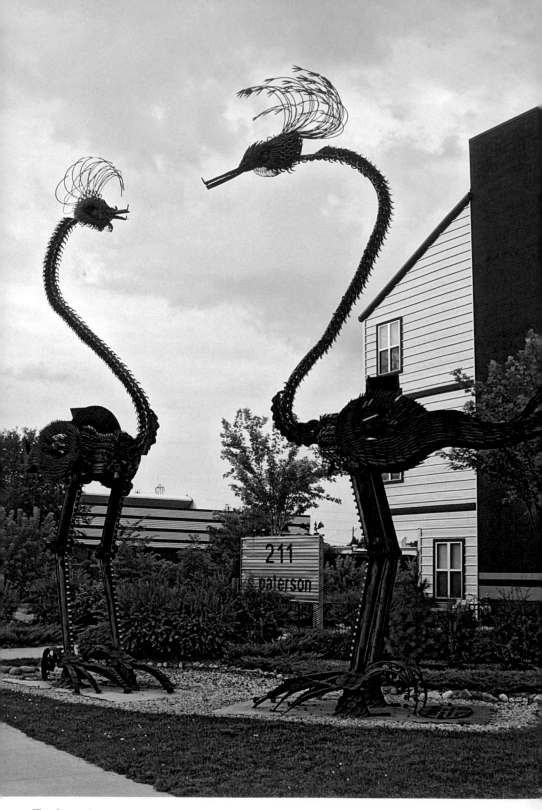

The *Dreamkeepers* in place JIM WILDEMAN

Tom and Eleanor in happy times DORIS LITSCHER GASSER

Eleanor painting at the *Joel la Troll* JIM WILDEMAN

Happy Hatter JIM WILDEMAN

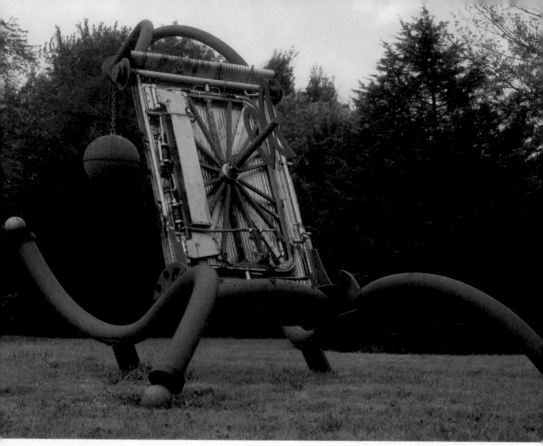

(top) *Moonmaiden* JIM WILDEMAN
(bottom, left) *Semi Still Underhummer* JIM WILDEMAN
(bottom, right) *Mars Answerer* JIM WILDEMAN

Komodo Dragons JIM WILDEMAN

UFO TOM KUPSH

7

The *Mirror Eye*
The Trickster's Scheme

In the early days of World War II, the War Department realized that in order to defeat Germany and Japan an unprecedented volume of materials and munitions would be needed. They searched for a site for the production of propellant as distant from either coast as possible, fearing invasion from east and west. In 1942 the government acquired the rights to ten thousand acres of prime farmland on the Sauk Prairie in southern Wisconsin, just south of the Baraboo Hills. Dozens of farm families were moved off the land, and by 1943 a seventy-three-hundred-acre munitions facility began to stretch out across the prairie. Over the next thirty-three years, the plant produced propellant for cannon, rocket, and small arms ammunition for American wars, from World War II through Vietnam. During this time the plant employed tens of thousands of people, who worked under the most dangerous of conditions. Production stopped in 1975 and the plant was placed on standby status until the mid-1990s, when it became clear that the army intended to close the plant, and discussions and arguments began about the reuse of the facility. The plant was finally closed in 1998 and became the responsibility of the General Services Administration of the federal government.[1]

The reuse of the land and the facility became a contentious issue locally and regionally. The families who had lost their land sixty years before wanted to be heard, Native Americans claimed it as their ancestral land, manufacturing interests wanted it to remain an industrial site. A growing awareness of the serious soil and water pollution in and around the site caused environmentalists to come forward with their concerns.

In the midst of this sometimes hostile debate, a group of citizens came together in 1997 and formed the Sauk Prairie Conservation Alliance under the chairmanship of Curt Meine.[2] Curt says, "Our approach was to enter the discussion and reduce the social tension around it because it was a very divisive issue. So our goal was to enter into this in a way that would bring people together."

Dr. Evermor was soon in the thick of it with his dreams, his vision, and his way of doing business. He had formed the Evermor Foundation in 1996 to help with the management of the sculpture park and to ensure that his work would be preserved and kept together for the future. He also wanted help in submitting his own proposal for the reuse of the Badger facility. A few members of the foundation would, in the late 1990s, dedicate considerable time and effort to Tom's Badger proposal and the furthering of Tom's work in general.[3]

Blaine Britton, a retired photojournalist, visited the park often in the 1990s. He and Tom spent hours talking about their interests and scheming about the future. When discussions started about the reuse of the Badger Army Ammunition Plant, Blaine dedicated a great deal of time on behalf of the Evermor Foundation, putting forward the proposal to the General Services Administration and to anyone in the government who would listen. He explained and promoted Doc's work and the proposal through many letters and conversations with officials. He offered in the proposal "a living war memorial for the workers of the Badger Ammunition Plant and, through them, for millions of American war production workers."[4]

The foundation proposed that the site would combine a sculpture park, a memorial to munitions workers, and an education and welcome center. The new park was also envisioned as an environment for sculptors to come and work using materials at hand for their own creations. The original proposal also called for "the most beautiful farm in America," consisting of one thousand acres that would "embody the latest conservation and farming techniques." The idea also included a sustainable hardwood forest.[5]

The plan for the centerpiece of the proposal, the Mirror Eye, took shape over the next four years. It began when artist Jake Furnald first saw the sculpture park in the mid-1990s while he was a sculpture student at Beloit College. On a summer day in 1997 while he was visiting the park, he spotted among all of the sal-

vage an old VW van. He had an interest in old VWs and asked Doc if he might want to trade it for some drawing.

Dr. Evermor just eyed him up and down, sizing him up, and said, "Hop in the truck. I want to show you something." He took Jake over to the Badger Ammunition Plant and for the next seven hours showed him the facility. Tom had hoped to acquire the massive compressors from the facility and incorporate them in a new site plan. He talked about his dream to move the *Forevertron* over to Badger. Jake recalls, "That day spawned the idea for the drawing; he wanted a drawing done of his idea."[6]

From then on, Jake became a frequent visitor and part of the Evermor circle. Tom soon told him that the VW was staying where it was, but Jake was now more interested in Doc and the park than in the van. He visited when he could get free time from his artwork and his day job repairing cameras, and over the next year and a half they talked about ideas for the drawing. Jake returned to the compressor building at Badger and did a few sketches and, in time, a general

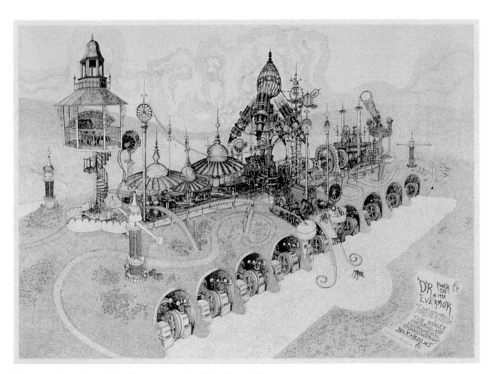

Fantasy drawing of the *Forevertron* by Jake Furnald

sketch of the idea. Doc approved of the way it was going and asked him to do a larger drawing. In 1999 Jake set about working. He spent six weeks producing the best work he could. The drawing shows the Forevertron atop a shaped berm with the eighteen Badger compressors clearly visible. For clarity's sake it did not include the satellite pieces that would be radiating out from the Forevertron.

Jake approached this work with dedication and watched as his skills grew. He says, "It helped me jump a level in what I was doing in my own drawings." The pattern and textures of the drawing mirror the sensual surfaces of Dr. Evermor's work. A detail barely visible in most reproductions is a godlike figure in the clouds to the left of the travel chamber. Doc says about this, "It's like another power looking down because the whole thought about the Mirror Eye is that it's looking out and there are forces looking down too. So it's a double way: the eye is looking up with all these industrial things, and whoever is looking down from the heavens trying to figure out and see what the hell all that stuff is."

When Jake was finished, Doc was pleased and paid him the agreed-upon fee. Jake sort of hemmed and hawed around and said that he had put more time into the project than he had planned and it seemed that it was worth more. Dr. Evermor didn't disagree but said that artists need to learn how it works when they are young. The life lesson from Dr. Evermor went like this according to Jake: "Well, Jake, you've got to learn a lesson about life as an artist. Your price at first—you got to have the right price because people aren't going to give you more in the end. In the beginning you say you're going to do it, and that's what you've got."

Later he asked Jake to make a model of the Mirror Eye for presentation to the decision makers. Instead of starting with a foam core and balsa wood, Doc wanted it made out of metal, just like his sculptures. He wanted an aerial view, a model of the site with the compressor building and all the landscape. Jake says, "I just laid in all the scissors blades and other stuff and welded it in. I thought I had to make it look more geometric."

Dr. Evermor planned that the Forevertron would rise to a height of eighty-five feet above the old compressor building. He would blend the two together into one gigantic work. The heartbeat of the old ammunition plant would become a site of welcome. The negative spirit of the site's past would be buried under berms of its own rubble to form an earthwork of monumental proportions. Tom

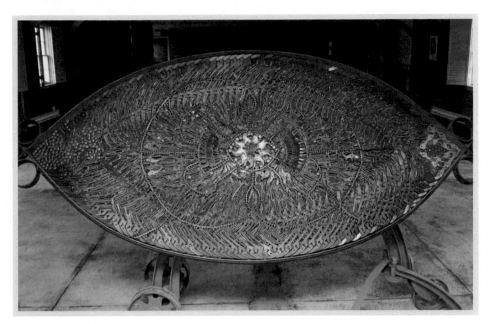

Mirror Eye model by Jake Furnald (4′ w × 9′4″l) <small>JIM WILDEMAN</small>

is to this day a member of the Ancient Earthworks Society, a group dedicated to the understanding and preservation of ancient mounds and other earthworks throughout the world. He named his idea the *Mirror Eye*. Jake Furnald's drawing shows the *Mirror Eye* in aerial view peering out at the universe; they hoped that it would be visible from space. Dr. Evermor explains further: "The *Mirror Eye* would be about thirty-five hundred feet long and I would use all the rubble from [the demolition of] Badger Ordnance in the berms to make the outside of the eye. The building would no longer be there. We would take the building out of there and the *Forevertron* would be the only thing that would be in the eyeball. It has to do with leaving something here in this world that would be of significance. Here was an example of using all the negative things and turning them into the positive."

The *Forevertron* itself was to be placed in the very center of the "pupil" and surrounded by a huge reflection pool. The *Overlord Master Control Tower* and the *Gravitron* as well as the other satellite pieces would radiate out from the center of the eye. Here Tom also planned to install the *Sultan of Salvage*, first proposed for the Kohler park in the early 1990s as a resource for sculptors creating works on the

site. He planned to plant the berms with prairie grass, with paths leading visitors in and around the sculptures that would be, in Tom's view, "like the blood vessels in the eye and the people would be like the blood flowing." This is a notion that he first used at the House on the Rock in the Organ Building, where he had proposed a series of bridges and pathways not unlike the Badger plan. He says, "I wanted the animation being the people flowing through."

Psychiatrist Gary J. Maier points out in an article about Tom's work that Freud held that "physical eyes give 'out-sight,' the ability to perceive the external world clearly. The mind's eye gives 'insight,' the ability to perceive the internal world clearly." The *Mirror Eye* has a brilliant dual function: it challenges us to look out at and welcome in the cosmos and invites us to look in at the world through the art of Dr. Evermor and the other artists who would have been represented there.[7]

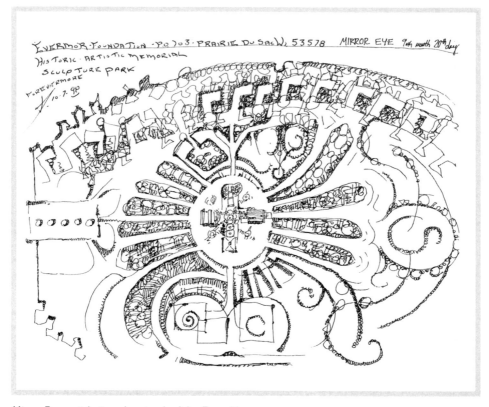

Mirror Eye aerial view drawing by Jake Furnald

Badger Bugs on the march near the *Forevertron* (each about 29″ l) JIM WILDEMAN

While all these plans were moving forward, Doc stayed busy with other things. A dozen or so of the key players in the decision-making process for the reuse of Badger woke up in the night to voices on their lawns. Tom and his helpers "spooked" *Badger Bugs* onto their lawns under cover of night. A "spook" is, according to Tom, a job done under cover of night, sometimes for business reasons and sometimes just for fun; it harkens back to Tom's youthful days climbing the cemetery fence to get into the Stoughton dump. Doc even had a scheme to close traffic on Highway 12 and install the *Badger Bugs* in a long procession, starting at the sculpture site and leading over to the ammunition plant as if marching in to take it over—an idea that it seems was best left to the imagination. Curt Meine thinks that this kind of event "exemplifies the role of the arts in greasing the wheels in the social discussion by taking it out of the realm of pure politics and making it part of the community discussion in a creative way."

Doc was a wild card in all of these dealings, and Curt feels that he played a role traditional in Native American culture in all this: "He has been the trickster, and that's not a light role to play. Every community needs a trickster and that's true for all human history. Around Badger there is a community of people who

want to discuss the future but they are often antagonistic toward each other. In getting past this you need people in different roles and Doc just naturally fit into the role of the trickster—someone from the margins of the political discussion."

In 1998 Tom built the *Badger Clean-up Bug*, which was later renamed the *Juicer Bug*. Tom heard that there was a great deal of pollution at the old plant and he planned to install this fifty-five-foot-long, sixty-thousand-pound bug at the entrance to Badger as an symbol of the cleanup (see page 61 and accompanying text for description).

His role as both trickster and creator of symbols is perhaps best illustrated by what appeared at the north gate of the plant on April Fools' Day 2000. During the night, much to the surprise of everyone, seven large metal birds landed there. They were named the *Nenime Namod* birds (that's Eminent Domain backward in Tomspell). The seven birds lined up just outside the gates. Those who stopped to look at them found that each bird had foreign words on its base.

While attending a meeting of the Ancient Earthworks Society, Tom noticed a man dressed in traditional Indian garb who kept looking at him. When the meeting broke up he went over and introduced himself. Standing Elk greeted him and said he had something for Tom. He produced a package wrapped up in rubber bands. He said, "This will give you the answers for everything. Just open it any time and you'll get the answers to everything." According to his story, Standing Elk had received the package from a tribal shaman. Tom took it home and put it away.

Sometime later when he was working on the *Nenime Namod* birds he got stuck trying to come up with names. He opened the package and found lists of Indian words followed by English translations. He used these words to name the birds:

"Matomani"—opens gates that are closed
"Shangii"—opens doorways of the grandfathers
"Wanyeca"—assists sacred paths
"Istato"—sets eyes on the creator
"Zizi"—golden road of health
"Oyate"—creative energy of manifesting
"Mnesunha"—the one who heals emotional body and heart[8]

It is significant that there are seven birds. Doc feels that the number seven has mystical qualities and signifies power and perfection.

Everyone was entertained by these birds—more or less. It was still government property. The civilian base commander, Dave Fordham, contacted Doc and told him he couldn't leave them there. He ended up offering Tom a short-term lease so that the birds could stay temporarily.

When the lease ran out, Tom searched for a place for them. They ended up at Goose Pond Sanctuary near Arlington, Wisconsin, where the Madison Audubon Society has them on loan. They form a migrating row overlooking and guarding the pond. Tom calls them "The Guardian Angels of Goose Pond." He adds, "We put them over in a natural prairie site where they're all walking straight up and overlooking things. I had the feeling they were migrating and I couldn't have them migrate over to the sculpture site—it's just a little ways from Badger Ordnance."

Tom and the foundation members continued to work on the Badger proposal. In March 2001 a day was set aside by the Badger Reuse Committee for the presentation of proposals from all interested parties. Doc and crew moved Jake's metal

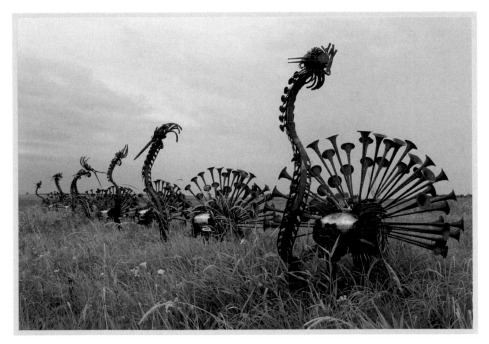

Nenime Namod birds at the entrance to Goose Pond (about 11′ h, sizes vary) JIM WILDEMAN

model of the Mirror Eye across the road to Badger for the presentation. They set it up in the exhibit area and flanked it with two guardian birds.

The Reuse Committee evaluated twenty-five proposals falling into three clear groups. About a third of them received high scores based on the criteria laid down by the committee, one-third were ranked very low, and one-third were evaluated as in a neutral category. The Evermor Foundation proposal fell into this last group. The committee was very interested in listening to Doc's proposal and gave it serious consideration. In the end, specific ideas within the proposal interested them, but the committee wanted an approach that addressed the whole vision of reimagining the Badger Plant. They still thought that Doc could play some role in the whole picture, but they did not feel that it was quite the role the foundation had proposed.

The final disposition of the Badger Ammunition Plant is still not completely resolved, but cleanup continues on the site. The government sold the eighteen compressors from the Badger Plant that were important to Doc's vision of the Mirror Eye. The Evermor Foundation members eventually moved on to other pursuits, and the Badger proposal faded away. Tom's evaluation of these events is summed up in what he told poet Petra Backonja, "The trouble there [at Badger] was there was no poetry."[9]

The Badger Clean-up Bug (the Juicer Bug), the Badger Bugs, the Nenime Namod birds, and the drawings and model of the Mirror Eye remain as evidence of the grand vision that Doc had for the relocation of his work to the Badger Ammunition Plant. Less easy to measure is the effect his role as the trickster had on the process.

8

The *Dreamkeepers*
Dream and Fantasy Meet Reality

When Erika Koivunen walked through Delaney's side lot and into the sculpture park, she thought she had passed into another dimension. She was twenty-two years old, a University of Wisconsin art student in torn jeans, hobbled by a sprained ankle, and now mystified. She limped around that park and looked at everything. She recalls, "I was pretty darn sure that I wasn't going to leave without connecting somehow because this is what I wanted to do. I tooled around and looked the Bird Band and everything and then he [Dr. Evermor] came out in his black hat and his leather coat down to his feet with the scarab buttons on it and the cigar in his mouth. And, grrrr, he was doing that eyeball thing and staring at me." Tom's appearance often puts people off at first. And that "eyeball thing" is him getting the "cut of your jib."[1]

Back in the car with her friend Laura, the wheels began to spin. Two important things to know about Erika are that she loves junk (nobody she knows throws anything away without checking with her first), and she loves welding. She says, "We're driving back and I'm not conscious of what I'm about to embark on. I would like to go back (like so many people do who go there). I started that summer [1996] and every Saturday I would jump in my car and drive and just be there and drive home and wake up Sunday and drive there and be there."

She hung around looking at the sculpture and the piles and bins of scrap wishing and waiting for a chance to weld. She would approach Doc and mention that she could weld, feeling all the while like a child tugging on his sleeve

and begging. One day she found some blades in one of the bins and put them together in the shape of a butterfly. Dr. Evermor was holding court with some of his friends but it didn't stop her. She took the blades and went up to him and said, "Can I weld up these blades? See, it's a butterfly." She had a blade in each hand and she put them together and showed him. He looked at her, she remembers, "like I was overstepping my bounds, and all along I was just trying to be helpful and not get in the way. So he looks over at these folks in the circle and makes an announcement, 'Little Erika here wants to weld up some of these blades into butterflies, and she's going to weld a thousand butterflies.' I said three, I just want to weld three!" He wasn't listening; he just went on talking.

She welded the three and together they welded the thousand, and the butterflies became the *Bonsai Butterfly Tree*. Erika named herself the Butterfly Jester. Over the next seven years she worked with him on large and small projects and they moved in and out of each other's lives. She came to understand his way of working perhaps more clearly than anyone. He says that she has "the true passion of the spirit to build."[2] Dr. Evermor would become her mentor and friend and she would consider herself his apprentice.

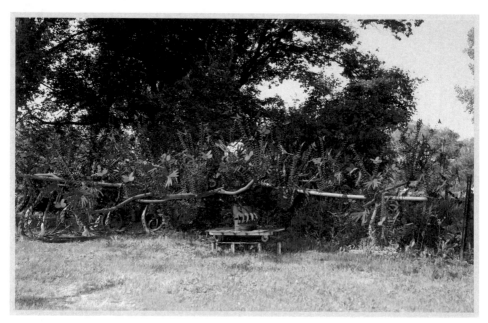

Bonsai Butterfly Tree, seen here at the sculpture park (6′6″ h × 26′ dia.) JIM WILDEMAN

To get started on the thousand butterflies project, Tom invited her down to Cooksville, Wisconsin, to the shop owned by his son Thayer. The small community of Cooksville was formed along the Bad Fish Creek where a sawmill was built around 1840. The railroad bypassed the village in the 1860s and it became "the town that time forgot."[3] Older homes and carriage houses are scattered among newer buildings on the tree-lined streets of the village, and the Cooksville General Store is a charming frame building right out of the past. The shelves are lined with a little bit of this and that, and old signs and calendars fill the walls. The locals (and Tom when he's there) sit at a table by the stove in the back and pass the time. Next door is the Cooksville Blacksmith Shop, which Thayer Every purchased in 1999. The original blacksmith shop had been torn down in the 1970s. Tom had supplied timbers and other materials for the new structure from his salvage work at the Pet Milk plant in New Glarus. The lot out front is filled with Thayer's equipment and salvage, and here and there the head of a bird or other creation pokes up among the stuff. Upstairs is a small apartment where Tom used to crash. In summer it is a shady, quiet, peaceful place.

In the Cooksville shop Tom and Erika worked on the *Bonsai Butterfly Tree* for three months. There are eighteen different "species" of butterfly on the tree. Erika says, "He or I would take them and weld them onto the springs and these springs would be welded onto plates and each plate would hold twenty-five butterflies and the plates would be bolted onto arms." The finished tree was put on display at Olbrich Botanical Gardens in Madison during the following summer. It became her senior project for graduation from the University of Wisconsin.

Erika wanted to go to Paris and the south of France, but she didn't have enough money. Doc agreed to have her make some small birds, called *Firebirds,*

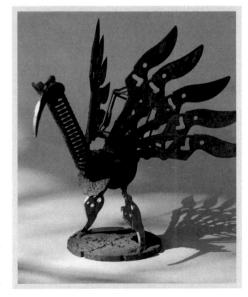

Firebird (10″ h) JIM WILDEMAN

for him. Like Tom, she can be a savage worker, and in five weeks she completed five hundred of them. She got the money and was off to Paris.

They continued to work together on a series of smaller projects including *Sea Horses*, *Wish Fish*, and a number of *Swordfish*. The *Swordfish* are especially memorable for Erika. She says, "It takes two people to get that *Swordfish* together. Because of the bend that you want in the blade, one person welds down on one end and the other has to push down the other end and hold it down while the other person welds it. So we were making these *Swordfish* and Doc is an intense guy and he just would work the crap out of you. . . . And I get kind of testy. You know, you get pushed to

Swordfish (6'2" h × 3'1" w) JIM WILDEMAN

a particular place. And I was getting mad and arguing with him and fighting. So we made the *Swordfish* fighting." Things did not always go smooth and easy at the park, but later they were able to laugh about their conflicts. "The *Swordfish* is made from blades crossed as if they're fighting each other,"[4] Erika says, "reminiscent of our time together."

They would laugh less about the monumental project they worked on together at the turn of the century. Don Warren, the owner of Warren Heating and Air Conditioning in Madison, had admired the works of Dr. Evermor for some time. Now he wanted to commission something on a large scale. He showed Tom two huge blowers he had recently salvaged and suggested that they could be turned into birds. He also wanted Tom to incorporate some tools that had been in his family for years. In January 2001 Tom produced a sketch of the birds showing them in side view, showing their shape and scale, and explaining some of the components he intended to use. Soon Don's blowers and the family tools to

Tom's drawing of the *Dreamkeepers*

be incorporated were delivered to Cooksville, the five-thousand-dollar deposit was in hand, and work could start on the birds.[5]

Tom plunged himself into the work and expected everyone else around him to do the same. Al Chavez, a welder who had worked for Tom's friend Dean Meeker, Thayer, Erika, and a student from Beliot College, Jim Liola, worked with Tom on the birds. Erika says, "When he gets working, taking a bathroom break is a privilege—when you get fifty blades welded up, you can go to the bathroom. We always built in places to gets to so you can have your reward—eating. I could have gotten up and walked away at any time." But she didn't. The pressure was con-

stant, and she was in tears more than once, thinking that she couldn't continue. She says, "I don't think that I'm worse for it. And through everything, it's been worth it." They worked like madmen. She began to realize how much she was learning; nowhere else she could get this kind of experience.

As the birds began to take shape, Don stopped in from time to time and approved of what he saw. At one point he called Tom and reminded him that he had a limited budget of fifteen thousand dollars per bird. Tom remembers the call, but he was totally immersed in the work, and in his words, "I just blew it off." He recalls that at first, "I actually made a deal with Warren to build a bird that was only about fifteen feet high. And then I built those two other ones. . . . I just went ahead and built the damn things." Before long the birds towered three stories high among the trees in Cooksville.

Don expected to take delivery, but it would not be that simple. When Tom looked up at the towering birds, thirty thousand dollars didn't seem to be enough. He couldn't part with them. Don tried repeatedly to reason with Tom, but the birds remained in Cooksville. Tom's friend and spiritual advisor Kim Knuth (Miss Tibet), who has been a healing force for him, came and looked at the birds. Kim had gotten to know Doc on visits to the sculpture park some time before. She says, "He sometimes calls me his spiritual advisor, and in that role we sometimes discuss the spiritual aspects of his art."[6] Miss Tibet says further, "For some reason, I understand the spiritual aspects of his work. He often asks me to look at a piece and tell him about it—he doesn't tell me anything, just asks me to feel into it and tell him what I see. Sometimes an entire story comes flooding out. . . . We often go into deep conversations about these [stories], and relate the energetic/spiritual stories to current events in our lives and this often leads to healing insights about different situations." Regarding the positioning of the birds, Tom explains that the negative space between them forms a "spiritual portal." When Kim looked at the birds in Cooksville and looked at Doc, she felt that he seemed exhausted and sick—he had given a great deal to this work. She named them the *Dreamkeepers*,[7] explaining, "When you stand near the birds, you might be able to feel a strong nurturing energy, maybe even feel that you want to crawl up there and rest. It feels like an incubator, a place where all your needs are taken care of, a place where dreams can be safely kept alive for when they are ready to take physical form."

The individual names of the birds, Yond and Eond, were given to them by Nobuyoshi Kitamura, a physicist with the University of Wisconsin. Tom calls Nobuyoshi "Nobu" and honored him by giving the *Dreamkeepers* the birth date (on the base of the sculpture) of 9/22/01, the day that Nobu came to see Dr. Evermor for the first time. Nobuyoshi had heard about Tom from a friend and recalls, "I was doing something sort of similar in the lab using laboratory junk and sticking things together and I had a small portfolio [photographs] and I brought it along and I showed it to him."[8] Tom was delighted, and the two of them became friends immediately. Later on Tom called him and asked Nobuyoshi to give individual names to the *Dreamkeepers*. He explains how he came up with the names: "I was thinking—they are dream keepers . . . so dreams have two components I thought—one is the time scale and the other is the spatial scale. The time scale is to go back into the past to historical times and into the future of dreams. The spatial scale is to travel all around the world and to the end of the galaxy. So these two elements were the starting point." Then he thought about time and he came up with "eon" and shifted that into "Eond." Then he thought about space and came up with "beyond" and shortened it to "Yond." Although he was not considering the sex of the birds when he was thinking about the names, Nobuyoshi feels that Eond is the male (right on page 116) while Yond is the female.

A partial list of the components used in the *Dreamkeepers* reads like the history of the industrial past of the east side of Madison and of southern Wisconsin: steel from the Columbia Power Plant in Portage, farm wheels from Baraboo, wagon wheels from the Don Quinn collection in Dodgeville, hundreds of laser-cut "cookies" from Hartland, various salvage parts from Delaney's including six overhead door springs for the eyelashes, leg parts from the Badger Outdoor Theater, brass balls on breasts from the Beloit Corporation, blades from the Fiskars Company, a 1920 farm hay rake and dump rake (headdresses) from Bob Leecher of Baraboo, tin snips from Fritz Wolf for beaks (a gift to Dr. Evermor in 1956), copper survey markers (eyes) from Berntsen International in Madison, and blowers and large tin snips (beaks) from Don Warren.[9]

There they sat in Cooksville. Don did everything that he could do to get them delivered, but each attempt at negotiation ended in frustration. The months dragged on. In mid-2002 Don turned to his friend Jim Wildeman in one last

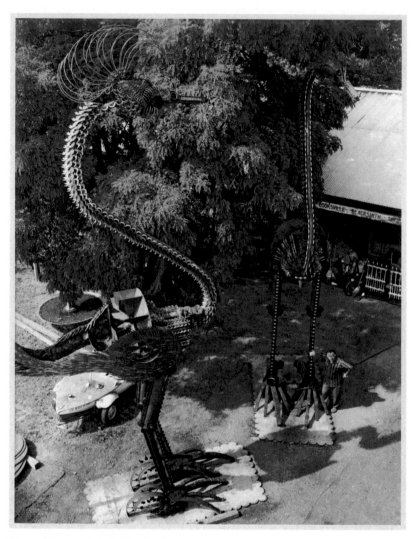

Tom with the birds in Cooksville ANN PARKER

attempt to move things along. Jim is a professional photographer from the east side of Madison and has leased studio space from Don for the last ten years. Jim had come to know Tom in his visits to the sculpture park beginning in the late 1980s and is an admirer of Tom's work. He had no idea that Don had commissioned Tom to do this work until Don took him out to Cooksville to see the birds. Jim was amazed when he first saw them. He was very familiar with Tom's work and found these pieces to be of high quality and "among the most interesting

pieces that he had done in a while." He also learned from Don that there was a problem with the negotiations between the two men about the price and delivery of the birds. Jim immediately volunteered to go talk to Tom about the stalemate. He says, "By the time that I became aware of the problem, the day we went to see the birds, I think that Don had already realized that he had run out of options, and one of the options that he was considering was a legal option. Of course, I've known Tom Every for a very long time and also understand his stance with authority in general and also the role he can sometimes play as being the complete outsider—outside the system. So that didn't give Tom many options either. So I became the carrier of offers back and forth."

Jim carried messages between the two during the summer and into the fall of 2002. He would go and talk to Tom and explain Don's position; Tom would listen and sometimes respond in writing. Tom's writing is often cryptic and stylized but the meaning of the messages came through: he didn't think thirty thousand dollars was nearly enough. He held that the birds were not owned by him or the Evermor Foundation or Don Warren but really belonged to the people of the east side of Madison. Tom produced a list of the component parts showing the provenance of the pieces and their relationship to Madison and to southern Wisconsin. At one point he sent Erika with a pair of vintage tin snips for Don like the one from his family that had been incorporated into the birds. It seemed that Tom wanted to call off the whole deal.

The negotiations finally came to an end. Don reluctantly brought a lawsuit against Tom and the Evermor Foundation asking that he be granted possession of the birds in exchange for the twenty-five-thousand-dollar balance of the agreed price. In January 2003 the court granted a default judgment against Tom and the Evermor Foundation. Tom was there for the hearing on March 14, 2003, in which the court issued an order that permitted Don to have the birds picked up in exchange for the money. Tom's response to the judge was, "So, we use the court action to steal something?" Judge O'Brien responded, "I guess that is your view of it."[10] Don rose, went over to Tom, and extended his hand in a gesture of friendship—a handshake Tom returned.[11]

Jim Wildeman says, "I think that Don Warren communicated directly with Tom that, 'We're coming tomorrow.' He may even have called on that day telling

Tom that they were on their way." Don hired a moving company known for handling art, two flatbeds, and a crane.

Early on the morning of March 21, 2003, Tom left a message on his friend Aaron Howard's answering machine: "Aaron! Aaron! They're trying to steal the goddam birds! Bring guns, money, and whiskey—whatever you've got and get out here now!" He sent that message to more friends than just Aaron.[12]

So they all assembled. Nobody remembers any whiskey, but six deputies were certainly armed, and Don stood ready with the money, a court order, and his lawyer. They formed two camps: Don, the deputies, the lawyer, and the trucks and crane crew on one side; Tom, Al Chavez, Aaron, Demetra (Thayer's girlfriend), later Thayer, a host of angry locals, and later Erika on the other side. Bill Howard (Aaron's dad) arrived, and he and Aaron tried to act as go-betweens. Earlier Tom had placed a second call to Aaron, "for historical purposes," and had left the cell phone on during the first part of the confrontation. It went like this: "Nope, nope, you can't have them. You're stealing them! They're mine!"

So it went. After a while everybody began to lose patience. Now the deputies stood there with one hand on their radios and the other on their handcuffs.

Finally the crew hooked up the first bird and tried to lift it, but it was too heavy. They could lift it just off the ground and then it came slamming back down. This happened again and again. At last, worried about damage to the sculpture, somebody showed them where to remove the bolts to take the birds apart. Like so many pieces that Tom has made, these fit together precisely in modules. Once the crew learned how to take them apart the work went smoothly, and soon they were loaded up and gone. The Dreamkeepers were reassembled that day in front of Don's building on the east side of Madison, just off Williamson Street.

Williamson Street is in the Marquette neighborhood, which stretches out along Lake Monona and forms part of the near east side of Madison. Banners hanging from the light posts read "Williamson Street—A Place for All People." The shady streets are home to a colorful community of university students and local residents and look much as they did fifty years ago. The neighborhood takes us back to a time when everything was within walking distance and mom-and-pop businesses were scattered along the main streets; the businesses have changed but the buildings remain largely the same. Here and there, a brightly painted storefront

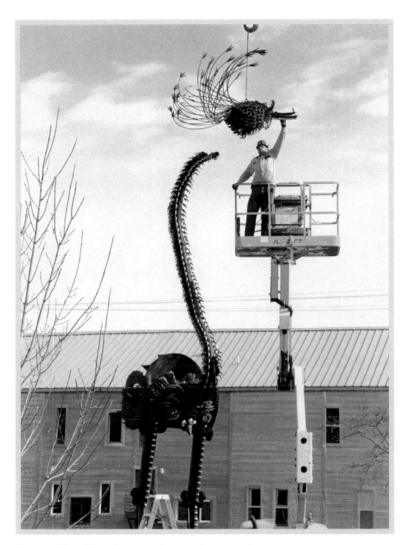

Reassembly of the *Dreamkeepers* on Paterson Street JIM WILDEMAN

announces the latest reincarnation of an old building as a café, bistro, or art gallery. Mixed in are small offices and specialty stores, St. Vincent de Paul, the Willy Street Co-op, Broom Street Theater, a hardware store, a few vacant buildings, and a variety of small businesses that come and go. The old two- and three-story frame houses stand close together and are often divided up into apartments. On summer evenings, locals lounge on the balconies and porches facing the street. Some buildings are freshly painted and well cared for, while others seem to be in a state

of benign neglect. The sounds of reggae, blues, and rap drift out of the open doors in summer. It's still Wisconsin, so you're not far from a choice of neighborhood watering holes. The sweet aroma of fresh coffee and the spicy smell of food cooking in ethnic kitchens washes out over the streets and sidewalks. The main street is a blur of bikes, motorcycles, cars, buses, and pedestrians. Southeast, a few blocks to the lakeshore, the streets are a quiet and shady refuge. To the northeast the Yahara

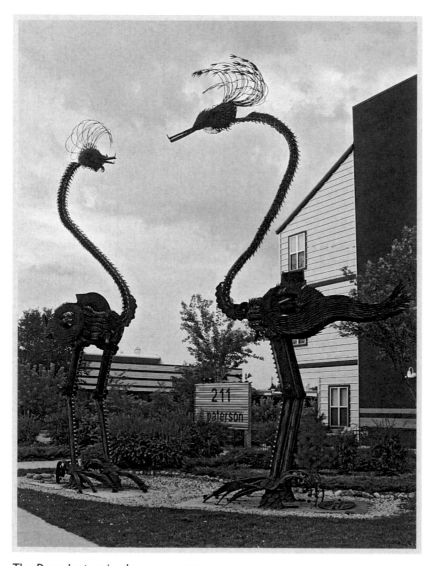

The *Dreamkeepers* in place JIM WILDEMAN

River flows lazily through town; beyond it lies the Atwood neighborhood where Tom lived and foraged as a small boy.

To the northwest, there are fewer trees, and the neighborhood changes into the industrial part of downtown Madison. A former railway has been converted into the Capital City Bike Trail, which roughly parallels Williamson Street and joins the near east side with downtown Madison. The bike trail bends north and passes the sculptures of Tom's old friend Sid Boyum along the way. After Sid's death, his son Steve donated a number of his sculptures to the city, and they were installed along the path for the pleasure of all. Across the bike trail, the warehouses and commercial operations are served by what remains of the Chicago and Northwestern Railway—the same railroad that inspired Tom as a boy and, yes, supplied him with fireworks.

The people in the neighborhood had not been told that the three-story-high birds were coming—they just appeared. The buzz in the taverns and cafés as well as on the streets of the Williamson and Atwood neighborhoods was all about what was in front of 211 South Paterson. Although Dr. Evermor was a native son, he did not have any public sculpture in the city. Some had heard of him and knew his work, but many didn't have any idea who he was. Everybody came and stood, bending their necks to look up at the *Dreamkeepers*.

Jim Wildeman felt that there was more he could do. He says, "After the birds were installed, my last part of this was to help create a ceremony that would do a couple of things: first, to honor Tom for creating this piece of art and all the other art that has influenced so many people, and second, to heal the wounds." He called on his friends in the art community, and they rallied to the idea. Russ Bennett, who is a fan of Tom's and had worked with Jim on other projects, came forward to help. The first thing was to choose a date that would be acceptable to Doc. Jim suggested June 21, 2003—the summer solstice. Tom thought that was good but never really said that he would be there. He did send Jim a mysterious note saying something about the "Fancy getting ready to set sail."

The arts community of the east side turned out in force, and Dr. Evermor rolled in driving the Fancy. He was given the chair of honor. Russ Bennett read a proclamation honoring Doc and thanking him for this art and all the art he had created. As part of the ceremony, Jim recalls, "We encouraged people to write out a

dream that they would like to see come true. We had printed up paper with an icon of the birds on them. The pieces of paper were rolled up and put into two copper eggs. The eggs were lifted up and installed in the backs of the birds by stilt-walkers." Don says that his own dream of having this sculpture for the east side of Madison was fulfilled at that moment. Out came a flock of dancers dressed as birds. They swirled around Tom and then landed in front of the stage where they perched squawking slowly. Tom came to

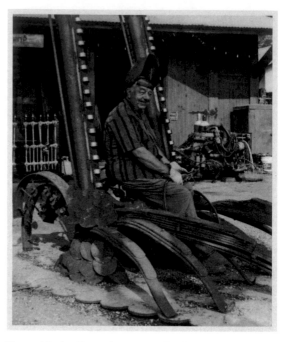

Tom with the *Dreamkeepers* in Cooksville ANN PARKER

the stage and spoke about his connection with the east side and about what had gone into the birds and then he thanked everyone.

Jim says, "For all of us, I think something was resolved. It was a moment that I think helped kind of resolve this." Tom was grateful and gave Russ and Jim each one of his small sculptures.

Don Warren was there too, in the background. Don to this day speaks with respect about Tom and his work, which he continues to collect. He harbors no ill will. Jim says, "Even though Don Warren was an adversary, I think that he was an honorable one. Even Tom in the worst of it, when he would be mad at Don, never resorted to name-calling—he just held his ground. . . . There is no doubt in my mind that Tom's heart was in the right place. He believes things that maybe are hard for him to defend, and his beliefs are not always understood by me or other people. But I believe that he honors them in his own way—he's bizarre but consistent."

9

The Rolling Atelier
The Evermor Circle

"One account describes Every as middle sized, inclinable to be fat and of a jolly complexion. . . . His mannar [sic] of living was imprinted in his face, and his profession might easily be told from it."[1] This is a description of the pirate Henry Every, given during his lifetime during the late 1600s, but in some ways it fits Tom as well.

Some, meeting Tom for the first time, are put off by his gruff exterior, but he is quick to warm and passionate about his work. The characteristic cigars that he chomped on for thirty years are now gone, a result of high blood pressure and strokes, although he does, for mischief and to irritate Eleanor, sneak one in his pocket from time to time. In his years at the House on the Rock, when he called himself Mr. Buildmor, he generally wore a hard hat on the job. Later at the sculpture park he switched to a pith helmet. At leisure he wears his broad-brimmed Amish hat. It's curious that an ancient remedy for depression is "to put on a broad-brimmed hat."[2] Medieval philosopher/astrologer Marsilio Ficino advises that those suffering this way balance their lives "by associating with 'solar' people (blonds! He advises)."[3]

Some notice that Tom always seems to be wearing a shirt that is a little too good for his kind of work, and he never goes without a colorful cravat sewn by Eleanor. In winter he wears his long coat with the scarab buttons. Tom doesn't wear safety boots, a habit that nearly cost him his toes on a wrecking job one day when a motor shaft being cut gave way, pinning his toes to the floor. In spite of

The pirate Henry Every with his ship, the *Fancy*

the pain, he calmly told his helper to get something to get it off him; he ended up in the emergency room, got fixed up, and hobbled back to work the next day.

Tom is by nature gregarious. Many have heard him say "Hop in the truck," only to find themselves on a winding trip through the countryside with only the foggiest idea of where they might be headed. He might stop to visit old friends, do a little bit of business along the way, or be off on an unspecified quest. They would find themselves sailing down the road in the Fancy, marshal music blaring from the tape player, Doc driving and wearing a broad-brimmed hat, cigar

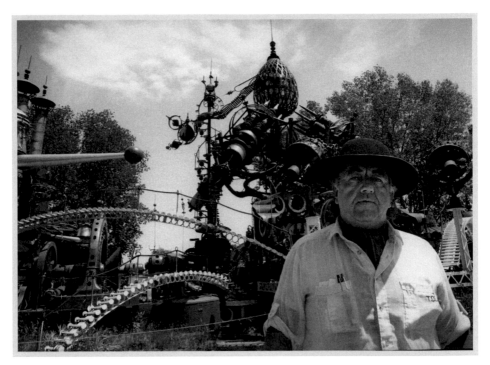

Tom Every with the *Forevertron* RON GORDON

in his mouth—the willing or willingly shanghaied. Just as his work is made by joining together a wide variety of components, so too his wide circle of friends seems joined together with him as the glue. The work and the circle of people seem to be interlocked in what amounts to a virtual kinetic work of art.

The work, Tom and Eleanor, and the friends who come and go form a rolling atelier. The ever-expanding and contracting circle includes professors, scientists, artists and artist wannabes, musicians, teachers, the religious and the irreligious, reporters, welding enthusiasts, local friends, museum curators, collectors, and always a supply of bewildered tourists.

One day Tom looked up from his work to see Chicken John arrive at the park. Chicken, whose dog's name is Damnit, was the leader of Circus Redickuless, a troupe of thirteen performers touring the country in their bus. They performed their little circus for Tom and those who had the luck to be there that day, and Tom did a little welding for them. He says, "I asked John if they had enough money to get back to the West Coast and he said, 'I got $537.' I thought that taking care

of thirteen people with $537, they can't get very far in that bus. I went over to Delaney's and loaded up a cart with whatever food he had and threw it in their bus so they'd have a little bit of something to chew on. Over the years Chicken John has been a good person and has come back once in a while."

The cross section occasionally includes what Tom calls "cult members," who make him and Eleanor uncomfortable. Tom says, "They envision the Forevertron as having great powers and that it attracts energy from someplace. Some of them want to dance around and they think that the egg [travel chamber] is a feminine thing and that it will attract feminine ions and help fertilize the ones dancing around." Some cult people have been asked to leave and not return. Tom does say that the Forevertron seems to be "a magnet for these kind of people." He further says, "When cults tried to take over the Forevertron I just popped right out and said, 'Straight as a line, narrow as a road,' and simple things like that. There is no question that the Forevertron is of the spirit." Above all, Tom and Eleanor want the park to remain a positive place.

Sculptor Homer Daehn heard about the park while working for the Circus World Museum in Baraboo. Homer is a wood-carver who has done a great deal of restoration work at the museum, especially on their collection of historic circus wagons. He became friends with Tom and Eleanor immediately, a friendship that lasted through the years. He had an antique hat press that he had been moving around with him, and now he brought it to the park. Tom, enthralled, made a few "improvements" on it, turning it into the Happy Hatter. On summer days Eleanor presses tin foil hats on the machine for visiting children (and adults). Homer later carved a portrait of Tom that is now on display at the park.

One day Homer brought his friend Richard Springer, a painter, to meet Doc. After they toured the park and met Doc, Homer said to Richard, "He's crazy, isn't he?" Richard answered, "Maybe." And Homer added, "Yeah, just like the rest of us, creative people are all nuts."[4] Rich and Tom understand each other and have always gotten along. Rich gives an explanation of their relationship that rings true for many artists who visit Tom or come to know him well: "I love Doc's work but it isn't anything that I could do. That's the wonderful thing about it. We both have different visions but we have the same spirit. We can be independent of each other yet we can work together. There is an energy here. The relationship with

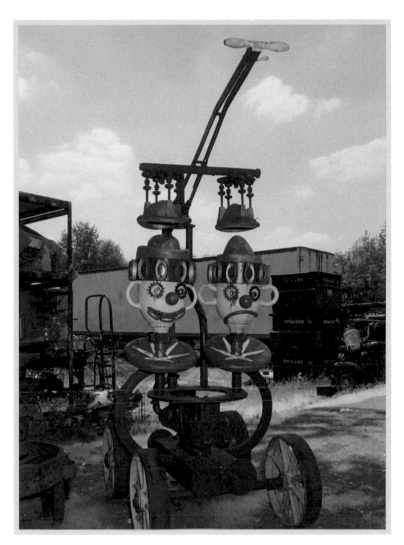

Happy Hatter (64″ h) JIM WILDEMAN

Doc is a high-energy relationship. We give each other energy and we take energy from each other. The artists who come up here all walk away from the thing inspired. Although their vision is different, they're inspired by the fact that Doc is a producing artist. And this is an amazing thing because most artists are always struggling, looking to get some inspiration so they can do something. . . . Doc just produces. There's a spiritual energy that doesn't burn you out or anything—it just keeps you going."[5]

It all revolves with Tom at the center; he welcomes everyone and accepts them just as they are. They may get a rambling philosophical, pseudoreligious monologue, the latest explanation of his work, or a lecture on the effect of the Chinese steel industry on the price of scrap in the Midwest. He keeps everything spinning with telephone calls, letters, and visits and never tires of talking about his work and his dreams. Homer Daehn says, "He's an excellent storyteller on top of everything. When somebody takes a sculpture home with them, they take a piece of Doc and Eleanor with them." Some find the park so seductive that they freely give their time and talent. They are attracted by Doc's personality and the work and dream of outrageous creativity and endless possibilities. Artists take inspiration for their own work or find themselves renewed. As photographer Jim Wildeman reflects, "Being up in Tom's art site with Tom is like being in another reality in which things are possible that aren't possible other places. I find that my mind soars more than it would in other places. There are places I go in the world to open my mind up, and the sculpture site is one of them. Tom is the reason, because his vision is so realized in his works, and he has another element: ceaseless energy."[6] Some become exhausted, burn out, and drift away from the maelstrom, but they find, after a time, that they return again and again. For their own reasons, Tom and/or Eleanor find it necessary to uninvite some. Many form lasting friendships with people they meet in the rolling atelier. It is largely a place of dreams and smiles. Erika Koivunen says, "The folks he gathers around himself and the folks that gather around him are as varied as the crew of a pirate ship."[7]

Amid the work, the gathering, and the talk there are sad moments too. When Tom's friend Blaine Britton, who did so much work on the Badger proposal, died, his son Doug brought some of his ashes to the park, where Tom sealed them into the *Forevertron*. Later, in a poignant memorial, a bagpiper stood piping alone from Tyco's Telescope platform above.

The six acres adjoining Delaney's Surplus that became the sculpture park are a flat piece of land now surrounded by a wooden fence. Here and there are the remains of the Badger School's foundations, chimneys, and smokestacks. The park is partly shaded by large cottonwood trees and smaller wild shrubs and bushes. The open spaces are mowed in summer, but some areas revert to weedy prairie.

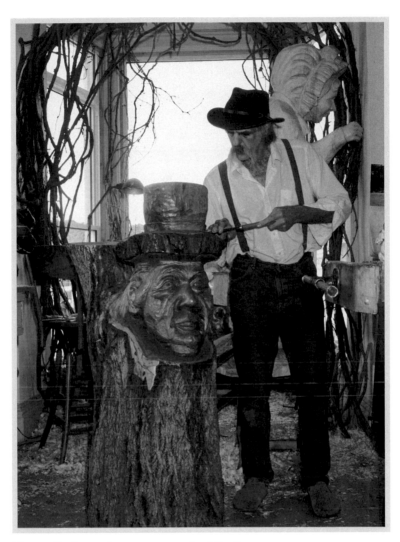

Homer Daehn working on a portrait of Dr. Evermor JIM WILDEMAN

The vegetation provides shelter for songbirds that nest and sing throughout the park—both in the trees and in the sculpture. A winding roadway of crushed granite circles the *Forevertron*, which towers above everything and can be seen from State Highway 12. The whole place has the feel of a salvage yard that in places has been cleared out to make room for the sculpture. The space joins Delaney's side lot in an informal way, and many customers at the surplus store wander in not understanding where they are.

Either the sculpture is encroaching on the scrap (the Everys don't use the word junk) or the scrap is encroaching on the sculpture—take your pick. There are sections dedicated only to scrap. There is industrial salvage of every size and description: numerous semi trailers, a few choice old cars and trucks, copper cheese vats, parts of motors, armatures, hundreds of milk crates filled with miscellaneous metal parts, sinks, light fixtures, wheels, valves, bed frames, brass beds, coffin parts, old stoves, car and truck radiators, chains, stainless steel pipe, bins of fasteners, rakes and other garden implements, hand tools of every use and description, industrial devices of all sizes and uses, gauges, dials, scales, a military jet ejection seat, and piles and piles of the refuse and detritus of industry. There are forklifts, hoists, and cranes parked, ready to lift the larger pieces. All of this is part of an open-air workshop, and among all these things are worktables and welding equipment where the sculpture is produced.

The sculpture is everywhere. Tom likes to make large editions of some of the smaller work, and he never tires of making birds—everywhere you look you can see at least one bird. In the less groomed places the pieces poke up through the weeds and grass or almost get lost in the summer growth. For visitors to the park, it can be like a scavenger hunt, only for art, and they are often delighted and surprised to stumble upon metal beasts or birds or whatever as they walk around. Nothing is marked with a price tag, and buying here is personal. First you have to find Eleanor and ask her if the piece you want is for sale and what the price is. Eleanor handles all the sales—she knows all the pieces and all the prices. With each piece comes a signed birth certificate, and Eleanor records to whom and where the piece is going. She conducts all this under the business name "Metahappenings," which Tom derived from "metal happenings."

Off to one side is a section dedicated to Troy's work. The pieces (more than two hundred of them) are displayed on the ground, on tables, or in special displays that Tom has designed for them. Countless people offer to buy this work, but it is not for sale. There are many other works in the park that are not for sale. Tom says about visitors, "It drives them nuts because a lot of these pieces are park pieces—they're not for sale, they're parked."

Scattered through the park are a number of open-air pavilions, known as teahouses, where visitors can sit or meet and talk to Tom and Eleanor. When the

weather is inclement, they take refuge in an old tour bus that has been converted into an office and visiting space. Nearby is Eleanor's *Joel la Troll*, her paint station, where she works on some of the pieces and transacts business. Soon after Tom and Troy started to create the bugs, birds, gladiators, and other pieces, Eleanor started to paint some of the work. She asked Tom to make her a shelter to protect her and her paints from the weather. She also wanted a troll. She says, "Not a cute troll, but a nasty-looking one."

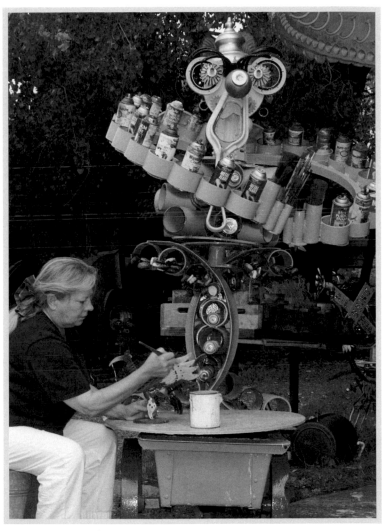

Eleanor painting at the *Joel la Troll* (7'6" h × 4' w) JIM WILDEMAN

In June 1994 Tom built a painting shelter for Eleanor. All of the other shelters at the park are either called gazebos or teahouses. This one is called The Tuffet. Tom explains, "Little Miss Eleanor sits on her tuffet painting her heart away." The Tuffet was made from antique water tanks salvaged from the University of Wisconsin water treatment plant and odds and ends around the site. One day Eleanor left to get some lunch, and Tom, together with his summer helper, Joel, put together Joel la Troll (1994)—not really the nasty troll that she wanted but a troll nonetheless—and a paint and brush holder as well.

Although Eleanor has painted many of the sculptures, she actually designed only one that Tom built for her. It is known as the Margaret Bowling Ball Holder and

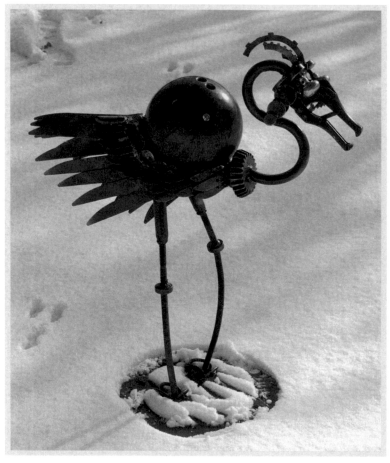

Margaret Bowling Ball Holder (c. 36" h) JIM WILDEMAN

was made for her mother, who was an avid bowler before age caught up with her. It is used as a bowling ball holder and is dated September 24, 1992, her eightieth birthday.

Tom and Eleanor have had serious disagreements in their marriage and now live apart—Eleanor filed for divorce in 1997. They work at the sculpture site together on business days (when Tom is able) in spite of it all. Although their differences remain deep, it was Eleanor who came forward after Tom's disabling stroke in May 2004 to take him into her home and care for him. In her words, "Putting him in a rest home would have killed him."[8] Homer Daehn says of Eleanor: "I see her as always here. It's probably a harder role than most people would expect . . . when people talk about the sculpture, they talk about Doc, and Eleanor is kind of a secondary image. But people who see how much she has put into it know that she's put tons of creativity into it and a lot of sorting of metal, and a lot of heavy lifting, a lot of moving things around, a lot of cleaning things up, a lot of painting, and a lot of everything else. Eleanor has worked endless hours. . . When you see her and she's got her painting clothes on, you can probably see hundreds of sculptures in the clothes she's wearing."

It is a place where the unexpected is commonplace. It is the most accessible of work, and they are the most accessible of people.

From time to time, when Tom passed through his hometown of Brooklyn, he would stop in at the family home to see his mother. He would often leave a small sculpture for her garden. In 1996 Tom combined all of the sculptures into a work he calls the Omnimater. He says, "I thought I would make this piece in honor to her and possibly someday if we had a park down in Brooklyn we would put it there—so that was the thought." The base is inscribed: "Omnimater 3/18/1909 Clarice Mildred Doane Every 3/18/96."

When he is focused on a project, Tom becomes something of a binge worker. "I don't like to get up early in the morning. I start work about ten o'clock and go until about two or three in the morning. That's the cycle that I'm on. . . . I produce a tremendous quantity of things that I like and I'm very well organized. So when you come into the shop you can see how I can produce so damn much because . . . I lay it out and I can go like hell. . . . I'm a firm believer in building in stopping points or you'll go crazy. Building a number of pieces, I may do

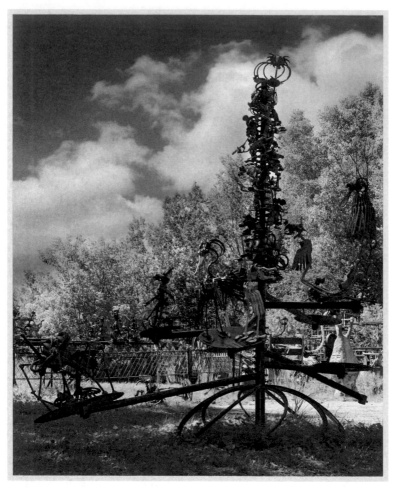

Omnimater (13' h) JIM WILDEMAN

it in a certain rhythm. On big pieces I'm pretty well focused. . . . I like to get things done."

Aaron Howard, Tom's helper in the early part of the century, reflects that working with Tom has been a valuable experience. "Working with Doc taught me to think outside the box." He also noticed the price that a full commitment to work can exact as he watched Tom's health deteriorate and his walking become more difficult. He used to stop by the shop to lift a few things up on the bench for Tom and put some wood in the stove just to keep him going. "You've got to be passionate about your work—I learned a lot about passion working with Doc."

And pain too. Aaron (about thirty-five years Tom's junior) reflects, "It amazes me how much work he cranks out. I wish I could crank out that much work."[9]

A story that Tom laughs about involves a small sculpture called *The Happy* (see page 74 and accompanying text). Tom wanted to make a large run of them, so he set to work making copies of the piece. Visitors to his shop found him surrounded by, almost buried in, these small sculptures. Tom says, "The best day I ever had was 134 pieces. Then I had to go lay down on a cot upstairs. Sometimes I laid on the welding bench, woke up, and away I went again." He ended up making 920 *Happys*. "I was grabbing everything that I could throw into these things . . . and they started to sell like hotcakes."

There were compelling reasons why themes of healing began to reappear more regularly in Tom's work in the early part of the century—he was beginning to fail physically. When progress on the *Dreamkeepers* in the Cooksville shop seemed slow, Erika recalls, "I needed a break from the birds and he needed a break from the birds too. So we started building the *Harmonic Modulator*. I think that this was so that I could feel that I did something and finished it—the birds were taking months."[10]

Tom had picked up a circular staircase somewhere. They set it up and started welding without much of a plan. A series of curved pipes at the bottom provided access to the stairs. Ann Parker stopped by and saw the staircase leading nowhere and named it the *USS Superfluous*. They continued work, making two benches (Tom calls these peapod benches) beneath inverted tanks that now serve as domes, and they finished by adding seven copper tubes at the top. Kim Knuth (Miss Tibet) visited the shop, took a look at it, and named it the *Harmonic Modulator*. She tells this story about it: "It works when a person sits on one of the seats with their head inside of the acceleration chambers. The person then makes a sound, any sound that suits the moment . . . the tones should be made loud enough to reverberate inside the acceleration chamber. When the correct tone or series of tones is made, the body feels as if it is being lifted upward. The body is then freed and the resulting sound rises up the spiral staircase and

causes the seven tubes above to vibrate, causing the overtone tube to transform the sound into light waves. The light shoots up to heaven and the process is complete, leaving the individual with a clear, fresh, rejuvenated mind, able to see truth without judgment."[11]

The *Modulator* can also be used by couples to heal troubled relationships. When both parties use it together, the disharmony of their relationship can be dissipated and they can return to a "harmonious balance." Miss Tibet also speculates that a lightning bolt might reverse the process with uncertain results.

Tom needed some healing by the late 1990s. Years of punishing work and irregular hours were beginning to show. Hip joint deterioration began to cause

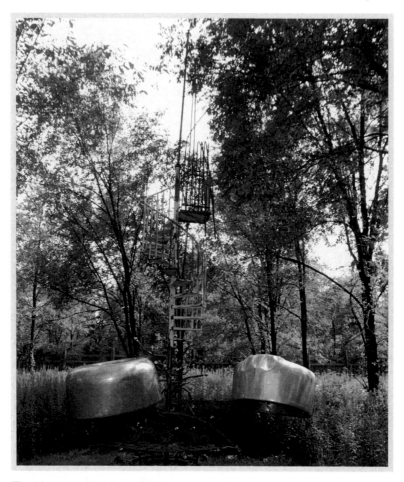

The *Harmonic Modulator* (26' h) JIM WILDEMAN

pain and difficulty walking. Plagued by high blood pressure and depression, he was haphazard about taking his medications and ate and did what he wanted, when and where he wanted. Those who visited him in the Cooksville shop (not a large building) tell about being just able to make him out through a thick haze of welding smoke.

Misha (Miroslav Backonja, MD) is a neurologist who came to the park like so many others because he was passing by and had to see what was there.[12] Misha and his wife, Petra, became admirers and friends of Tom. Misha, never his physician, acted as a friend and advisor, trying to direct Tom toward the best health care. He tells the story of being outside the veteran's hospital in Madison in September 1999, trying to convince Tom to go back into the hospital—trying to explain the possible consequences if he did not. Tom had suffered what appeared to be stroke symptoms; he had been in the admissions process but did not like the way the questioning was going so he bolted out the door. Misha says, "I remember finding myself sitting on the steps of one of the buildings and it was kind of surreal. There was something wrong and by all accounts it must have been a stroke. It took a long time to get him to go back in."

Tom did undergo treatment then for what was a small stroke and soon went back to work. On Christmas Eve he had a more serious incident and was rushed by ambulance to Madison, forty-five miles from New Glarus. This stroke was more serious. Misha recalls, "He had a small stroke and no problem—he got up and walked away and then he had the bigger one; the one thing that is incredible is that he got out of the hospital in the beginning of January and by the end of January he had already made over twenty sculptures." To make things worse, Tom had great faith in a Chinese herbal remedy he believed would help him. It turns out that the remedy was dangerously increasing his blood pressure, and it took a long time for the doctors and nurses to convince him to stop. His strokes had occurred in the part of the brain that controls his left arm and leg. His memory, understanding, and spatial knowledge were not affected. It didn't harm his mind (didn't do it any good either). An operation in his neck to increase blood flow went well. This procedure was made easier for Tom, and the family, by a visit from Miss Tibet, whose reassuring presence put Tom in a more willing frame of mind. Misha says, "He is a man who is defying the laws of gravity."

Tom and Eleanor in happy times DORIS LITSCHER GASSER

In May 2004 Tom suffered another stroke from which he has never completely recovered. He says that tests have shown that the grip in his right hand is one hundred pounds; in his left it is twenty-seven pounds. He was well enough to undergo successful right hip replacement surgery in June 2005, but because of his need for constant care he lives in a local nursing home. In October 2005 he had surgery on his deteriorated left hip because of injuries sustained in a fall. From the time of his 2004 stroke until October 2006, Tom welded only occasionally but did produce a large number of drawings and plans, some of which are illustrated in chapter 12. In October 2006 Eleanor purchased a portable welder for him, which Thayer modified so that Tom could weld sitting down. Often (weather and strength permitting) he is seated at the park working as best he can. In June 2007 Tom was able, with a great deal of help from Eleanor, to attend the opening of an exhibition in which his work was included at the John Michael Kohler Arts Center. Tom enjoyed himself throughout the festivities and especially while signing copies of the book Sublime Spaces and Visionary Worlds: Built Environments of Vernacular Artists, which was published in conjunction with the exhibition.

10

The Twenty-Eight Intergalactic Meditation Points
Mystery, Poetry, and Steel

D ean Meeker and Tom became friends in the 1980s. Dean made his international reputation as a printmaker and sculptor while teaching at the University of Wisconsin in Madison. His search for materials eventually put him into contact with Tom. Dean had created an eight-foot Minotaur for a museum in Japan but felt that the piece was too small. He needed bronze sheets to make a larger version of the work, but the retail price of the material was prohibitive for the sculptor. Through Tom, Dean was able to find the bronze he needed, and it wasn't long before the two became friends. They met sometimes for breakfast at a local drugstore; Tom would be on his way to the House on the Rock and Dean on his way to the university.

The two were at polar extremes creatively. Dean, a product of his classical education, started with an idea and produced detailed drawings and models before beginning his full-size sculptures—everything was carefully reasoned and thought through. With Tom, the process is intuitive. Many times he has no idea where he is heading when he starts—he begins with the materials at hand and responds to them and to the people and events around him. He often talks about the "touch and feel" of the process. Dee Hanson, Dean's longtime companion, says of them: "He [Tom] was very important to Dean with respect to the materials. Dean liked

the way that Tom's mind worked and the fact that he was so creative and without the constraints of education. But Dean could not work like that; he couldn't just stick it together; it had to be a formal process. . . . He was classically trained and he was adamant that his students follow the process. Tom was a real anathema because he couldn't follow the process—he would see something and just do it.[1]

Tom suggested materials that sent Dean in directions he otherwise would not have gone. One evening Dean and Dee were having dinner when there was a knock on the door; it was Tom all excited and saying to Dee, "I've got something for you." Since both men had health conditions that forbade them from lifting, Dee hauled the buckets into the foyer; she now had three hundred pounds of thick glass shards. Little did she know she also had quite a bit of ice in the old buckets that would melt over night and soak the floor, leaking into the basement. Both Dean and Dee looked through the glass and got excited about it. Dee was already familiar with glasswork and soon found a place to get some instruction about using the glass shards. Soon Dean designed pieces for Dee to build out of their newfound material. She says, "Tom starts things. He throws out this stuff for people and you can either grab on to it or not."

The couple occasionally visited the sculpture site on weekend drives in the country. Dean and Tom respected and inspired each other, and Tom occasionally checked in with Dean at his studio where the two of them would sit and talk. Doug Britton recalls, "I have no question that they genuinely respected each other. . . . It was just a hoot to sit and listen to them. Dean would draw something out and explain it to me this way, 'Jesus, I put all this shit together and I get it all lined up and I do all the planning and here comes goddamn Tom. He just welds all this shit together and stacks it up and says that's tall enough. He props it together and sees if it will stay upright.'"[2]

They never actually worked together on any piece, but Dean contributed to one work. Tom got some huge and heavy doors as surplus from NASA. He was in Dean Meeker's studio and he told Dean that he was thinking of "floating a door." Meeker looked at him and said, "What do you mean, 'float a door'?"

Tom said, "I want to put it up and float it out there, kinda mystical."

Meeker said, "You know what Freud says about doors?"

Here Tom paraphrases the rest of the conversation: "Well, it represents a female anatomy part. Oh, ha, ha, that's funny as hell. I said I didn't look at it that way. I looked at it this way: A door you look at as a happening . . . one minute you're on one side and the next minute you're on the other side of the door and you're in another world. That's the way I look at it. Well, that's what old Freud says, well, I'll think about it."

Tom, of course, *did* think about it. He bent some pipes and spread them to look like "a feminine structure . . . and legs coming down . . . and then you got that damn door hung and . . . you open the door and . . ."

Dean came up to see Tom sometime later. He was stalled in his work and in a creative blue funk. When he felt like this he would sometimes go up to see Tom. He was excited to see what Tom had done with the door and asked if he could paint the *Moonmaiden* (2/22/88). Tom relates, "So all the paint was purchased by Dean . . . [he painted it] and then he was feeling better." Tom also installed a "key lock" on the outside of the door. The key is made so that no matter which way you turn it the letters "M" and "W" are visible. He explains, "I was so pissed off about losing that house in Madison." He was sending a message to Madison and to Wisconsin.

Moonmaiden (c. 15' h × 16' w × 17'6" l) JIM WILDEMAN

Tom bought authentic Amish broad-brim hats like his own for Dean and his good friend Doug Britton (Tom believes that Amish hats are the least confrontational hat you can wear). The three of them could be found occasionally on summer days sitting in the shade at the sculpture site. Doug says, "Tom looked like somebody from the Frank Lloyd Wright Foundation, Dean had his reblocked and decorated and with his white beard looked like a Spanish grandee, and I just looked like some goof in an Amish hat. So we had these three people who hung around together and had these goofy-looking hats. We all had a rapport that worked real well."

Tom continued to push materials Dean's way whether he wanted the stuff or not. He talked Dean into buying a number of four-foot-diameter metal balls. Dean wasn't too sure what he was going to use them for but ended up with some of them anyway—he just couldn't pass them up. There they were, the two of them—Dean eighty years old and walking with a cane, Tom hobbling around on questionable hips—climbing all over the balls. Dean did find uses for them. He cut some up (much to Tom's chagrin) to incorporate into his sculpture, and

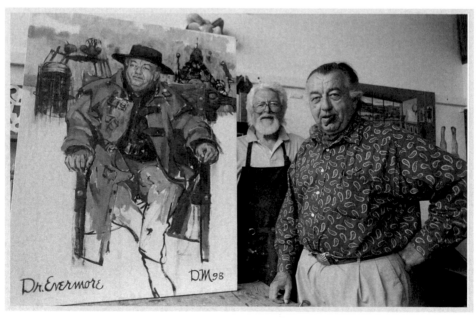

Tom and Dean with Dean's portrait of Dr. Evermor BOBBI LANE

others he painted brightly and rolled down the hill near his shop to see what would happen. The four-foot metal balls rolled well—a couple of them rolled down toward a neighbor's place (just for the irritation factor). Another one sort of got away and rolled out into the road. Nobody got hurt. As Doug says, "They played together real well."

A large quantity of stainless steel became available to Tom, and he asked Dean if he would like any of it. Dee recalls him saying, "For my eighty-first birthday I bought ten thousand pounds of stainless steel." He wrote the check out and looked Tom in the eye and said, "You know I'm over eighty years old." The answer was, "What the hell's that got to do with it?"

Tom says, "I don't look at people as being old. He was keeping his heart going and thinking about creative things and that's what he was doing." Dean set about creating some of his last works using this stainless. Within two years, in October 2002, Dean Meeker died of a heart attack.

Tom said that he had the sense that Dean wanted him to do something with a sculpture Dean had been working on just before he died—a nude entitled *Woman Struggling with Her Conscience*. He called Aaron Howard, who had done welding for him in the past, and they went over to Dean's shop to pick it up. He had Aaron weld a pedestal (the bronze had already been finished) and then they did a "spook job."

Aaron and fellow welder William Ballweg loaded it up and Tom fired up the Fancy. They swung through Madison to pick up Erika and made their way the forty-five miles over to Spring Green. He had planned it so that they would arrive at the House on the Rock Resort after dark. Aaron says, "We drove the Fancy around the parking lot for half an hour with the lights off and marching music blaring and a weird-ass sculpture in the back of the truck.[3] We were looking for the right place to put it and finally Doc kind of liked a spot on the golf course so we dumped it and got out of town." The resort owner knows Tom, so the list of suspects was short.[4]

Tom helped clean out Dean's shop and, Tom being Tom, he threw nothing away. He says about the materials from Dean's shop, "These are the waste energy products so it's just like sweeping the floor and doing something with all that energy . . . to come up with another energy force because a lot of forms and

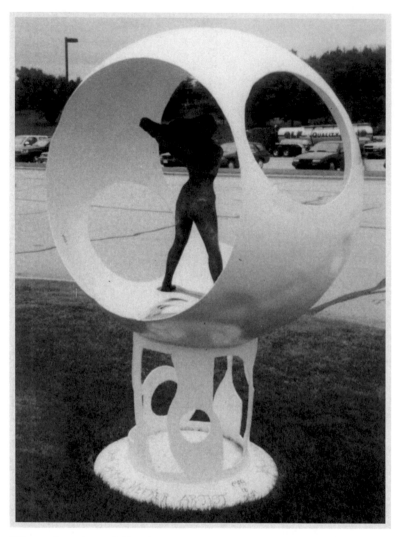

Woman Struggling with Her Conscience by Dean Meeker EVERY COLLECTION

shapes and curves and stuff that was in the original pieces that he took out of there—the negative part—is good stuff you see." He loaded up the stainless steel (the price of which had recently gone through the roof) and all of the scrap left over from Dean's last work. He took it all down to Newville, Wisconsin, to the shop of his friend Tom Uncapher. The shop is well equipped for handling these materials, with massive industrial equipment to cut the stainless and a forklift with seven-foot forks to position the pieces for welding and move finished work.

He visited his friend Tom Svoboda and gathered more materials, collecting four thousand pounds of electric motor armatures, heavy bronze castings, and stainless scrap. Some of the components came from salvage Tom had done at Badger Ammunition; other pieces came from the Beloit Corporation.

In the fall of 2003 Tom, with the help of Erika Koivunen and Tom Uncapher, began work with renewed energy, like a man on a mission. He cut some of the stainless pieces to manageable length, but as usual he changed none of the components. His monumental work, *Twenty-Eight Points of Intergalactic Meditation*, continues the themes of healing and harmony seen in the *Harmonic Modulator* (2001) and restates them with a new and powerful urgency. He may have been

Erika Koivunen and Aaron Howard seated on *Peacewise* (6'10" h × 3'6" l × 17" w) JIM WILDEMAN

Quiet Re-concocter (8'7" l × 4'3" h) JIM WILDEMAN

in an elegiac mood at this time, but these pieces are full of transcendent joy and welcome the viewer like playground equipment. He included some of the stainless and the scrap from Dean's studio, saying that he "wanted to do something with all that energy . . . a kind of a blend not trying to put any kind of a twist or torque on anything which had been Dean's but to use up all that stuff. So that was the purpose—to keep it alive and not scrapping it, you see. . . . Perpetuating something that I thought would be satisfactory to Dean and he would be happy to see them used up rather than have them go to scrap."[5]

Each of the *Twenty-Eight Points* (there are twenty-four completed at this writing) has a place for one or more people to sit. Tom says, "They're beautiful, and two people sit on them and there are rays coming down through the big pieces of copper. . . . They're open-spirited."

Peacewise is one of a set of three similar pieces. The other two in the series are entitled *Infatuator* and *Moonglade*. They are all dated 9/20/03, Tom's sixty-fifth birthday. Erika Koivunen (who was Tom's assistant throughout the production of these pieces) explains, "These chairs are for sitting like so, and you don't look at your partner at all; you just hang on to their hands so that you know they're there. And you can meditate through this stainless and you think about maybe any problems that you have or whatnot."[6] The vertical plane of the piece has ten tuning forks welded to its edges. Aaron calls them "harmonic tuners." Tom had acquired them sometime before, and they had been laying around the sculpture site. He

Semi Still Underhummer (7'7" h × 5' w) JIM WILDEMAN

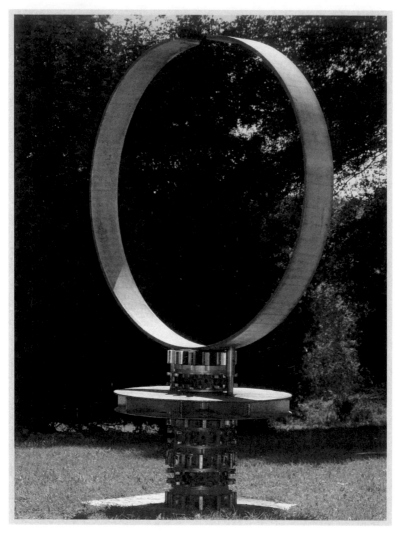

Melodious Rattletree (7′ 8″ h × 5′1″w) JIM WILDEMAN

says, "Wow, I was just thoroughly amazed at those tuning forks. I had never seen anything like it. They're about two and a half inches thick." Erika says, "They're perfect because they resonate these sound waves that can reach way beyond the dimension we can sense. All your energy is supposed to rise up through these tuning forks and up to the heavens to help to solve any problem that you have." As we have seen in the *Bird Band* (1990s) and will find in the *Komodo Dragons* (2004), Tom from time to time incorporates playable musical devices in his work, inviting visitors into the process.

The series of four, *Rockbell* (10/11/03), *Tantamount Warbler* (10/12/03), *The Harmonious Anti-Quibbler* (undated), and *Quiet Re-concocter* (10/14/03), are made from stainless steel planks from Dean Meeker's shop, components from Badger Ammunition, and electric motor armatures from the Beloit Corporation. The spring, from a railroad car, and a flexible rod inside provide a rocking motion for those seated or lying on the planks. They are meditation points, but they are built also as communication spots.

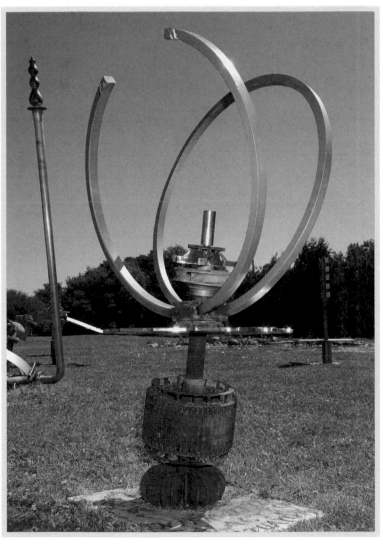

Intensifier Galactic Infatuator (5'10" h × 3'6" l × 2'5" w) JIM WILDEMAN

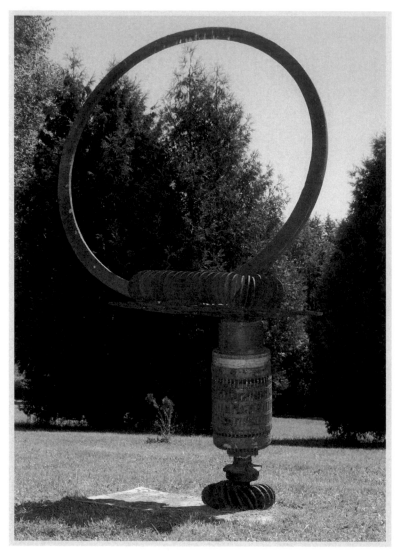

Night Watch (8'3" h × 5'4" w) JIM WILDEMAN

The Harmonic Innerworks (10/21/03) and *Semi Still Underhummer* (10/20/03) are twin works. Tom says that the beauty of the five-foot brass rings is that one side is of finished quality and the other has the fresh, rough texture of the casting. He intends to sandblast the electric motor armatures on the base to bring out the copper color. Components here are from the Beloit Corporation, and "cookies" from Tom's supply form the oval-shaped midpiece, which is meant to be overtly erotic.

The Melodious Rattletree (10/22/03), Melting Curve (10/24/03), and Cosmozoan Flotsam (10/23/03) are three similar pieces made of materials acquired from the same sources as above. The open rings, which are five feet in diameter, are stainless steel. Erika says, "He [Doc] had to lock the stainless into a sculpture before somebody did anything useful with it."

The Intensifier Galactic Infatuator (10/23/03), shown reaching skyward at the characteristic twelve-degree angle, features smaller double rings and seating at

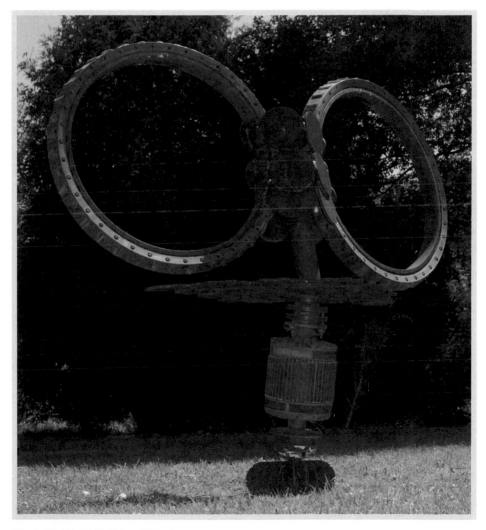

The Inside World (70″ h × 73″ w) JIM WILDEMAN

Soul First Adventurer [1] (7'4'' h × 4'1'' w) JIM WILDEMAN

the midpoint. Tom sees his work here as a place for sending and receiving "intergalactic rays."

Ground Bounce (10/25/03) and NightWatch (10/26/03) are two similar pieces constructed from electric motor armatures, "cookies" at the midpoint, and five-foot rings rising above at a twelve-degree angle. Tom says about these and all of the points: "I saw them sitting out in the woods and somebody comes along [asking], 'What the hell is this?' So they get weird and sink their ass in there and

sit on it and it's a meditation point. Energy coming in from the heavens or going up—it's a two-way deal."

The Meta-Galactic Speculator (10/27/03), The Useful Life (10/29/03), and The Inside World (10/28/03) have double three-foot rings that are actually bearings that turn in place. The interaction in these pieces is a subtle discovery for those with patience and curiosity. In addition, there is a "secret" compartment on the top of these pieces in which notes can be left for future users or for someone in particular. "So when you need to communicate with somebody. . . it's hidden in plain sight," says Erika.

Soul First Adventurer (10/30/03),[7] with its wide base, can be used by a number of people. Tom says, "That's [the vertical projection at twelve-degree angle] a copper condensing coil and these big gears and stuff down here [bottom] all come from Badger Ordnance."

The Ringegometer, the Twist Conjector, and the Soul First Adventurer are all dated 11/11/03. These three pieces are the only set positioned as a group, and they lean in toward each other at twelve degrees. Tom has also called these three the Sperm Cannons, named for the stainless steel canisters he claims were used to hold

Ringegometer, Twist Conjector, and Soul First Adventurer [2] (each c. 9'7'' h × 4'9'' w) JIM WILDEMAN

Untitled (6'9" h × 3'9" l) JIM WILDEMAN

semen collected from bulls. He did confess to this author, after close questioning, that the containers actually came from a local plant, where they were used in vegetable processing.

The untitled piece above is dated 11/23/03. The vertical (that's twelve degrees) threaded rod carries two perforated stainless steel disks that can be screwed up the rod; the meditators spin round and round on their way down.

Mars Answerer (12′6″ h × 8′ w × 5′9″ l) JIM WILDEMAN

At the top of the rod is a piece of copper ore. Erika explains, "It's got a big copper brain and I think that piece of copper is in the shape of a heart. It was [Tom's] birthday and I was up north [Upper Peninsula of Michigan where there are large copper deposits] and I laid fifty or sixty dollars in this guy's mailbox and I took this piece of float [copper ore] and it had this heart shape so I brought it back and I gave it to Doc for his birthday."

Mars Answerer is dated 12/21/03, the winter solstice, and it is the tallest of the points, at twelve and one-half feet. Aaron says, "It looks like it's going fast while standing still." It was named at the same time that NASA's Mars probe was landing on the planet. The rock on the far end covers a bowl-like form. "That's there to keep people from pissing in there, but if you do, it just gets on your shoes," Erika reassures us.

Tom does not want to give too much direction about how to use the points, saying, "I don't want to tell them what they're supposed to do; I just want them to sit down on them for meditation."[8] The *Twenty-Eight Points* and the *Harmonic Mod-*

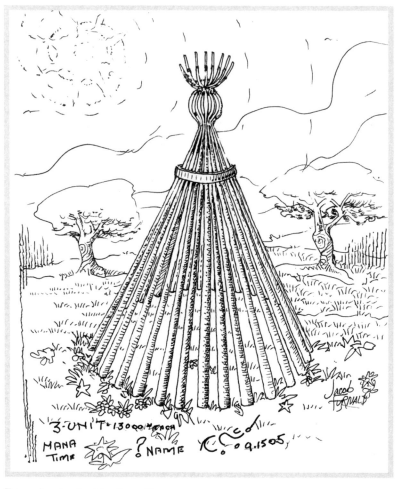

Tepee drawing by Jake Furnald

ulator are places of communication and places to connect with the forces of the earth and forces beyond. They do not serve the *Forevertron* myth like the *Listening Ears* does—they stand alone. The *Twenty-Eight Points* are placed right on the ground and are completely accessible. They are truly interactive and are incomplete when not in use. He envisions them as a separate park in which his UFO (2004) piece would be in the center and the meditation points positioned around it. He would also like to incorporate the *Harmonic Modulator* into this space and plans footpaths winding among the pieces to form a mysterious pattern when viewed from above.

There will be twenty-eight, one for each day of the moon's cycle. Plans for the remaining works include three tepee structures, each rising more than fifty-six feet, made up of twenty-eight steel poles held together by a metal collar. Also in planning are *Intergalactic Flowers*, made from metal and glass as companion pieces to the points. Tom explains, "I'm loaded with this copper and brass pipe around here. . . . I'm going to either solder or weld these other cylinders onto the pipe to make them kind of intergalactic leaves, you know. And they would be sitting next to the *Twenty-Eight Points*. . . . Some would be seven feet high or nine feet." Everything is built using a twelve-degree angle, one of Tom's favorite techniques. He bases this idea, which he calls the "Peruvian Principle," on discussions he remembers having with Jake Furnald. Jake observed, when he returned to visit Tom after a trip to the ruins of Machu Picchu, Peru, that the walls there are sloped at a twelve-degree angle.

Tom says, "I built all that stuff down there in thirty days. We concentrated on the twelve-degree angle and all these cantilevers and balances . . . and I'm just thinking that this is a good way to use up a five-foot brass ring that weighs four to five hundred pounds and look at the beautiful machining on one side and rippled on the back . . . and somebody can sit in it." Tom insists he's just trying to use up the metal he has before it goes missing and is scrapped for cash.

They are positioned alone in a field near the shop where they were built. Tom cannot always find the words he wants, but these poignant abstractions speak volumes. Doug Britton reflects on Tom's work: "My theory with Tom, and it's a theory that I have with all real artists, is that if he could really talk about these things he wouldn't do them. There's no question that he cannot explain—if he could explain he wouldn't have to make this stuff."[9]

The naming of his work has always been an important part of the process for Tom. When he wanted special names for the *Twenty-Eight Points* he turned to his friend, poet Petra Backonja.[10] He was at first vague in his descriptions of the pieces he wanted named, saying only that they were extraterrestrial, ancient, and involved the participation of people. Eventually he showed up at her home and made some drawings of a few of the points. At this writing, Petra has supplied him with twenty-two names for the meditation points, and Tom has asked her to name the rest of the set when it is finished. Among other pieces she has named are the two birds currently in front of the Cooksville shop: the In-Betweenity Bird and the Forewarner Bird. The following gives some idea of the care and thought she brings to this process:

The In-Betweenity Bird

Who hasn't stood in this exact spot torn between yes and
no, this and that, heaven and hell?

The In-Betweenity Bird roosts mid-way between here and
there. Aligned or anti-aligned within this narrow field, it
presides over thought and is the sensuous fore-type of
every decision.

The call of the In-Betweenity Bird is an ambiguous,
contrapuntal thunder-stroke, often confused with the
whisper of fate.

The Forewarner Bird

The Forewarner, or more correctly, the Plumed
Forewarner, is a cousin to the Patented Forewarner of the
Present driftless zone.

One of the limnal, which is to say, edge-dwelling birds,
The Forewarner overflies the ocean that subjoins future
And past.

Although the *Forewarner* builds its nest in the past, it
Conducts its elaborate mating rituals in the future. Thus,
Its luminous future eggs hatch in past latitudes. Early
Observers thought the opposite, and their poignant
Confusion is almost understandable.[11]

In-betweenity and *Forewarner* birds (c. 12′ h) JIM WILDEMAN

He then asked her to name a set of pieces that he described to her as "more mysterious than the Forevertron." She set about coming up with names. Petra has taken inspiration from Tom and his work for a long time. The method she uses in collecting words for her poetry comes from observing Tom's methods. She works in a library and says that she works in what she calls the "disorganized part." She is involved in making decisions about books that are donated, damaged, or outdated technical works; some of the books not of use to the library are even recycled into animal bedding. She noticed that in addition to this loss of books in this process, there is a loss of words; specialized words were passing away with the books. She began collecting unusual and specialized words and saving them in her own lexicon, which now, some five years later, contains about a thousand entries. She explains: "So I use the words in my poetry because they're really different. What happens is that people see a really unusual expression and they attach to it whatever other meaning is suggested throughout the rest of the poem." She agrees that this system came about as a result of going to the sculpture park and seeing how Tom works. She continues, "What he always says is that you don't change anything and I use preexisting shapes and forms. These really aren't new words. These are all existing words in the English language but they would be lost. So what I do is sort of weld them together—I put two of them together and suddenly I have some new thing and then I have to invent a world for that thing to occupy and that world is the poem."

Petra came up with the names for the Twenty-Eight Points from her lexicon and by responding to the descriptions and sketches that Tom gave her. She named them all without seeing them. Along with many others who are familiar with Tom's work, she was surprised when she saw the completed works for the first time in the winter of 2004. "The first time that I saw them I have to say the first thing that I thought of was that it looked like some kind of bizarre listening station. . . . But because it was winter and because it was so stark and in this empty field, they didn't look very promising. Misha [Petra's husband] was just thrilled, but I wasn't so sure. I got home and I started thinking about it and I thought that he's really got something there."

You'll know your sky by the harmonograms it sends
When in Aluminum Ages long past one astronaut
Already feels like a new adam and nothing is
Unchanged, so I too adore flirting from dirigibles
Adore it like a sentimentalist and jauntily having been
Wherever, and still these lifetimes arrive by
Gapeworm, the receiving cosmosphere gone all white
With wattage and snoozing upon snowdrifts, my
Milksick craniograph for example, stands still above
A ghost-cloud, hobnobbing with retro-rockets,
Upcaught in outbound counter-thwarting traffic.

—Petra Backonja[12]

11

Alien Visitors
Looking Out

Tom was working at Cooksville when he got a phone call from somebody he did not know. Her name was Karin Shoemaker, and she had read an article about Dr. Evermor. She called to ask if she could come up and see him. After Karin had graduated with a bachelor's degree in fine arts, she had found work through the local Union of Operating Engineers running heavy equipment, but she always wanted to learn welding. Her opportunity came during a layoff when the union provided welding instruction; what she wanted to do now was use her welding skills as a tool in her art.[1]

When she called, Doc said, "You're welcome to come up and we can have a hamburger or something." The next day she drove from her home in Rockford, Illinois, to Cooksville and found Doc in the general store next door. He was sitting at a table in the back with his friends. He invited her to sit at the table and have a piece of lasagna. She remembers, "It was delightful because, first of all, what I enjoyed so much was that he immediately opened himself to me. He never met me before and he invited me to share some food with him and meet his friends and sit and talk. I enjoyed that."

After a while she told him that she had her welding helmet and other equipment in the car and she asked if they could go over to the shop and weld. She recalls, "Then we went over to the shop and opened the creaky door. And it's really dark in the shop and it's crammed with equipment and metal and he was kind of shuffling along making like the sound of a broom with his feet."

He could see, as he recalls, that "her heart was in it." He showed her some things, she welded, he welded, they worked all the rest of the day and on into the night. Time flew by, and hours later they had produced a standing bird and she had found a whole new way of working.

Tom says, "She was a great inspiration to me and I said, 'Karin, what do I owe you?' She said, 'I don't want anything.'" He gave her eleven shovels as payment. She left feeling that the experience had been a watershed in her life. She says, "My life changed after going there and I started collecting metals and stopping and visiting with people and thinking more about interaction. My work had been too self-focused and not depending on people enough."

Karin would come and go at Cooksville and at the sculpture site from time to time. She would drop in or call ahead, and over time she worked on a number of small pieces for Doc at Cooksville. She did some work on the *Twenty-Eight Meditation Points*. She also went on excursions with him in the Fancy, meeting friends along the way, looking at works in progress, and just wandering around.

Karin feels that there can be a process of healing through the creation of works of art. She and Tom were both in need of healing in 2004 when she visited him at the sculpture park. They were both having health problems, and she told him about a piece she was working on to help with her healing. He pointed to the *Forevertron* and said, "Why do you think I made that?"

Aaron Howard grew up knowing Dr. Evermor. His father had been a friend of Tom Every's for a long time; he remembers going with his dad to visit Tom when he was a small boy. Aaron had learned goldsmithing from his father, an accomplished jewelry maker, and later picked up blacksmithing and took welding classes at Madison Area Technical College. In 2000 he was between wrought iron commissions and needed something to do, so he went out to the Cooksville shop and asked Doc if he had any work.

Under Tom's direction, he built a few birds and small creatures. Soon Doc started talking about the *Intergalactic Gawker Birds*. The whole idea of this group of works is connected with the Dr. Evermor myth. In a story similar to the *Gyromni*

(1998), space aliens had heard about the Forevertron and sent a space probe (the UFO that Aaron would later build) to visit the Doctor. The Intergalactic Gawker Birds would play a part in this event.[2]

Tom had acquired a number of stainless steel tubes originally intended to be used in ice machines by the PDQ Company. Some error in design or management resulted in Tom getting these tubes of varying lengths. He looked at the tubes and got the idea for the gawker birds. He would not allow Aaron to cut them off or to alter them in any way, telling him he had to keep "the spirit of the pieces" by using them just as they had come in. Aaron recalls, "I put together three sets of wings with him and did a couple of bodies and pretty much built one at Cooksville; he showed me how to do it for a bit and then let me run with it." The bodies are made from steam valves salvaged out of the rocket powder plant at Badger Ammunition; the other parts are vintage Evermor, from his stock of salvage. Aaron worked in his own shop and finished them in about a month. The Intergalactic Gawker Birds are curious creatures who hear the approach of the UFO and gather around to gawk up at it. There are fourteen of them; each has inscribed on its base the name of a Native American tribe.[3] While the work was in progress, Doc would stop by and visit and talk about the proposed UFO. It all seemed a little bit foggy to Aaron and he wondered what it was all about.

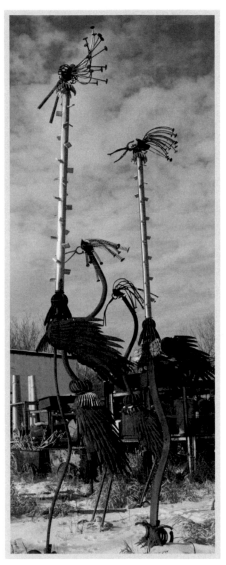

Intergalactic Gawker Birds (series ranges from 6'7" h to 12'6" h) JIM WILDEMAN

He went about his own work, moving in and out of Doc's life and doing this and that for him until the next major project, the *Komodo Dragons*. The bodies are made from steam pipes from the number two boiler plant at Badger Ammunition. When they started, the pipes were all U-shaped elbows; they cut off the straight sections and "macaronied" them together. Components were salvaged from the parts warehouse at Badger, and the twenty-five hundred scales (five hundred per dragon) are made from surplus round metal stampings. Tom used salvaged backup hydraulic tanks used in jet planes for the eyes. Aaron and his partner, William Ballweg, spent days using a heavy duty hand-operated roll press to shape each scale to the exact curve. Tom did not like how the claws of most dragons look, so he had the Komodo feet shaped into "sand pads." Each of the dragons is fifty-five feet long and weighs eleven thousand pounds.

The *Komodos* are peaceful intergalactic dragons who suck up sand and use the nutrients to create energy so they can spit out music. They can be played as a musical instrument, to the pleasure of many visiting school groups, by clanging the "Tibetan singing bowls" mounted on their backs. Actually made from

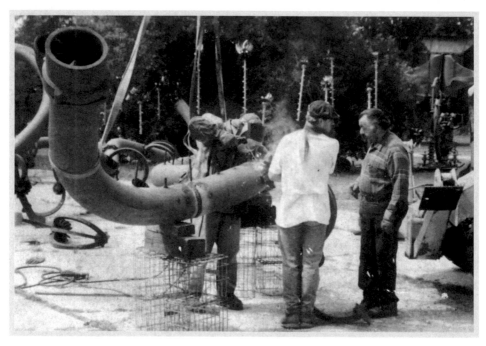

Aaron, William, and Tom at work on the *Komodo Dragons* AARON HOWARD

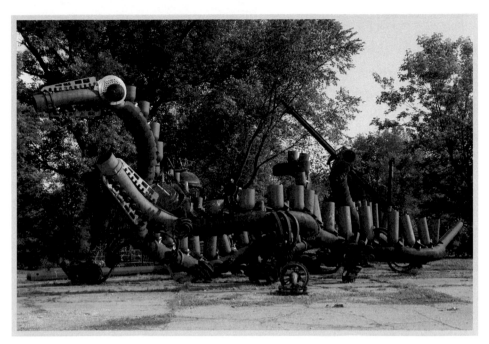

Komodo Dragons (heights between 7′ and 12′6″ [pictured] × 55′ h) JIM WILDEMAN

surplus oxygen tanks cut to various lengths, the bowls are made of spun metal, giving them a musical ring when struck.[4] Tom has not decided how he would like to display the dragons at this writing. He has considered having the dragons radiating out in a circle with a huge bonfire in the center; there has even been some talk of having the dragons spit fire. Kim Knuth talked with him about an arrangement of the *Komodos* in a circle with their bodies radiating out. Kim says, "I thought they could be used in healing and a person could be in the middle, and others could be around them ringing the bells, and the resulting vibrations and tones would then break up any dissonant energies and as the ringing follows the energy and changes, could then bring in any missing energies and create a feeling of wholeness." She further adds, "I remember thinking that this strange guy was really something special to the community, and that he would be someone who would be important in my life as well."[5]

One day Aaron was working in his shop when the phone rang. It was Doc, saying, "I got the big one. If they don't pull me over and I get arrested I'll be there with the big one. Don't go anywhere, stick around."

After a while he heard Tom's truck (the Fancy) rolling in. He says, "I could always tell when Doc showed up because you could hear the Fancy roaring and you could hear that music [of the First Brigade Band]. He would have that just cranked up and you would say, 'Here comes the weirdness.' I looked out my door and I saw the Fancy pretty much doing wheelies because he's got this eight-thousand-pound piece of stainless steel sitting on the back [of a one-ton truck]. And he's driven it like this all the way from Lake Mills [about thirty miles]." It was not uncommon for Tom to stretch the capacity of his trucks. When he was collecting for the House on the Rock, he came out of Baraboo one day with a load of steel and noticed that things didn't seem right. Something was dragging under the truck and he couldn't see the road as well. He had just loaded up with what he thought was two or three tons. Although the truck had a one-ton capacity, he always felt that really meant you could carry two or three tons or more. The frame had buckled, and from the side the truck looked like the shape of a broad V. Undaunted, he called for help and found, when they unloaded the Fancy, that he had been carrying eight and a half tons. He took the truck into the shop and bent the frame back—sort of.

Tom's truck with Tom and Jim Delaney EVERY COLLECTION

Aaron and Tom got the truck unloaded. It was actually a stainless steel hopper from Badger Ammunition that had originally been used to hold cotton balls for wadding in ammunition. Later Tom showed up with a variety of pieces, including some outboard motor parts. Then he sat down and drew up the only instructions on paper Aaron would get—on the inside of an unfolded kitty litter box (a plan now in the Aaron Howard collection).

UFO drawing by Tom Every AARON HOWARD

The UFO began to take shape outside Aaron's shop near Stoughton in the spring of 2004. The instructions were that everything was to be built at a twelve-degree angle, conforming to "the Peruvian Principle" (as seen in the *Twenty-Eight Intergalactic Meditation Points*). The legs are tipped in at twelve degrees, they lean forward at twelve degrees, the platform comes back at twelve degrees, and the antennae come up and out at twelve degrees. The tubular curved forms on the base are pipes that absorb energy from the earth to feed the spacecraft. The fifteen-thousand-pound ship rises forty feet. The finial on top is the guidance system positioned between two antennae, and the plumb-bob shape suspended from the bottom is meant to "drop down [for] people [to] get out of the spaceship," according to Tom. The legs of the UFO are made from salvaged light poles. When it was finished, Thayer took the UFO modules apart,

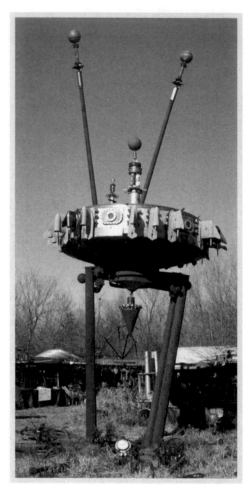

UFO (c. 38′ h × 12′ dia.) TOM KUPSH

delivered them to the *Forevertron* site, and reassembled it. The Discovery Channel was there filming for a segment about Dr. Evermor. The next day, May 14, 2004, Tom suffered a debilitating stroke.

At this writing, the UFO is the last major sculptural work created by Tom or under his direction.

12

Rhymes, Riddles, and Not Necessarily Coded Messages

Doc likes to talk about buried treasure he has squirreled away over the years. He claims he has buried valuables at various sites where he has worked. He is purposely vague about the what and the where. He also talks about locking things in (welding them in) so they can't be scrapped. Blaine Britton, in an article written for Tom about buried treasure, says: "Each statue is unique in itself, yet in each Dr. Evermor has buried one or several historical treasures. You can spend hours strolling through the park where Dr. Evermor has his art on display discovering these treasures." He considers this preservation. Even the most sober among us may be tempted to wonder just what might be out there on the sites where Tom has worked. With Tom there is always a playful spirit at work. Blaine continues, "It is Dr. Evermor's wish that archeologists a thousand years from now will see the superb technology with which our manufacturing plants of this century were designed."[1]

All of the sculpture is signed with Tom's characteristic signature. His monogram, which usually accompanies the signature, has changed through time. "Level Seven" (A) (on page 172) is Tom's designation of "the highest spiritual level." It can be turned upside down and it reads the same way. Tom often refers to various people in his circle or sets of ideas as "Level Seven"; it is his highest compliment. The interlocking hearts (B) represent Eleanor Every. When the monogram is turned on its side it is a double "E." Tom has used this symbol on

many of his sculptures even during the most difficult periods of their relation-
ship. The birds icon (C) is a symbol used on the base of the *Dreamkeepers* (2001)
and shows the negative space between the birds identified by Tom as "a spiri-
tual portal." The Evermor Foundation is symbolized (D) by the combined linear
"E" and "F."

Tom's monograms

The monogram that Tom is using at this writing (E) is based on his initials. He explains, "I've stuck with the T and it's a curved T and next is an O that's open and then the E at the end." The tail on the bottom of the E is the Forevertron "taking off into space." If the design is rotated ninety degrees it forms a question mark. The two dots under the T and the O represent "two eyeballs looking at you." Tom describes this as "an interlocking monogram," which he recalls using beginning in 2003.

The "lightning monogram" (F) was used by Tom between 1986 and 1992. Often he has simply used his initials, T.O.E., in block form when signing work. The three examples here (G, H, and I) are monograms used up until 2003. The "crusin'" monogram T.O.E. (J and K) Tom says was used before 1986. The "Power On," (L) with its seven (a powerful number in Tom's world) hash marks, is used on the base of the Dreamkeepers.[2]

Tom insists that he does not do drawings or make plans before he begins work, but this claim seems inconsistent with the fair number of drawings he has in his collection. When he says that he does not do drawings, he means that he does not plan everything out in a formal way on paper. He abhors the idea of making a plan or a blueprint to slavishly follow. Through the years he has sometimes worked out his ideas on paper, especially when it was necessary to explain what he wanted to his workers, or in the case of the Dreamkeepers to give a general idea of the design in advance. Tom says, "It goes back to fundamental principles. If you spend all your time drawing something out and then making a model, then you've lost the passion of doing it. I don't know—let somebody else judge that—years from now." Since 2004, while recovering from the effects of a stroke and unable to work with metal, he has produced a large number of drawings of his ideas, several of which are included here.

The Baby-Ball Submarine is a design that Tom had thought of in 1995 but now put down on paper. He describes the plan: "This is kind of a baby-ball submarine. I just drew it but I actually had the idea back in 1995. And it's those balls over there [the supply of four-foot metal balls]—it would be run by a cable down and it's got these arms and those are little floating adjectives. . . . I would make a pair of these little submarines—it would be like a one-man submarine."

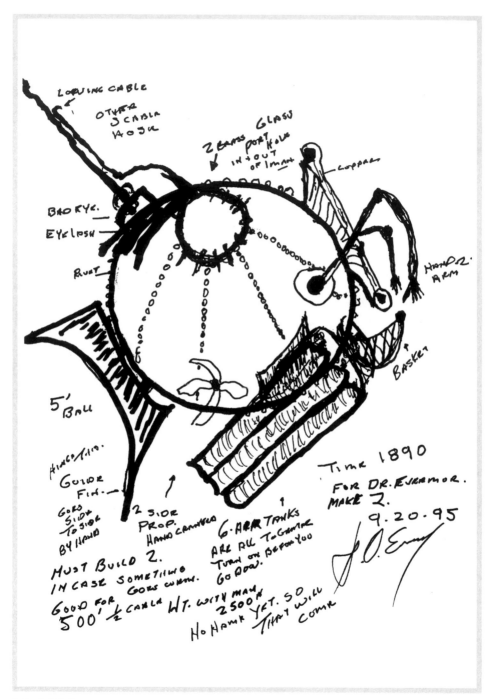

Baby-Ball Submarine

Rooty Toot

Tom has about thirty railroad crossing signs that he wants to incorporate into the *Rooty Toot* birds. They will assume two postures: one with the neck vertically standing some seven feet tall and one horizontally with a "roadrunner look," about four feet tall.

At this time Tom also designed a permanent protective cover for the Homer Daehn wood carving of Dr. Evermor (below) using a "TV dish frame" for the roof and a thousand-pound cast gear for the base.

Railroad signs for use in the *Rooty Toot*
JIM WILDEMAN

The *Slingher Bench* (7/7/03) is a drawing of a piece already in the park but here redrawn in February 2005. In the upper-left corner is the admonition, "Do as many as you can!"

Sculpture cover

Slingher Bench drawing

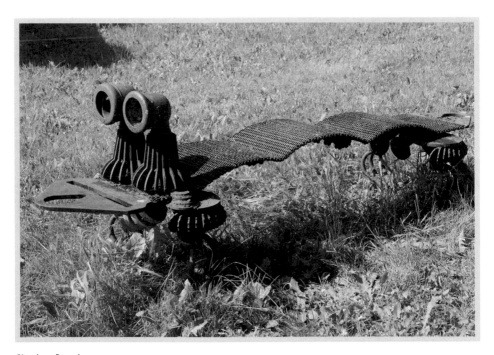

Slingher Bench JIM WILDEMAN

There is something refreshingly old-fashioned about receiving a handwritten personal letter; this is one of Tom's favored ways of communication. He spends part of nearly every day writing letters. To those unfamiliar with his calligraphy and writing style, a letter from Tom can be puzzling; for those expecting to do business with him, the letters can be frustrating. To those who understand them, they are always a stimulating adventure. Petra Backonja remembers Tom talking about "rhymes, riddles, treasure maps, and not necessarily coded messages." She says that "this

Letter in Tom's hand

Tom's "heiroglyphics"

is all part of his worldview. . . . It's part of his personal symbology."[3] Here is an example of his writing style in his own hand.[4]

More challenging is receiving one of Tom's hieroglyphics. He says about these: "I was interested in curves, arcs, and circles, not in Hebrew or Egyptian or anything else. And working those curves, arcs, and circles into a series of words. The lines are what I was concerned about—no straight lines at all—just curves, arcs, and circles as energy forces. So when you hold it up it

looks like a bunch of angleworms, you know, so it's an energy force type of thing. But within this concept there would be phrases, and riddles, and rhymes, and yet there would be the answer to where the treasures were or whatever message you wanted to get out of it. . . . I never explained it to anybody but I explain it to you [the author]." Some of this is tongue-in-cheek but his letters get people spinning, which may be what it's all about.[5]

Portrait of Tom BOBBI LANE

Conclusion

There are those who have pretty well removed Tom Every from the real world and treat him as an object—a weird and spacy folk artist or a rare talent almost too brilliant to communicate. No such confusion rests in Tom's mind. He is as sane and shrewd as a fox, conscious of the importance of his work and proud of his achievements. Some try to force him into the category of a lone, striving, eccentric genius, toiling alone and misunderstood against the cruel forces of authority and the unfair establishment.

Hogwash.

Although the forces of authority and bureaucracy are there in the story, his struggles have been with the dragon within. He is a man smiled on by opportunity who has freely chosen his path; he is not now, nor has he ever been, anyone's victim; he has spent his life in the midst of friends, family, and fellow artists, always creating and always looking forward to tomorrow.

The *Forevertron* environment itself is a singular and visionary achievement in the world of outsider art. Tom is the first to laugh at those who take themselves and his work, his "whimsical fantasy," a little too seriously. Nonetheless, he encourages those who want to wax poetic about his work and takes great pleasure in all such interpretations and musings.

Tom has not tried to accommodate society and its norms in his life and work but rather has tried to ignore everything and everybody that does not fit his vision. He is at heart an anarchist, and he has occasionally paid the price for this stance. He has chosen to serve his grand obsession with all his strength and will and with continuous attention to the collecting of scrap, its conversion into art (and sometimes into money), and the promotion of his myth; nothing else has ever been more important to Tom—nothing—except, perhaps, praise. And through it all, inside him is the shape changer and the trickster always ready to surprise,

confuse, charm, or slip away. He has laid his life's struggles bare for all of us to see in the laughter and pain of his work. It has been a quixotic journey. He surely has tilted at his share of windmills.

We can see in his work the story of our own strivings. In its best moments, Tom's work invites us to join with him in our common struggle to be free, to excel, to rise above our own frail human condition, and to live an uncommon life.

Endnotes

Chapter 1: "The Child Is Father of the Man"

[1] William Wordsworth, "My Heart Leaps Up When I Behold," in *The Essential Wordsworth*. Ed. Seamus Heaney (New York, NY: Galahad Books, 1993), 139.

[2] Background and genealogical information unless otherwise noted is from research and family oral tradition and documents provided to the author by Tom and Eleanor Every. The author also received information from Tom's sister, Barbara Banks, who has done extensive genealogical research about the family.

[3] Information and quotes in this book by and about Tom and Eleanor Every, unless otherwise noted, come from transcripts of many recorded conversations that took place beginning in November 2004. In most cases both Tom and Eleanor were present. To avoid a multiplication of endnotes, quotes or information from either Tom or Eleanor will be marked as endnotes only in instances where clarification or special circumstances dictate.

[4] Douglas Botting, *Pirates* (Alexandria, VA: Time-Life Books, 1978), 80.

[5] Ibid.

[6] Mark Twain, *Following the Equator: A Journey Around the World* (New York: Dover Publications, 1989), 33.

[7] At the point in the conversation when Tom said this, Eleanor looked at him and said, "Do you think that you're a little bit like him?" Tom looked at his shoes and mumbled, "I don't know."

[8] Family coat of arms and information provided by Eleanor Every.

[9] The author examined Tom's early report cards and found that he actually did reasonably well—although he could have listened better.

[10] From Tom's recollection and from an unpublished paper entitled "Historic Provenance of the East Side of Madison," dated May 5, 2003, by Lisa Ponti on the occasion of the dedication of the *Dreamkeepers* sculpture in Madison, Wisconsin.

[11] *Wisconsin State Journal*, May 1956.

[12] Quotes here and below from Pete Burno are taken from the transcript of a recorded conversation at his home on July 2, 2005.

[13] This and the quote that follows are from the transcript of a recorded conversation at Eleanor's home on June 20, 2005.

[14] Quote here is taken from a recorded conversation at the sculpture park on September 8, 2005.

Chapter 2: The Search for Artistic Voice

[1] Information about the Highlands house was provided in conversations with both Tom and Eleanor but especially in a recorded interview at Eleanor's home on June, 20, 2005.

[2] Tom later designed a similar gazebo that he installed outside a restaurant in Mississippi, where it survived intact a thirty-foot storm surge during Hurricane Katrina.

[3] This history and these observations about the House on the Rock and its surroundings are from the author's memory and knowledge. He worked for Alex Jordan as a sculptor from 1977 until 1983 while Tom Every was also working there. For more information about the House on the Rock and the life of Alex Jordan, consult the bibliography.

[4] This incident occurred in the winter of 1979 as recalled by the author.

[5] Quote here is from the author's recollection of a conversation with Jordan in late 1978.

[6] From the transcript of a recorded conversation with Eleanor Every on June 20, 2005.

[7] As was common with Jordan, there never was a written contract concerning a food concession with Tom Every. In the end Tom would sue Alex over what he claimed was an agreement. Although the suit was settled out of court and Tom was paid $25,000, Jordan and his attorney, John Mitby, did not concede that there ever was a contract. The point was moot, however, since the statute of limitations had by then (1983) run out.

[8] Some of the court cases from Dane County, Wisconsin: 82-CV-4820 *Nelson Steel v. Wisconsin By Products Corp. and Tom Every*; 83-CV-3615 *Wisconsin By Products et al. v. House on the Rock Corporation*; 84-CF-662 *State of Wisconsin v. Tom Every*; 86-CV-0072 *Nelson Steel v. Tom Every*. For a summary of these events see the *Wisconsin State Journal*, February 18, 1986, Section 3.

Chapter 3: The Myth

[1] This is a paraphrase of what Jordan told the author in October 1978.

[2] This version of the myth was compiled by the author as a result of listening to Tom's retelling of the story many times in the winter of 2004–05. These accounts were recorded and notes made of the variations. The author then questioned Tom, reconciled the differences in the versions, and verified details. The author read the resulting present version aloud to both Tom and Eleanor on April 21, 2005, and they approved it.

[3] Some versions of the myth, both of the oral tradition and in print, refer to Victoria and Albert as both being present and some refer to Albert as king. Albert was the prince consort and could not have been present because he died in 1861. The Prince of Wales in this version would be Albert Edward (seldom referred to as Prince Albert to avoid being confused with his father), who became Edward VII at the time of Victoria's death in 1901. The queen and the prince are seated in *The Cocoon Throne* here in spite of the fact that they did not get along. Victoria looked with dread upon "the rare, the rather awful visits of Albert Edward, Prince of Wales, to Windsor Castle." Presumably there had been a reconciliation for this event. Source: *Encyclopædia Britannica*, 15th ed., s.v. "Victoria."

[4] Earlier versions refer to the scale as an English jockey scale. Tom is no longer in possession of this artifact.

Chapter 4: The Forevertron

[1] Quotes and information here are taken from the transcript of a recorded interview with Jim Delaney in his office on April 28, 2005.

[2] These measurements are for the *Forevertron* in its current location and were made by the author. When it is moved to a permanent site the work will be spaced differently, according to Tom, giving it a length of at least 120 feet and a width exceeding 80 feet. The height will likely remain the same.

[3] Quote is taken from the transcript of a recorded interview of Richard Springer at the sculpture site in the presence of Tom Every on March 16, 2005.

[4] This story was told to the author during a recorded interview with Kim Knuth on October 10, 2005.

[5] Information and quotes are from the transcript of a recorded interview with Ray Blackburn in his home on March 26, 2005.

[6] This story is from the transcript of a recorded interview with Dee Hanson at the sculpture site in the presence of Tom and Eleanor Every on November 6, 2004. The story was told by Tom and Dee by turns and together.

[7] Tom's longtime friend and advisor, Walter Blaedel, wrote to NASA in 1991, describing the chamber and the trailers in an attempt to document these artifacts. A letter dated December 10, 1991, from Carol A. Homan, Johnson Space Center history coordinator, states in part: "Thank you for your recent letter regarding Tom Every's welded-art sculpture. We need to clear up a misconception in it regarding the Mobile Quarantine Facility built for NASA by Melpar Corporation. The MQF was ship-based as well as land-based. The entire facility was hoisted with a crane onto the deck of the recovery vessel and removed the same way after the crew had entered. It was subsequently transported by aircraft to Houston with the crew to the Lunar Receiving Laboratory. It is extremely unlikely that Mr. Every's 'lunar modules' are part of the crew recovery apparatus." The letter goes on to speculate that the chamber at the sculpture site may be part of a laboratory that was designed to "simulate the space environment and is not intended for human tests." The chambers at the Johnson Space Center that are used with human subjects are "several orders of magnitude larger than any in the Every sculpture," the letter says. A copy of this letter was given to the author by Tom and Eleanor Every. Tom feels that this is inconclusive and says that he had heard from the salvager that he had found a pair of space boots in the chamber. He says that the government didn't mean to let the chamber get away from them and that they are covering up. Tom continues to refer to these artifacts as the "decontamination chamber and the autoclaves" and the author will do the same.

[8] Quote is taken from the transcript of a recorded interview with Doug Britton in a Madison café on December 2, 2004.

[9] Guinness Media, Inc., wrote to Tom in May 1999 and accepted his claim for "Largest Scrap Metal Sculpture." The letter notes that Guinness does not guarantee that "every record will be selected for publication in *The Guinness Book of Records*." The letter from Guinness Media was provided to the author by Eleanor Every. The *Forevertron* is no longer the world's largest. That honor is now held by a North Dakota sculpture entitled "Geese in Flight." For more information on this piece see enchantedhighway.net.

[10] This chapter was read to Tom Every on December 22, 2005, by the author, at which time Tom verified the information and descriptions herein. He also stated that this is the first complete description of the components and workings of the machine ever.

[11] Information regarding this machine is taken from the transcript of a recorded interview with Pete Burno at his home on July 2, 2005.

[12] While the dynamos play a part in the myth as electrical generators, the motors in the collection play no role but are only there as a historic collection.

[13] Encyclopædia Britannica, 15th ed., s.v. "Faraday, Michael."

[14] Encyclopædia Britannica, 15th ed., s.v. "Brahe, Tycho."

[15] Information and quotes here are from the transcript of a recorded interview with Larry Waller on April 7, 2005, at the sculpture site in the presence of Tom Every.

[16] Quotes and information here are from the transcript of a recorded interview with Larry Waller at his home on April 15, 2005.

[17] Although there is only one speaker and it functions as a singular unit, it is always referred to as the "Listening Ears," and the author will always treat this unit as plural in this text.

[18] Information and quote here are from the transcript of a recorded interview with Pete Burno at his home on July 2, 2005.

[19] See chapter 7.

[20] From the transcript of a recorded interview with Aaron Howard in his shop on January 19, 2005.

[21] From the transcript of a recorded interview with Jake Furnald at his home on January 15, 2005.

[22] From the transcript of a recorded interview with Homer Daehn in his shop on January 26, 2005.

[23] Knuth interview (see note 4).

[24] Maria Reiche, Mystery of the Desert, from www.agutie.com.

[25] From the transcript of a recorded interview with Erika Koivunen in the studio of Jim Wildeman on June 25, 2005.

[26] Used with the permission of the poet.

Chapter 5: The Bird Band

[1] Quotes and information from Doug Britton are from the transcript of a recorded conversation in Tom's presence at the sculpture park on December 8, 2004, and from an interview conducted in a Madison, Wisconsin, café on November 30, 2005.

[2] The Badger proposal is treated in chapter 7.

[3] In January 2006 one of the Fiddle Birds was sold to the American Visionary Art Museum in Baltimore.

[4] Information and quote here are from the transcript of a conversation with Dan Woolpert at the sculpture site with Tom present on September 8, 2005. For more information on the First Brigade Band visit: www.1stbrigadeband.org.

[5] A partial list of names taken from a reading of the bases and an inventory list compiled by Eleanor reads as follows: "Capt. Doug Britton," and "Capt. George Reizner" (both longtime friends), "Sir John Every" (then head of the Every family in England), "The Gang

Graves" (Graves Machine Shop in Brooklyn, Wisconsin), "Bro. Roy Watkins" (an old friend from the scrap business), "Capt. Charlie Gibbs" (a pirate [goodness!]), "John Armstrong" (a high school friend), "Lyon 1956" (high school principal), etc.

[6] Don Krug and Ann Parker, *Miracles of the Spirit: Folk, Art, and Stories from Wisconsin* (University of Mississippi Press, 2005).

[7] This exchange and approximate quote were told to the author by Jim Wildeman, who was present at the panel discussion, in a recorded interview in his studio on March 25, 2005.

Chapter 6: The Middle Works

[1] Information about this piece is from the transcript of a recorded interview with Erika Koivunen in the photography studio of Jim Wildeman on June 25, 2005.

[2] The motto of the state of Wisconsin is "Forward," and the "W" stands for Wisconsin.

[3] This information comes from the following documents from the Kohler Company, provided to the author by Eleanor Every in the summer of 2005: "Consignment Agreement [draft]," dated 6/4/92; "Agreement for Consultant Services [draft]," dated 7/9/92; "Statuary Park—Letter of Understanding [unsigned, undated copy available]."

[4] This quote comes from the transcript of a recorded interview with Dee Hanson at the sculpture park on November 6, 2004. Present were Dee Hanson, Tom Every, and Eleanor Every. This story was told together and in turns by Tom and Dee with Dee supplying the last quote.

[5] This idea and image come from Doug Britton as spoken in an interview in a Madison café on December 8, 2004.

[6] The author read aloud the section of this chapter having to do with the Kohler proposal to John Green on September 15, 2005, who found it to be accurate. John was an employee of Kohler at the time of these events and played a central role in the Kohler proposal.

Chapter 7: The Mirror Eye

[1] Information about the history of the Badger Ammunition Plant is from the Web site: http://badger.org/about.htm.

[2] Quotes and information about the reuse of Badger are here quoted from the transcript of a recorded interview conducted in a local restaurant on June 8, 2005. Curt has worked for years for and on behalf of the International Crane Foundation near Baraboo, Wisconsin. He is the author of *Aldo Leopold: His Life and Work* (University of Wisconsin Press, 1988) and earned his Ph.D. from the University of Wisconsin, Madison.

[3] Ann Parker and Gail Lamberty are those Tom remembers as most dedicated.

[4] Quoted from an article entitled "A Proposal, The Badger Army Ammunition Plant National Living Memorial to Munitions Workers of America," May 6, 1998. Documents about the work of the late Blaine Britton on behalf of the foundation were provided by his son Doug Britton.

5 Information and quotes here are taken from a short document entitled "A Proposal, The Badger Historical and Environmental Research Conservancy," produced by the Evermor Foundation and dated 2/17/98 BSB [Blaine S. Britton].

6 Information and quotes by Jake Furnald are from the transcript of a recorded interview conducted at his home on January 15, 2005.

7 Quotes here are taken from an unpublished article by Dr. Maier entitled "The Firebird: Phoenix from the Wasteland." The quote from this article was referred to in a telephone conversation with the author on June 27, 2005.

8 Information here was provided to the author by Tom Every and further researched by a visit to the Goose Pond site. Tom has lost the original package and list given to him by Standing Elk, but he did provide the author with a copy of a newspaper clipping of unknown origin. The article in the clipping lists the names of the birds, and the list and story matches Tom's version.

9 Quote here is from the transcript of a recorded interview with Petra Backonja at her home on July 16, 2005.

Chapter 8: The Dreamkeepers

1 Quotes here from Erika Koivunen are taken from the transcript of an interview at her home on December 16, 2004.

2 Quoted here from a letter to the author.

3 This information and quotation are taken from a historical marker located in Cooksville.

4 This quote is taken from the transcript of a recorded interview conducted in Jim Wildeman's studio on June 25, 2005.

5 Quotes here from Jim Wildeman are taken from the transcript of a recorded interview in his Madison studio on March 24, 2005. Later that summer, the author read aloud a first version of this chapter, essentially the same as this final version, to Don Warren and Jim Wildeman in Jim's studio. They both approved, and Don had only minor corrections to the text.

6 This quote, the information relating to Kim Knuth, and the quotes following in this chapter are taken from a letter to the author in August 2005. The letter was in answer to questions posed to her earlier.

7 Her letter has them spelled Dream—Keeper birds. The inscription on the base of the birds has the name in one word, Dreamkeepers, and that is how it is now usually spelled.

8 Quotes and information here are taken from the written transcript of a recorded interview with Nobuyoshi Kitamura at the sculpture park on October 14, 2006.

9 This list was compiled by Ann Parker at the time of the legal negotiations about the ownership of the birds.

10 From the court transcript: State of Wisconsin, Dane County Circuit Court, Case No. 02-CV-2987.

11 This incident was related to the author in an unrecorded interview with Don Warren in Jim Wildeman's studio on June 25, 2005.

12 Quotes and information about this entire incident come from the transcript of a recorded interview conducted in Aaron Howard's shop in Stoughton on January 19, 2005.

Chapter 9: The Rolling Atelier

[1] Douglas Botting, Pirates (Alexandria, VA: Time-Life Books, 1978), 80.

[2] Thomas Moore The Re-Enchantment of Everyday Life (New York: HarperCollins, 1996), 207.

[3] Charles Boer (trans.). Marsilio Ficino: The Book of Life (Irving, TX: Spring Publications, University of Dallas Press, 1980), xiii–xiv.

[4] This and following quotes by Homer Daehn are taken from the transcript of a recorded interview in his studio and nearby coffee shop on January 26, 2005.

[5] Quotes from Richard Springer are taken from the transcript of a recorded interview at the sculpture park on March 16, 2005.

[6] Quotes from Jim Wildeman are taken from the transcript of a recorded interview in his photography studio on March 24, 2005.

[7] Quote from Erika Koivunen is taken from the transcript of a recorded interview at her home on April 6, 2005.

[8] This quote is from a private unrecorded conversation between Eleanor and the author at the sculpture site in the winter of 2004–05. Because of physical complications following Tom's hip surgery in the summer of 2005, as well as difficulties in their relationship, Tom resides in a local care facility at the time of this writing. Eleanor drives him to and from the park on business days, and friends frequently stop by to take him on day trips.

[9] Quotes and information here are from the transcript of a recorded interview with Aaron Howard in his shop on January 19, 2005.

[10] Quotes here are from the transcript of a recorded interview conducted in Jim Wildeman's studio (with Jim present) on June 25, 2005.

[11] Quotes here are from the transcript of a recorded interview conducted in a local café on October 10, 2005.

[12] Quotes here from Dr. Backonja are taken from the transcript of an interview with him and his wife, Petra, at their home on July 16, 2005.

Chapter 10: The Twenty-Eight Intergalactic Meditation Points

[1] Comments of Dee Hanson are taken from transcripts of recorded interviews: one on November 6, 2005, at the sculpture park with Tom and Eleanor and the second at her Madison home on February 24, 2005.

[2] Quotes and information from Doug Britton are from the transcript of a recorded interview in a Madison café on February 24, 2005.

[3] My apologies to the model. Rest assured, Aaron speaks here only figuratively and is not making a disparaging remark.

[4] Remarks of Aaron Howard here are taken from the transcript of a recorded interview in his Stoughton shop on January 19, 2005.

[5] This quote is taken from the author's notes made immediately following a nighttime telephone conversation with Tom on January 28, 2005.

[6] Quotes here from Erika Koivunen and Aaron Howard come from transcripts of recorded conversations and comments on and around the Twenty-Eight Points on August 6, 2005, during a photography session there with photographer Jim Wildeman. I make extensive use

here of her reactions and comments because she was part of the creative process and listened to and talked with Tom during the production of the works.

[7] This name is used again in the three-piece set on page 153.

[8] This quote is taken from notes made by Petra Backonja of a telephone conversation with Tom at the time that he was working on these pieces. The quote was related to the author during an interview with Misha and Petra Backonja at their home on July 16, 2005.

[9] Quote from Doug Britton is taken from the transcript of a recorded interview in a Madison café on February 24, 2005.

[10] Comments of Petra Backonja are from the transcript of a recorded interview at her home on July 16, 2005.

[11] Used by permission.

[12] Used by permission.

Chapter 11: Alien Visitors

[1] Information here and quotes from Karin Shoemaker are from the transcript of a recorded interview conducted in a Janesville, Wisconsin, restaurant on January 15, 2005.

[2] Information and quotes here are taken from the transcript of a recorded interview conducted in Aaron Howard's Stoughton shop on January 19, 2005.

[3] This is a list of the names as they appear on the bases of the birds: "YOO—MATIL—7" (6/12/02), "KLIK—E—TAT" (undated), "ALLE BAMOO" (undated), "HAVA—SOO—PIE" (undated), "HUNG—PA—PA" ([summer solstice] 6/21/02), "ZOO—NEE" (6/21/02), "NOOT—KA" (undated), "TONG—KA—KA" (6/21/02), "HO—PEE" (6/21/02), "TLING—GIT" (6/32/02), "YOO—MA—TIL-A" (undated), "O—GLA—LA" (undated), "BELLA—KOO—LA" (undated), "KA—YOO—GA" (undated).

[4] Information about this is from Aaron Howard.

[5] This quote is taken from a letter to the author from Kim Knuth in August 2005.

Chapter 12

[1] From an unpublished article by the late Blaine Britton, "Dr. Evermor's Buried Treasures," dated May 29, 1998, and provided to the author by his son Doug Britton.

[2] Drawings and explanations here are from the transcript of a recorded interview during which Tom drew and explained these monograms and symbols. The interview was conducted at Eleanor's home on April 28, 2005.

[3] These quotes from Petra Backonja are from the transcript of a recorded interview conducted at her home on July 16, 2005. Her quote here from Tom is from her memory and notes of a telephone conversation with Tom on an unspecified date.

[4] Copies from correspondence between Tom and the author in 2005 and other writings shared by Tom.

[5] This explanation and these quotes are from the transcript of a recorded interview conducted at Eleanor's home on January 6, 2005.

Selected Bibliography

In researching this book I relied almost entirely on the transcripts of recorded interviews I conducted with Tom, his family, and those who have known him over the years. As an introduction, I found the following articles helpful. They represent only a scant few of the many resources that might be helpful as a starting point for those interested in learning more about Dr. Evermor and the places and people in this book.

Cubbs, Joanne, and Eugene W. Metcalf Jr. "Sci-fi Machines and Bottle-Cap Kings: Recycling Strategies of Self-Taught Artists and the Imaginary Practice of Contemporary Consumption." *Recycled Re-Seen: Folk Art from the Global Scrap Heap.* Eds. Charlene Cerny and Suzanne Seriff. New York: Abrams, 1996: 46–59.

Erickson, Dave. *Powder to the People.* VHS. Baraboo, WI. Badger Group History Media Productions, www.saukcounty.com/schs, 2000.

Goc, Michael J. *Powder, People and Place: Badger Ordnance Works and the Sauk Prairie.* Friendship, WI: New Past Press, 2003.

Hayes, Jeffery R. "Dr. Evermor's *Forevertron.*" *Folk Art Messenger* 11(1), 1998: 9–10.

————. "Dr. Evermor's Machine on the Prairie: Art, History, and the Mirror Eye." *The Southern Quarterly* 39 (1–2), 2000–2001: 112–135.

Krug, Don, and Ann Perry Parker. "Power on! The Fantastic Environment of Dr. Evermor." *Raw Vision* 25 (1998–1999): 26–31.

Leff, Bob. *Statues by the Road: "Power on!" at Dr. Evermor's Sculpture Park.* VHS. McFarland, WI: Video Art Productions, 2003.

Moe, Doug. *Alex Jordan: Architect of His Own Dream.* Spring Green, WI: House of Wyoming Valley, 1990.

Index

Photographs are indicated by bold page numbers.